inkBloom

DRAW AND PAINT A FANTASY ADVENTURE

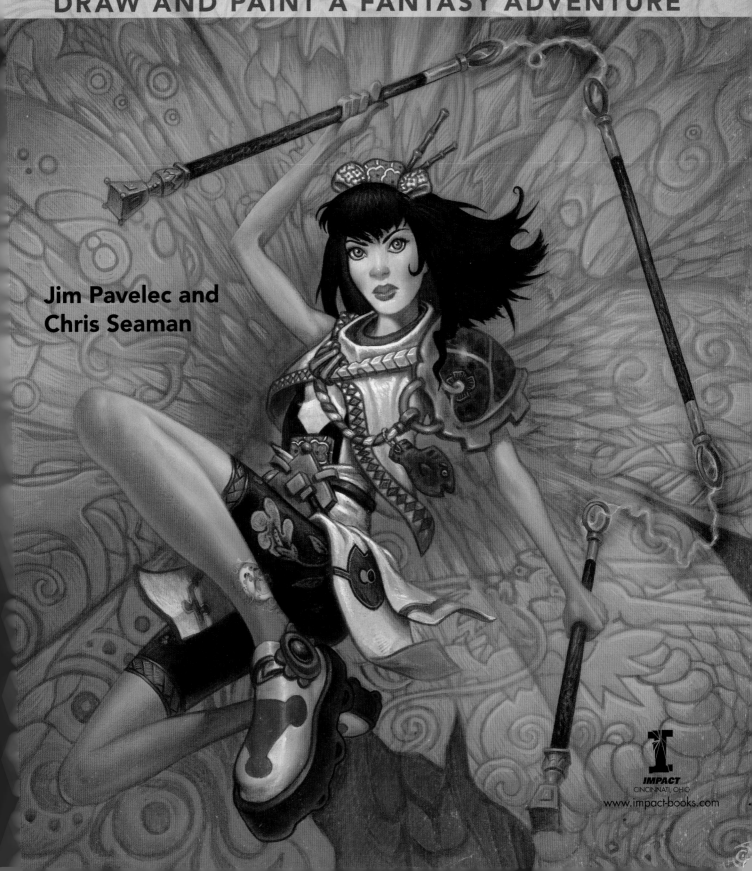

Jim Pavelec and
Chris Seaman

IMPACT
CINCINNATI, OHIO
www.impact-books.com

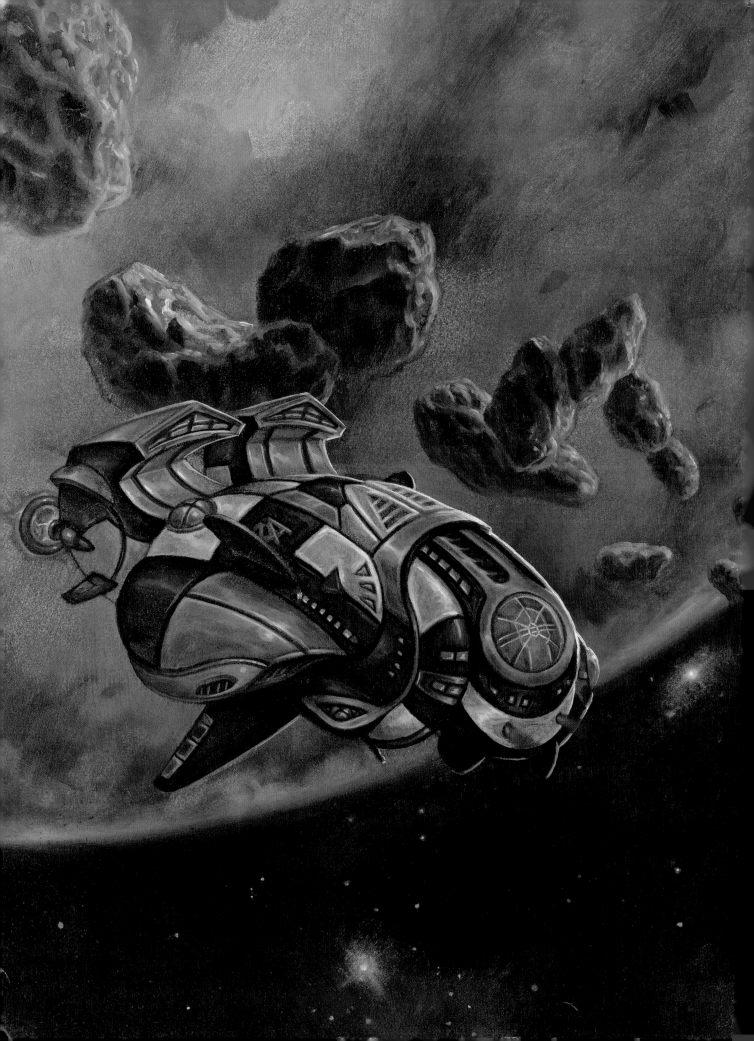

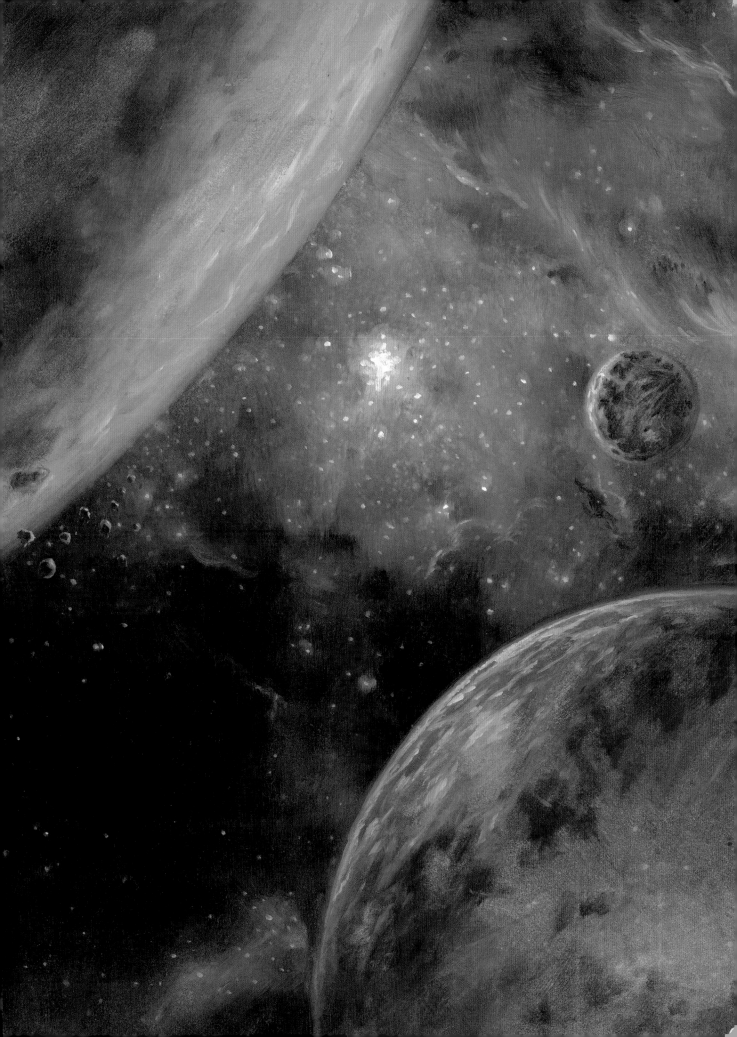

Published by IMPACT Books, an imprint of F+W Media, Inc., 4700 East Galbraith Road, Cincinnati, Ohio, 45236. (800) 289-0963. First Edition.

Other fine IMPACT Books are available from your local bookstore, art supply store or from online suppliers. Also visit our website at www.fwmedia.com.

14 13 12 11 10 5 4 3 2 1

DISTRIBUTED IN CANADA BY FRASER DIRECT
100 Armstrong Avenue
Georgetown, ON, Canada L7G 5S4
Tel: (905) 877-4411

DISTRIBUTED IN THE U.K. AND EUROPE BY DAVID & CHARLES
Brunel House, Newton Abbot, Devon, TQ12 4PU, England
Tel: (+44) 1626 323200, Fax: (+44) 1626 323319
Email: postmaster@davidandcharles.co.uk

DISTRIBUTED IN AUSTRALIA BY CAPRICORN LINK
P.O. Box 704, S. Windsor NSW, 2756 Australia
Tel: (02) 4577-3555

Library of Congress Cataloging-in-Publication Data
Pavelec, Jim.
 Ink bloom : draw and paint a fantasy adventure / by Jim Pavelec and Chris Seaman. -- 1st ed.
 p. cm.
 Includes index.
 ISBN 978-1-60061-819-2 (pbk. : alk. paper)
 1. Fantasy in art. 2. Comic books, strips, etc.--Japan--Technique. 3. Illustration of books--Technique. I. Seaman, Chris R. II. Title. III. Title: Draw and paint a fantasy adventure.

 NC1764.8.F37P38 2010
 741.5'315--dc22 2009040854

Edited by Mary Burzlaff Bostic
Designed by Guy Kelly
Production coordinated by Mark Griffin

Metric Conversion Chart		
To convert	to	multiply by
Inches	Centimeters	2.54
Centimeters	Inches	0.4
Feet	Centimeters	30.5
Centimeters	Feet	0.03
Yards	Meters	0.9
Meters	Yards	1.1

About Jim Pavelec

This is Jim's fourth project for IMPACT Books. He wrote *Hell Beasts* and co-wrote *Wreaking Havoc: How to Create Fantasy Warriors and Wicked Weapons* and *How to Draw Blood-Sucking Monsters and Vampires*. *Ink Bloom* marks his debut as a fiction writer.

As a freelance illustrator, Jim has worked on projects including *Star Wars*, *World of Warcraft*, *Magic: The Gathering*, and *Dungeons & Dragons* and contributes regularly to *ImagineFX* magazine.

Jim lives in Chicago, and his hair is turning gray at an alarming rate. To see more of his work, visit www.jimpavelec.com.

Acknowledgments

I would like to thank Chris and his wonderful wife Mindy for their dedication to this project, even in the most difficult of times. All of you artists out there who think you are working hard, Chris is working harder than you.

I am especially grateful to everyone at IMPACT Books for having the courage to try something a little different and for getting behind it with such vigor.

I would also like to thank John Hallam for the Japanese translations in the book and Amber for posing as Hachi.

Finally, I would like once again to thank my new bride, Aimee, for hanging in there with me. Fifteen years wasn't so long, was it?

Dedication

I would like to dedicate this book to artists and writers the world over who keep me motivated with the tremendous work they do.

About Chris Seaman

Educated at the Columbus College of Art & Design in Columbus, Ohio, Chris began his career as an illustrator for Seedling Publications. Experimenting with photography, light, color and design, Chris settled on oil paint as a preferred medium in a style he calls "stylized realism."

Chris's new work has attracted such clients as Upper Deck, Blizzard Entertainment, Wizards of the Coast and Alderac Entertainment Group. His work has been featured on the cover of *Dragon* magazine and *Dungeons & Dragons, 4th ed.* He also co-wrote *Wreaking Havoc* and *How to Draw Blood-Sucking Monsters and Vampires*.

Chris's work has been received and recognized by the Society of Illustrators and the Society of Illustrators of Los Angeles. His collected body of work was awarded Best in Show at Gen Con 2009. Visit Chris at www.chrisseamanart.com.

Acknowledgments

I would like to thank Jim Pavelec for recognizing my artistic strengths and pushing me to work hard. It's been an honor to work with you and to see our idea come to fruition. I will look back on this as the most creative and enjoyable process in my professional career. This book is only the beginning, dude! I would also like to thank Uncle Skip for helping me to understand that luck has nothing to do with it. A special thank you to Mona Michael, Mary Bostic, Pam Wissman, Guy Kelly, Eric Camper and everyone at IMPACT Books for letting the ink fly. Thanks for believing in us. I would also like to thank my family and friends who have supported me through the years. Thank you all!

Dedication

This book is dedicated to my honeybee, my Hachimitsu, my wife Melinda!

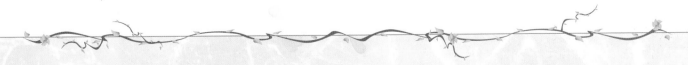

Contents

INTRODUCTION

Chris and I love fantasy and science-fiction art. We love the big swords and the cool armor, the sleek spaceships and the terrifying aliens. For us, discovering the book covers of Frank Frazetta, Boris Vallejo and Michael Whelan was like finding diamonds and rubies in a pile of gravel. They had bold colors and dynamic figures that screamed, "Pick me up!" So we did. Those covers made us believe that whatever was written inside must be awesome, and it was. They introduced us to the worlds of Robert E. Howard's Conan, Michael Moorcock's Elric, Edgar Rice Burroughs's John Carter of Mars and Isaac Asimov's robots.

We wanted more. We found comics. We still wanted more. In 1985, an animated TV show called *Robotech* came directly into our homes for free, and we were never the same. At the time we didn't even know we were watching a show originally created in Japan that was in a style of animation called *anime*. What we did know was that it was the coolest thing we'd ever seen on television. We were experiencing something epic. For me, it brought clarity to a defining principle of my existence: great artwork captures the imagination, while a great story captures the soul, and when the two come together something happens that consumes you entirely. Their combined effects linger like no other force can and leave you with a unique sense of happiness.

Since that time it has been our quest to contribute something to this great pool of happiness, and this book is the cul-

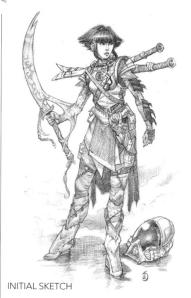

mination of the hard work and dedication required of such a noble quest.

The process started over two years ago. After finishing work on *Wreaking Havoc*, Chris and I approached IMPACT Books with the idea for a how-to book that included a story, pulling together our favorite genres. We wanted to create a story and a look that would appeal to fans of science fiction, fantasy, anime and manga. The result is a science-fiction epic featuring a seventeen-year-old girl named Hachi Hachimitsu. We did some initial sketches of her, which you can see here, to include with our story. IMPACT thought we were on to something.

Our goal is to show young artists not just how to draw and paint, but how to illustrate a story. We wanted you to see what it's like to work with a manuscript and how to incorporate your own ideas to make the world more vibrant and exciting.

We started a blog so that readers could track our progress and our influences. We plan to keep it going for a long time because we aren't nearly through with Hachi yet. The back and forth between the two of us during the creative process was incredible. Characters and settings gained depth and layers we wouldn't have been able to come up with on our own. Together we were able to find creative ways to solve the problems of combining a how-to book with a science-fiction tale.

We hope that you enjoy what we've come up with and that you learn new ways to illustrate a story. Ideally you'll get as excited as we were when we were young and decide you want to carve out a spot for yourself among the storytellers. We look forward to seeing you there.

—Jim Pavelec

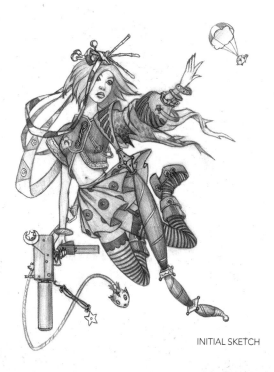

The Story Continues

Continue to learn about the creative process. Follow the Ink Bloom blog at www.hachihachimitsu.blogspot.com.

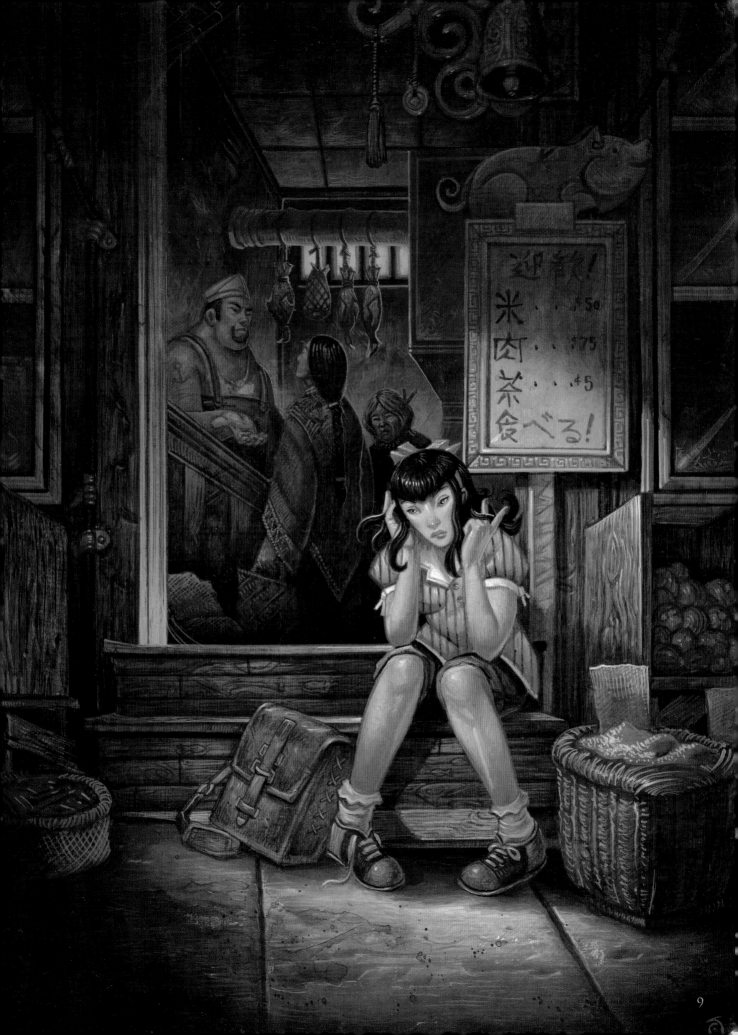

CHAPTER ONE

THE MASTER'S TALE:
Materials and Techniques

Eighty-eight. In English, *eighty-eight* is simply a word representing a number. It's a quantity, nothing more.

The Japanese language, on the other hand, has developed a beautiful subtlety and layering over a long history, and its words can be associated with a variety of meanings. Eighty-eight, or *hachi-ju-hachi*, has become linked

with good luck and a bountiful harvest. Because of this, one's eighty-eighth birthday, or *beiju*, is a day of great celebration.

My name is Hajime, and today is my beiju.

Many of my friends stopped in to pay their respects. I was especially happy to see Hideaki because I knew he would bring

my favorite gift, incense. He sat down next to me with a creaking thud and with a glorious grin said, "*Kimi, mou hachi-ju-hachi*?" Hachi-ju-hachi. The word had been buzzing around in my head for weeks, but hearing it spoken out loud caused a blissful memory to blossom. It was a memory unrelated to my birthday, good luck or a bountiful harvest, but to a special young girl named Hachi Hachimitsu. Through the haze of years I could see her clearly.

She came to my tattoo studio in San Francisco shortly after the Chinese New Year celebrations of 1950. At that time I was a young man of 29. On that particular day, as I recall, overcast skies muted the colors in the shop windows, and rain dampened the fragrant aromas that usually abound in the streets of Chinatown. I was happy to see a customer, for business was slow in the years following the war.

I liked her immediately. She was different from my regular customers, who were mostly sailors on leave or local thugs with something to prove. I tattooed anchors and eagles on the sailors, dragons and tigers on the gangsters; full of bluster and bravado, they bored me.

When she entered, she stumbled slightly over the lip of a small rug and then fussed with the pleats of her pink and black patterned skirt as if she had planned it. She sat nervously on the edge of a bamboo chair and flipped through my sample books with blazing speed. But I had no designs for a teenage girl.

I tried my hand at some salesmanship. "Are you familiar with the teachings of Confucius?"

"This is Chinatown," she replied without looking up. "I've heard a few."

"My grandmother used to tell them to me often," I said. "One of my very favorites begins with Confucius's student asking, 'What does it mean when the *Songs* say:
Dimpled smile so entrancing
Glancing eyes so full of grace
Purest silk so ready for color?'
"Confucius answered, 'For a painting, you need a ground of pure silk.'"

She looked up at me. I closed the sample books in front of her. "I would like to create an original work for you, one that is true to who you are."

"But you don't know me," she said.

"I know a little. One of your parents is Japanese, correct?"

Her eyes grew wide. "My father. How did you know?"

"Not too many people with a Japanese accent in Chinatown," I said. "Also, something in the guarded way that you carry yourself reminds me of myself. You see, I share your heritage, and I too know the inner turmoil that comes with it." She settled back in the chair and smiled faintly. I had gained a new customer.

As a tattoo artist, I hear about people's lives. Lying still in my studio for hours at a time, the customers talk to take their minds off the mild discomfort that comes with transforming one's body into a piece of art. Hachi told me of her father, a brave Japanese soldier who had served during the war but never returned. She also told me of the difficulties his absence had caused her family after the war, and how she, her mother and her grandmother moved to San Francisco to help out at her aunt's grocery store. I was saddened by her tale but impressed by her toughness. My other patrons could learn a thing or two from this one.

When I finished the piece, she was very pleased, as was I, for it was one of the best I had ever done. I knew this would not be the last tattoo for young Hachi.

Hachi's story begins on page 26.

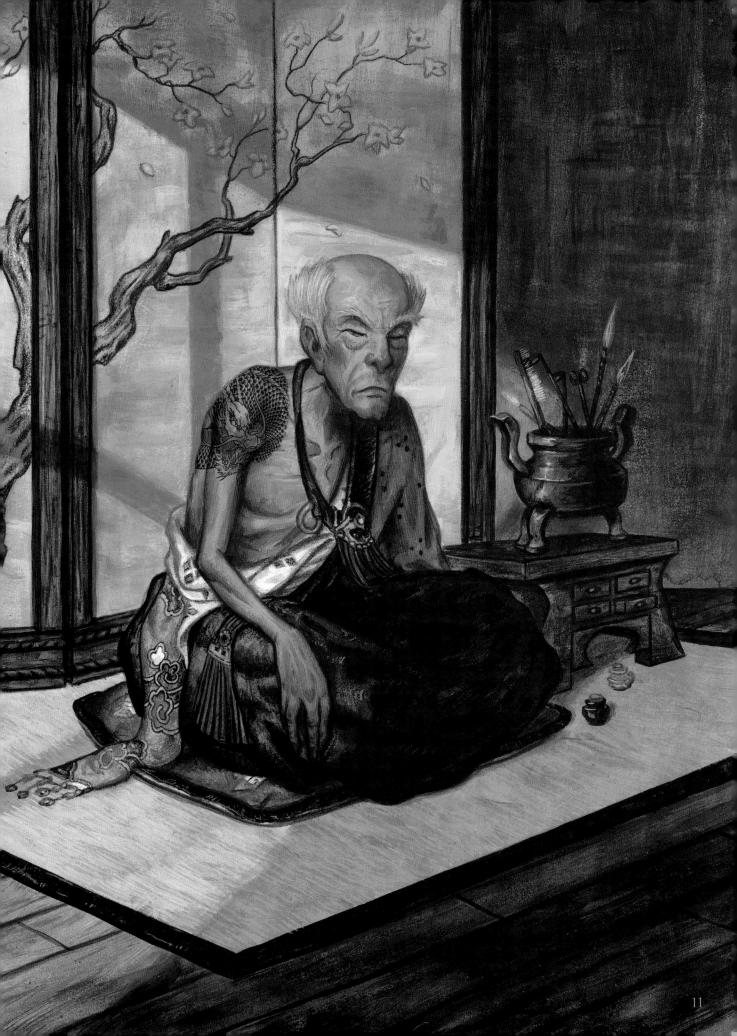

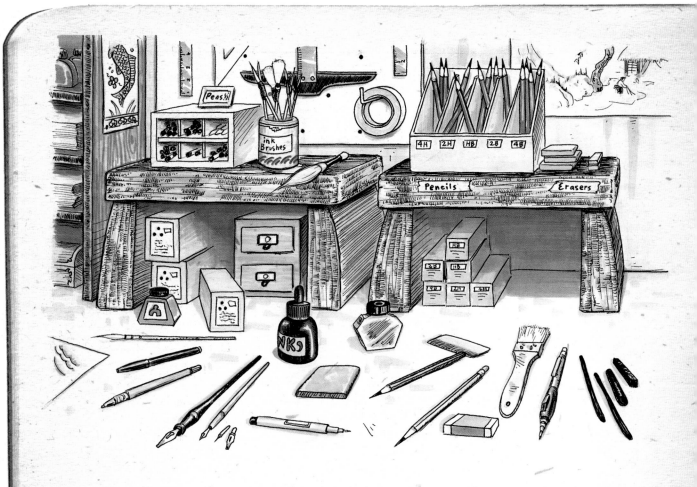

TOOLS

The tools of a tattoo artist are more than just ink and needles. A truly great artist must be skilled in drawing and painting and must master the wide variety of tools used in each discipline.

Drawing Tools

Pencils are the primary drawing tools of most artists. They contain graphite, which varies in hardness from the softest 9B to the hardest 9H. The softer graphite makes darker marks, and the harder one makes lighter marks.

Pens distribute ink. Some artists prefer to use a nib holder, which can hold a wide variety of metal tips that make different types of marks. There are also technical pens, each of which has a set diameter, and felt-tip and ballpoint pens.

Charcoal is made of compressed carbon. It has the same hardness scale as pencils but is more porous than graphite and thus distributes unevenly on the page.

Erasers remove the marks made by dry media, mostly pencil marks. A kneaded eraser is the best tool for erasing large areas. But for erasing small details a plastic eraser is more appropriate because it can form a sharp tip similar to a pencil.

You need a **sharpener** to get a good point on your pencil. Many sharpeners are self-contained and portable, so you can have one wherever you go and won't have to worry about making a mess. Some artists prefer to rub the sides of their pencils on fine sandpaper while rotating them to achieve a sharp point.

Brushes are used to apply ink for drawing purposes. A wide brush is also handy for whisking away crumbs left after erasing. Your hands contain oils, so brushing crumbs away with your hand will smudge your drawing.

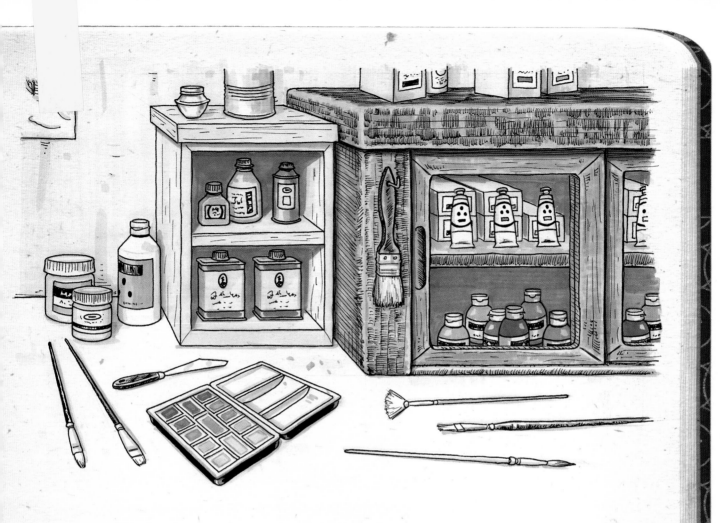

Painting Tools

Brushes are also used to apply wet media to your painting surface. They can be made of natural fibers such as animal hair, or synthetic fibers like nylon. They come in five distinct shapes:

1. Filbert
2. Bright
3. Fan
4. Flat
5. Round

Watercolor paints come in individual tubes, or are grouped in portable trays for painting while traveling. Watercolors can be diluted, applied and cleaned up with water. They dry relatively quickly.

Acrylic paints are water-based as well, but are made of a plastic polymer base that dries very quickly. Once dry, acrylic is incredibly durable. It can be thinned and cleaned with water, but can also be mixed with a variety of acrylic mediums to give it more body or extend its drying time.

Oil paints dry slowly and are therefore ideal for mixing directly on the painting surface. Colors vary in transparency. The level of transparency will be listed on the tube. Oils must be diluted and cleaned with chemical paint thinners. A wide variety of products can thicken or thin their consistency as well as speed up their drying time.

Palette knives are used to mix paint broadly, either on your palette or directly on the painting surface. You can use different knives to achieve different textures and to scrape paint away from the surface.

STUDIO SETUP AND PAPERS

"A flower falls, even though we love it; and a weed grows, even though we do not love it."

This saying from the thirteenth-century Japanese philosopher Dogen hangs on the wall of my studio. It humbles me before my work.

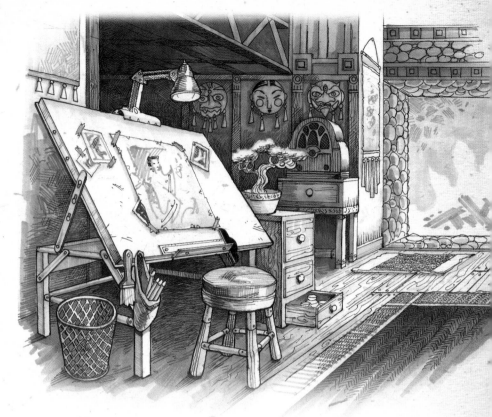

DRAWING STATION

Here is where I work on my drawings and sketches. Inspiration may strike at any hour, so I have everything I need at hand. With the radio humming quietly in the background, I am able to work long into the night.

DRAWING PAPER SWATCHES

There are many types of drawing papers to use with dry medium. Most have a tooth to them, which traps the medium on the paper. Greater tooth simply means a rougher paper surface. Here are examples of papers I use regularly.

COLD-PRESSED BOARD is very good for holding a gritty medium such as charcoal.

COLD-PRESSED BOARD is very versatile and also holds chalky pastels with ease.

BRISTOL BOARD is not as toothy as cold-pressed board, but it's good for holding graphite.

VELLUM BOARD has very low tooth, so it keeps markers and pens from bleeding on the page.

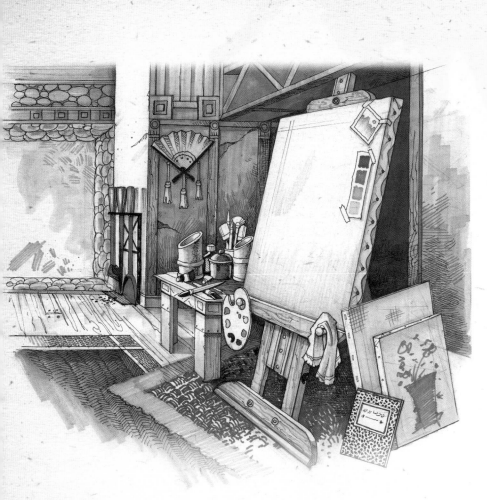

PAINTING STATION

Painting is where I find my greatest peace. It is much like meditation for me. During the act of painting, my daily troubles are washed away, and I can indulge in the tactile process of making art.

PAINTING PAPER SWATCHES

Certain papers hold wet medium very well and are specific to that medium. Here are examples of the surfaces that are most suitable for the different kinds of wet mediums.

COLD-PRESSED WATERCOLOR PAPER is made specifically for wet watercolor paint. It is extremely durable, and it can absorb the paint and leave clean edges.

GESSOED CANVAS or a primed surface, such as Masonite or illustration board, is best for oil paints.

COLD-PRESSED BOARD is versatile and works great for acrylic paint. It is resilient and holds synthetic paint well.

HOT-PRESSED BOARD has a lower tooth than the cold-pressed variety and is well suited for inks and dyes.

COMPOSITION

I am a firm believer that things need to be put into a certain order. Some aspects of life are more important than others, and need to be dealt with in a more intense or thoughtful manner. The same principles apply when composing a drawing or painting. You must guide the viewer's eye to the part of your design that is the most important. A good composition brings order to chaos and transforms a random group of objects into a unified whole.

April 29, 1938

For Golden Week our family is visiting the residence of an influential family that my father works with. I fear I will be terribly bored. They have no children my age, and they seem quite reserved in their social interactions.

Upon our arrival, the head of the household informed us he had some last-minute business to attend to. I asked if I might sit with him and work on some sketches, and he begrudgingly agreed.

GENERAL TECHNIQUES

Many tattoo artists today don't take the time to master the fundamentals of art. When I began my internship as a teenager, my colleagues and I did extensive study in drawing before we were allowed to work with the needles. We carried journals with us everywhere, documenting everything we saw: still lifes, the human form, landscapes and architecture. We learned the importance of light and shadow, composition, and shape in all things. We studied the work and techniques of great Japanese woodblock masters such as Hiroshige and Yoshitoshi, as well as those of the Europeans such as Leonardo da Vinci and Rembrandt.

Using the journal drawings I have created over the years, I will show you the basics of making beautiful artwork.

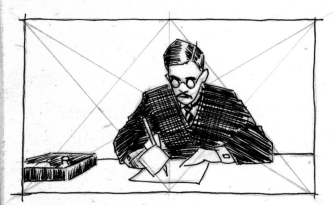

SIMPLE COMPOSITIONS: MAN WRITING LETTERS
Simple compositions can often pose big problems. With so few elements in the drawing, the placement of each becomes even more important. Use a grid like this one, which was created by the great European Renaissance masters, as a guide for placing objects. Let the diagonals form paths for elements such as his arms or the box on the table. Also, resist the urge to place the figure's head directly in the center of the composition.

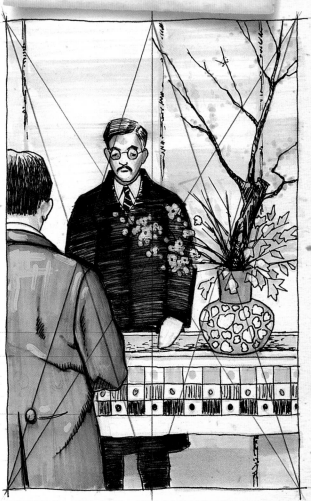

MULTIPLE FIGURES: MAN ADDRESSING SERVANT
Use the same grid construction you used before, only this time on a vertical composition. This framework was devised to be used on a rectangle of any shape and was built to deal with any number of figures or items, no matter how complicated. With the grid in place you can tackle a difficult problem such as placing a figure with his back to the viewer in the foreground of your drawing.

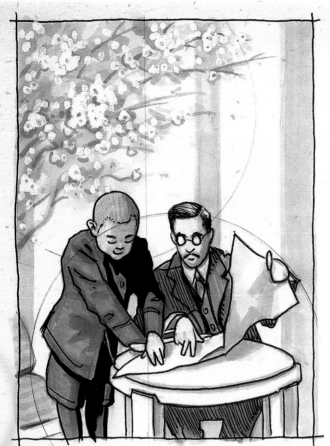

CIRCULAR COMPOSITIONS: MAN AND HIS SON

Another great guideline to use for a unified composition is the circle. You can connect important elements of a drawing or contain groupings within circles. You can also use the circle to influence a figure's gesture.

May 2, 1938

As a surprise, our host family took us to see a sumo match in Osaka. Brilliantly colored kimonos receded into the background as the giant competitors stamped their feet and charged at each other in a bizarre combination of brute force and ferocious grace. It was a spectacle of grandeur and ritual that I was honored to witness.

SCALE AND GROUPING IN COMPOSITIONS: SUMO MATCH

Use scale (the relative size of objects in comparison to one another) as a tool in creating compelling compositions. Draw attention to a small figure by surrounding him with much larger figures. Also, the way things are grouped can have a tremendous impact on your composition. If you group

April 30, 1938

Today feels more like the vacation I had hoped for. We enjoyed a leisurely breakfast and then took a trip to Kamakura to see some of the ancient shrines and temples.

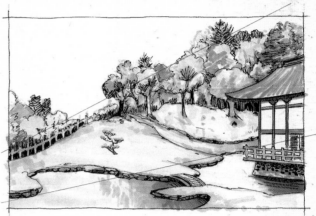

LANDSCAPE COMPOSITION: KAMAKURA SHRINE

Break up the picture into several unequal portions with a few diagonal lines. This simple method gives different weights to the background, middle ground and foreground. Use varying amounts of lights and darks within each section to achieve movement within the piece.

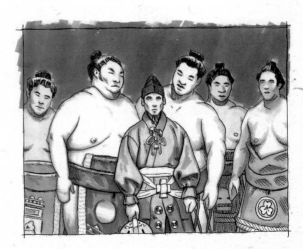

individual objects together and keep their tonal value similar, they begin to act as a single unit. In this drawing from the sumo match, the huge sumos act as a backdrop for the central figure, the *gyōji* (sumo referee).

17

TEXTURE RENDERING

My robes are silken, but my skin is coarse.

I sit silently reflecting on my time in Japan as a boy before I moved to San Francisco in 1939. I remember the teachings of the Shinto priests. They said that the world was filled with spirits called *kami*, and that these kami are not separate, but materially connected to everything. The Japanese use sacred straw ropes called *shimenawa* wrapped around gnarled tree trunks, and *torii* gates of wood grown smooth with age to help people connect with the kami.

To me, the kami not only inhabit these objects, but also express themselves boldly through their textures. With careful observation and rendering of these textures, the artist can make drawings filled with life. Over the years, even during my internment during World War II, I have made drawings intended to capture a wide variety of textures, along with notes on how to draw these textures.

March 21, 1945

Today marks the first day of spring in the West, but in Japan spring does not officially start until the cherry trees bloom. Beneath the pink and white blossoms people gather to eat, drink and laugh. It is a joyous time. Today I will draw a cherry blossom and perhaps bring myself a bit of that joy.

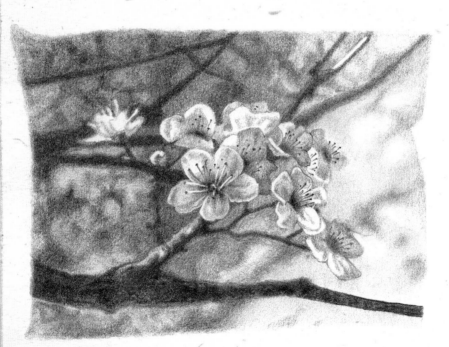

RENDERING A SMOOTH TEXTURE: CHERRY BLOSSOMS

To achieve a smooth texture, use a sharp pencil on bristol board. When your pencil begins to get dull, sharpen it. Using small strokes applied in a circular motion, press your pencil at varying pressures from light to hard. Going over the same marks repeatedly will make them darker. Remember that graphite pencils are transparent. The harder you press, the darker and more opaque the line will appear. For a lighter mark, apply less pressure. Practice on scrap paper before doing your final rendering on bristol board.

July 30, 1945

A massive air raid on mainland Japan began about a week ago. I saw a picture of the devastation in a newspaper one of the guards had. I convinced him to trade it for one of my sketches. The destruction was the worst I have seen since the war started. The emotion the photo portrayed pitted my soul. The senseless destruction, which tore and blackened the once beautiful landscape, plagued me. I turned to my journal to make a drawing of the scene so that I would never forget what men are capable of.

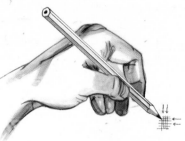

RENDERING A CROSSHATCHED TEXTURE: DESTRUCTION ON THE JAPANESE MAINLAND

Crosshatching is a great way to achieve a gritty texture. Sharpen your pencil and draw straight horizontal lines. Keep your pencil sharp and draw vertical lines overlapping the first lines. Overlap those with diagonal pencil lines until you have the desired darkness. This technique is good for drawing stone and rubble, but is also good for shading in an area quickly. Crosshatching is a very versatile rendering technique. It can also be used to render something soft. The more you work the overlapping lines, the smoother the shading will become.

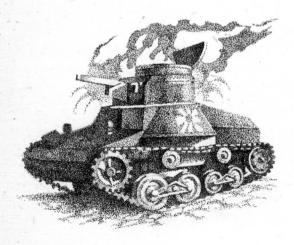

August 11, 1945

Today a group of guards were passing some photos back and forth. They laughed and slapped each other on the back. We heard the commotion and asked to see the photos. They were happy to oblige. One photo showed a charred, burned-out Japanese tank on the Pacific front. The machinery of war was crumbling away. An end was in sight.

RENDERING A STIPPLING TEXTURE: BURNED-OUT TANK

Stippling is a simple technique to learn but can be labor intensive. With a sharp pencil or pen, dot the surface of your paper. The tighter you group the dots, the darker the shading will become. To get an area near black, go over the dots continuously until the white of the paper is nearly obscured. Avoid drawing straight lines as they will ruin the illusion of shading.

PERSPECTIVE

Once I was released from the internment camp after the war, I moved back to San Francisco Chinatown and opened my own tattoo parlor. The atmosphere in the States was not the same as it was when I first arrived. I saw a look of contempt in people's eyes when they met me. It was a difficult time for me to make friends, and I turned to my sketchbooks to fill the void. My youthful optimism had worn away, and I started to see things in a whole new perspective.

From this standpoint I began to look more critically at my surroundings. I studied the angles and lines of the streets and buildings. I strove for a deeper understanding of drawing objects from a three-dimensional world onto a two-dimensional page. After a while the constant observation required to master the theories of artistic perspective had an unforeseen result. I began to see people in their day-to-day lives. I saw their insecurities instead of my own, and I was able to forgive their judgments of me and work on making long-lasting friendships.

January 20, 1947

I enjoy rising early and walking through the streets of Chinatown. Vendors bring their wares out into the streets. Smoke from cooking mixes with the fog from the bay. Bags of rice and other grains line the streets next to carts full of fire-red pigs, the symbol of the New Year. Dogs bark and awnings flap. A pork bun and a pot of tea keep me company as I sit down to rest.

ONE-POINT PERSPECTIVE: CHINATOWN STREET
Objects seem to get smaller as they move away from us toward the horizon. In one-point perspective, parallel lines perpendicular to the picture plane converge at the horizon line in a single point called the *vanishing point*. Establish a vanishing point on the horizon. Then lightly draw a series of lines radiating out from that point. These will be your guides for the roofs of buildings, and the edges of stairs, windows and streets.

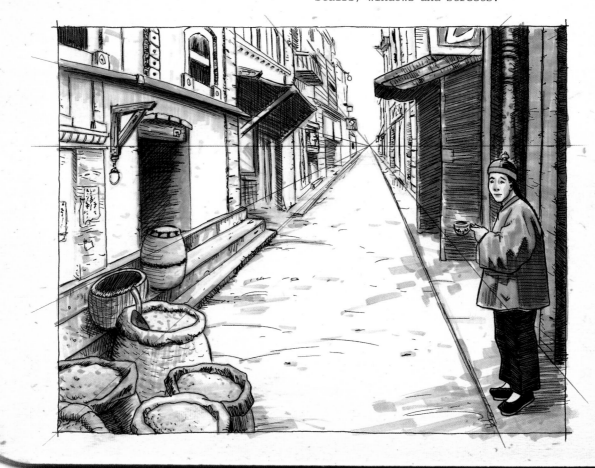

March 5, 1947

The weather was beautiful today, so I walked over to the beautiful Sing Chong store to buy a few things to make the studio more inviting.

TWO-POINT PERSPECTIVE: SING CHONG COMPANY STORE

Scenes depicted in two-point perspective have two separate vanishing points. In these scenes none of the flat surfaces are parallel to the picture plane. Set two points far apart on the horizon line. Where the lines from the vanishing points meet up with each other defines the corner of the object you're drawing.

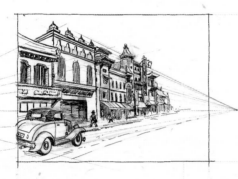

June 26, 1947

One of my regulars brought by the '34 Chevy convertible coupe he has been working on. I may not be one for cars, but this was truly a piece of art in its own right.

CROPPED TWO-POINT PERSPECTIVE: '34 CHEVY, CHINATOWN

When working in two-point perspective, one of the vanishing points often falls beyond the edge of the drawing area. In this case, tape another piece of paper to the side of the one you are drawing on and extend the lines with your ruler. When you are finished, remove the extra sheet and you will have a drawing with accurate perspective. Do not try to line it up with your eye and guess at the angles. You will wind up with a flawed drawing.

August 1, 1947

I was thinking of a friend in Japan whose birthday is today. As boys we once visited the Itsukushima Shrine in Miyajima. We were truly convinced it was floating.

THREE-POINT PERSPECTIVE: ITSUKUSHIMA SHRINE

Three-point perspective is mostly used to draw very tall structures from either a very high (bird's-eye) or very low (worm's-eye) point of view. In this low, worm's-eye example, a third vanishing point is located high above the structure. As in two-point perspective, horizontal lines converge at two separate points on the horizon line. The difference now is that all of your vertical lines will converge at the vanishing point you created above the structure.

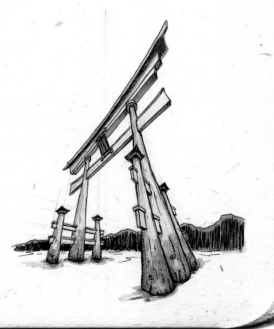

LIGHT AND SHADOW

Sunlight blankets half of the Earth, leaving the other half in shadow. Day and night cause people to feel and act differently. Light is a powerful force in nature. The same is true of light and shadow in your artwork. When understood and applied properly, they can bring forth a desired emotion in the viewer.

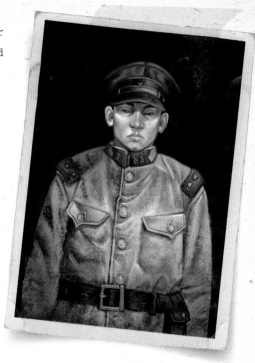

April 12, 1448

Today I did a terrible thing. I entered a Buddhist temple near my tattoo studio in Chinatown to make still-life drawings of the daily fruit offerings and ornate incense burners. Resting gently against a pile of oranges, a tattered photo of a young Japanese Army officer struck me in a profound way. Had he died in the war, or was he simply missing? His face was calm and proud. I wanted to study the photo more closely, with intensity, and in a moment of weakness I tucked it into my clothes and fled the temple in shame.

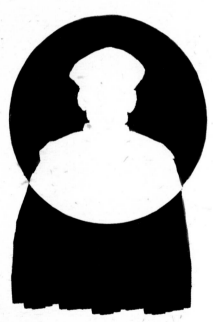

SPOTLIGHT

This man seemed to possess the confidence and charisma of the great *Kabuki* actors I had seen as a young man. When they moved about in the spotlight, everything else fell into shadow. I found this concept also applied to drawings. If a drawing were a stage, the focal point would have a spotlight on it. Elements of the drawing that were less important would be in shadow.

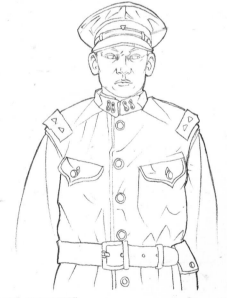

LINE DRAWING

To get a comprehensive understanding of this man's form, I rendered him as a simple line drawing. By observing the edges of a drawing you can get a better idea of how to approach the light and shadow on the figure. The edges of the lines will determine how the light will cast a shadow on a fold in the cloth or on the planes of the face.

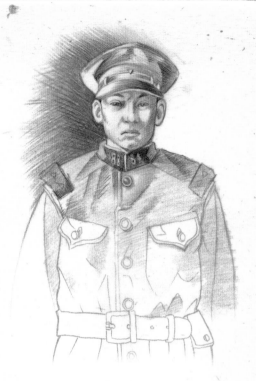

BLOCK FIGURE

At one point, I felt as if the soldier's eye were staring at me accusingly. I needed to strip him of his complexity. I drew him as a collection of the simplest shapes. When you break things down, you get a better understanding of the light source. It becomes easier to see the shadows of the form and the highlights.

LIGHT FROM THE SIDE

I went back to the photo and imagined this man in different lighting scenarios. Using the line drawing, I drew light coming in from his right side. The light hitting the side of his face created the most intense highlights, and there was a gleam in the corner of his eye. The opposite side of his face was gradually consumed by shadow.

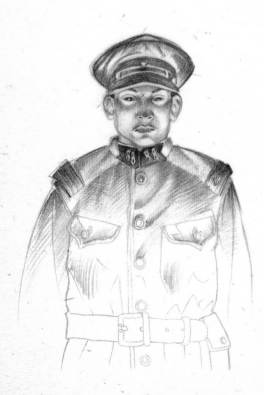

LIGHT FROM THE BOTTOM

Here the light is coming from below the soldier. The folds in the uniform cast shadows upward. The face of the soldier is almost completely in shadow except for areas that protrude from the skull, like the underside of the nose and the brow ridge.

SHAPE

*"Dimly visible, it cannot be named
And returns to that which is without substance.
This is called the shape that has no shape,
The image that is without substance.
This is called indistinct and shadowy."*

This passage from the *Tao Te Ching* made me think about the importance of shape in art. A design without solid shape is like an image without substance. It will be confused and ineffective. Everything we see can be broken down into, and be defined by, simple shapes.

september 13, 1947

Customers had been telling me about the wonderful food at a restaurant called the Lion's Den. I was so intrigued I invited a friend to meet me there for dinner. Outside the restaurant two magnificent Chinese lion statues greeted the customers. The statues were so ornate, I wondered if I was going to be able to afford the meal.

On the walk back to my studio I came across a rickety old food cart. It had no carefully carved details, no gilded edges and lacked polish of any kind, but to me, it was as striking as the statues I had just seen, and even more charming.

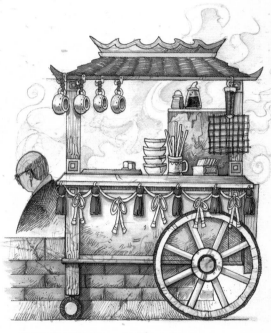

SQUARE SHAPE: CART
Most people associate carts with movement, so they immediately think of a circle. You can play to these associations in your design, or you can contradict them. Here the square shape gives the food cart a sense of sturdiness.

TRIANGLE SHAPE: CHINESE LION
Although this lion sculpture was cast with elaborate flourishes, its design is elementally bound to the triangle. Likewise, its structure can be broken down into three simple shapes, none of which has more than four sides.

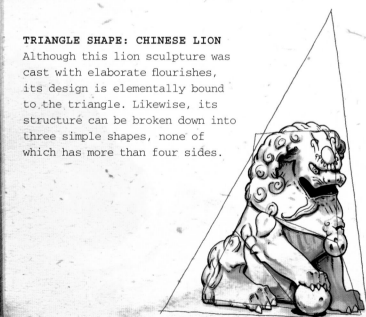

December 15, 1949

I have spent the last week tattooing an intricate dragon onto a man's back. He was dense with muscle and did not have a very pleasant disposition, but the work I did was quality. I do not let customers' personalities affect my work. Instead, I hope that the care with ~~will~~ which I work on them will in some way change them for the better. Perhaps that is naïve of me.

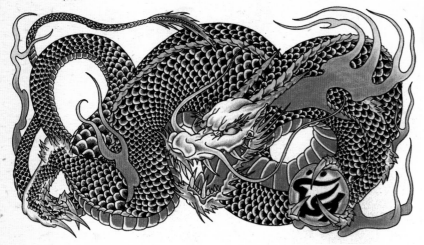

RECTANGLE SHAPE: DRAGON TATTOO
Shape is important, whether you are trying to render something three-dimensionally, or you are creating a flat design such as a traditional tattoo. Although this dragon seems to be coiling back on itself chaotically, and is accented by licking flame and claws and scales, it is still confined within the basic shape of the rectangle.

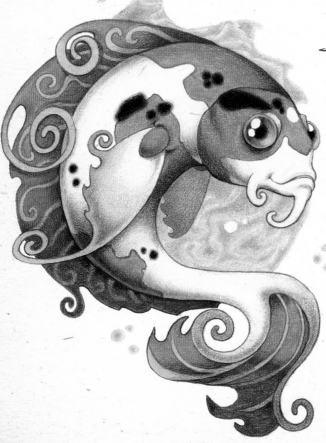

March 8, 1950

I tattooed this unique circular koi design on a young girl named Hachi. Something tells me that I will see her again soon.

CIRCLE: KOI TATTOO
The circle is the shape without beginning or end. It is the symbol of perfection. I used the circle as the basis for this koi and repeated its shape throughout the design in the swirl of its fins, the shape of its eyes and the spots on its body.

CHAPTER TWO

The Adventure Begins

I did it. I actually did it. It looks so cool!

I thought for sure I'd chicken out, but I toughed through it. It did hurt, but that didn't worry me nearly as much as the scolding my mom would give me if she found out. She'd ground me through the rest of my junior year at least, and probably all the way until I graduate from high school.

Even so, I could have floated all the way home. The experience had revved up all of my senses. The scent of the incense from the tattoo parlor swirled in my head, and rain pelted my skin and soaked my clothes. Combined with the throbbing tattoo, my skin felt electrified.

I had to snap out of it though. I was supposed to stop in at Mr. Zhou's to get some pork for dinner. I'd have to tell my mom it took longer than expected because of the rain, which wasn't a complete lie. It was really pouring. I could hardly see. Slogging up the street, I swear the stupid pig Mr. Zhou had painted on the sign outside his shop looked like a fish.

I ducked inside. Newspapers were scattered across the floor to help soak up the rainwater. The plump, apron-clad form of Mr. Zhou was like a blur behind the counter.

"Uh, excuse me, can I get six pork chops, please?" I felt like I was interrupting him, but as he turned toward me, the look on his face betrayed a hint of joy.

"Ah, hello, Hachi. Of course. Of course." He tore some paper off a large roll. "How is your aunt doing? I don't see her very often now that she has you to run errands." I was sure Mr. Zhou had a crush on my aunt, but she said he looked like the pig on his sign out front.

"She's fine," I stammered. I was suddenly overwhelmed by a fishy smell, and without thinking, I asked, "Have you gone into the fish business too, Mr. Zhou? It really smells in here."

"No, I have not, Hachi, and I would say that that is a rather rude thing to say about my store. Perhaps I will stop by your aunt's place and tell her how you talk to your elders."

That's the last thing anybody wanted. "Please, don't bother, Mr. Zhou. You are a very busy man, and I am very sorry. I think I'm coming down with a cold. That may be why things smell weird."

He seemed to accept my excuse, so I paid for the meat and dashed out of the store, leaving his "Tell your aunt I said hello" floundering in my wake.

Maybe I really was coming down with something. Everything seemed out of whack. All the signs I passed had fish on them, and every store window was packed with fish. I rubbed my eyes, but nothing changed. I didn't even feel the rain hitting my skin any more, but I was itchy all over. I lifted my face up to clear my head, hoping I was imagining all of this. No such luck. Hovering directly above me was an enormous, brightly colored koi fish vigorously slapping raindrops with its tail.

"Aaahh!" I screamed.

"'Aaahh.' That's a peculiar greeting. I thought humans said 'hello,'" said the fish. Well, 'aaahh' to you, too, Hachi Hachimitsu."

Was I going crazy? I needed to get away from the people in the streets and hopefully this fish as well. I burst into a full sprint, and the fish flew right behind me. I ran past Market Street toward the rail yard.

I ran as far as I could. I felt like my lungs would explode. My head was dizzy and my leg hurt, but the fish was still with me. There was no one around to see me, so I decided to face it. "Leave me alone," I panted.

"Leave you alone? That's quite impossible. You summoned me here," he said.

This was insane. A translucent film blinked over his blue eyes.

"And how exactly did I do that?"

The fish swam a circle in the air. "Although I find the likeness a bit crude, you have just recently had me tattooed on your leg. There, underneath your sock. It was getting smelly in there, so I came out for some fresh air."

I peeled back my sock. The tattoo of the koi was the same as the big fish floating two feet away from me.

"Can you please go away?" I cried.

"Indeed," he said with a flutter of his gills. "That's the plan after all, for me to go quite far away, and for you to go with me."

The story continues on page 40.

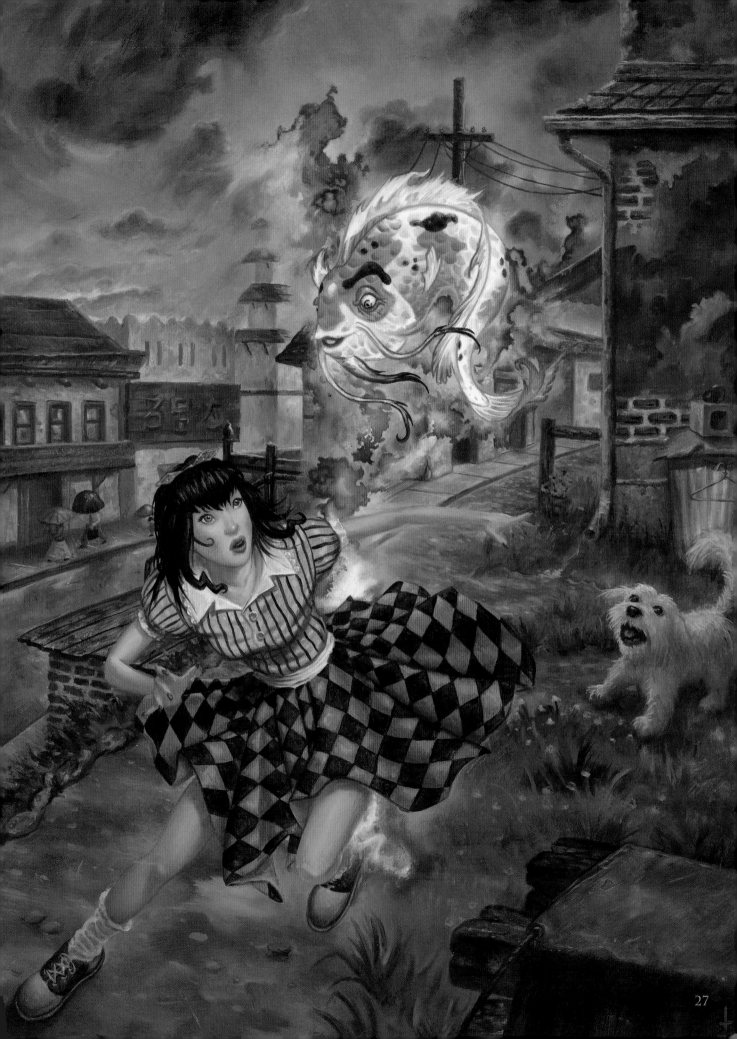

Chinatown

As you know from the story, the background for this scene is San Francisco's Chinatown on a rainy day in March 1950. Armed with this information, go to your local library, bookstore or even the Internet to find reference photos. Get a feel for that time and place, and make some thumbnail sketches of the composition. Use a pen and work quickly to establish the ground and the basic shapes of buildings. Try approaching the scene from different angles until you get one you like.

Thumbnail Sketches

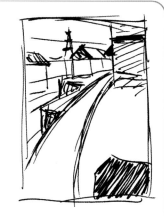

Thumbnails are little sketches used to get your ideas down on paper quickly. You may be able to nail down your ideas in one sketch, or it may take a dozen. The key is to work quickly. Don't get bogged down. If it isn't working within the first minute, move on to another one. Map out the major shapes, and don't worry about details.

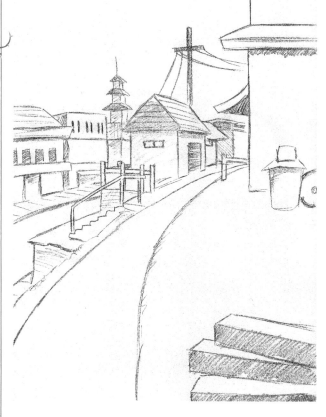

1 Shaping Up

Using your thumbnail as a guide, draw the shapes of the buildings in the background. Use two-point perspective to line up the buildings correctly. For a sense of movement, make the road a wide, sweeping arc that dramatically decreases in size as it recedes into the background. In the story Hachi runs from the crowded streets to the rail yard to get away from anyone who might see what is happening to her. Add a foreground element, such as some railroad ties, to highlight this aspect of the story.

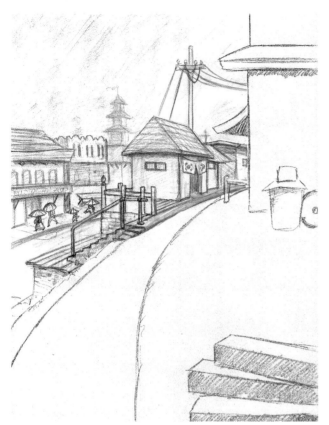

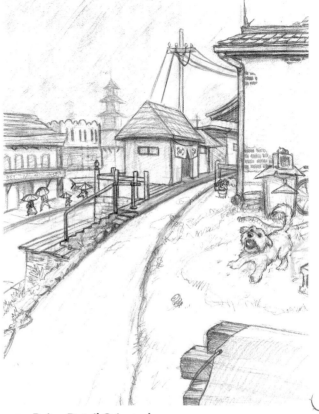

2 Fantasy vs. History

Get out your reference photos and add details to the architecture of the buildings. Use the reference as a rough guide. Since this is a fantasy story, you don't need to achieve 100 percent historical accuracy. Try to get the feel of 1950s Chinatown, while arriving at a composition that works well with the movement of the characters you have designed.

3 Being Detail Oriented

Authors can't describe every detail. It's up to you as an illustrator to fill in some of those gaps. The addition of little things like flower pots, garbage cans, old bicycle tires and cinder blocks scattered around the foreground will give the viewer a better understanding of what the neighborhood is like. Draw a little dog barking at Hachi as she runs to add tension to the scene. Is the dog barking at her, or can it see the mysterious fish splashing about? Leave it to the reader to decide.

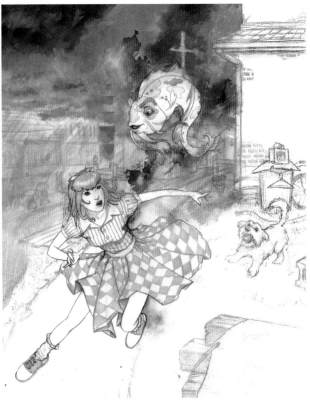

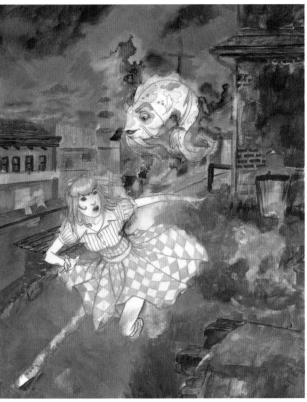

4 Mixing Media

Paint a magical aura around the fish, connecting him to Hachi. Apply watercolors with an eyedropper, then spray with a water mister. Use Cadmium Orange as the central color, and fade out the edges with Cadmium Lemon Yellow and Titanium White. Add a drop or two of Turquoise Blue in the pools of orange. Once dry, cover the entire painting with a clear acrylic medium.

Now switch to acrylics. Using large flats (from no. 10 to 1-inch [25mm]), quickly rough in the clouds with Titanium White, Naples Yellow, Light Portrait Pink, Baltic Green, Baltic Blue, Light Blue Violet, Raw Umber, Cobalt Blue, Neutral Gray and Carbon Black. Lay in gray washes over the buildings.

5 Back to Front

Using the same colors, rough in the ground and building in the foreground. To separate the background and foreground, introduce Raw Sienna to the earthy parts of the ground, and Cadmium Yellow to the grassy parts. This will warm them up without making them too intense. Reapply the magic colors, using the same colors and technique from step 4. This will help integrate the magic into the cloudy background.

Where'd They Come From?

You may have noticed that as we moved from the drawing of the background to the painting of it, some crazy characters appeared in the image. This will occur regularly throughout the book. The reason for this is that we wanted to show you how to bring story elements into each aspect of the piece individually. The background drawings have certain characteristics that need to be discussed separately from the figure drawings for educational purposes. As you work on an entire piece, though, you should draw everything together on the same page to ensure a strong composition. That way, when you get to the painting part, everything is in place and ready to go.

Washes

A wash is the application of water-based media, such as watercolor and acrylic, with a generous amount of water. This thins out even the most opaque colors and allows light to pass through to reveal what is underneath. Colors are often built up with many layers of washes. Since water-based media dry quickly, it is an effective way to achieve vibrant colors.

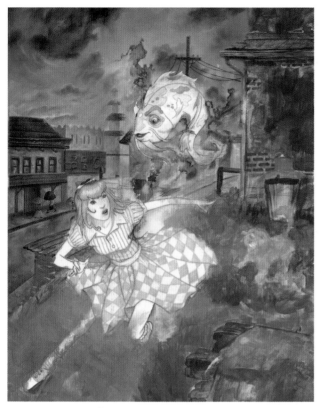

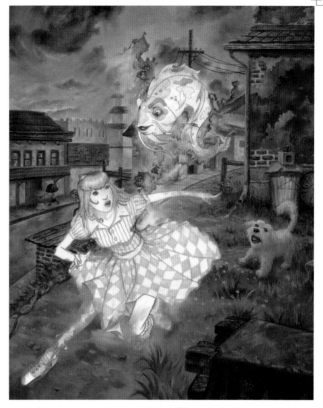

6 Mixing Media, Again

Finish the background with oils. Mix Radiant Green and Cobalt Turquoise into the grays for the clouds. Offset this with Cadmium Yellow and Cadmium Orange on the underside of the clouds on the lower left side of the sky, showing a bit of the setting sun's light peaking through.

The buildings in the background should remain gray, with warm and cool variety mixed in. If everything is the same temperature gray, it runs the risk of becoming a boring mess.

7 Warm Accents on a Rainy Day

Bring more warm accents into the foreground. Add some yellow and pink flowers. Mix in Burnt Sienna and Mars Violet on the large building on the right and on the railroad ties in the extreme foreground.

Use a wide flat to block in large patches of grass, then come in with a smaller round to bring out individual blades here and there. Paint darker clumps of grass on top of lighter areas that are less detailed and vice versa.

See the complete scene on page 27.

The Dog

The dog is not of major importance; therefore, it needs to act as part of the background. Mix a medium gray to block in the dog. Then, with a small round, bring out some hairy details with a lighter gray. Add a little pink for the mouth and tongue.

Hachi

You've got a pencil in one hand and a story in the other. Now you need to bring the words to life on the page with an illustration. To begin, read the story carefully, making important notes as you go, such as the height and body type of the characters, the weather conditions, the settings and which scenes will make the most impact as illustrations.

In Hachi's story so far the climactic moment comes as she realizes there is a giant fish floating over her head. This is the point at which her adventure is about to begin, so it calls for some action. Let's draw Hachi running through a Chinatown street with her fishy visitor swirling through the air above her.

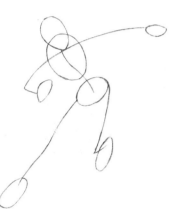
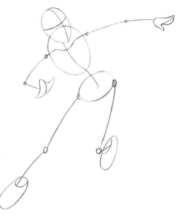
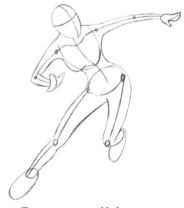

1 Start Simply
Use single lines to capture the movement and position of her arms, legs and spine. Anchor these lines with ovals that capture the important structures of her body, such as her head, rib cage, pelvis, hands and feet. Since we're looking at Hachi from above, her head will overlap her rib cage.

Gesture

A gesture sketch can be used to express feeling in your drawing. With sweeping diagonal lines you can convey motion that you can develop into fierce rage or exuberant joy. Likewise, with stiff horizontal and vertical lines, you can imply grim determination or overwhelming boredom.

2 Create Key Landmarks
Place small circles at the joints of the knees and elbows. Put similar circles where the collarbone (clavicle) ends at the shoulder joints. It's important to place the points properly in order to capture the motion of the figure correctly.

Draw the centerline and eye line of Hachi's face. These lines are curved because they wrap around a three-dimensional oval, and will bend according to how the head is positioned. Since we're looking down at the figure on her right side, the eye line should curve towards the ground, and the centerline should be on the right side of her head and curve in the same way as the far edge.

3 Teenagers are Unique
Add volume to the framework. Refer to the notes you have made on the character. You know from the story that Hachi is a junior in high school, so she's about seventeen years old. This means that she shouldn't be too curvy, but she also shouldn't be excessively bony like a younger teen might be.

Refine the shapes of her hands. Group the four main fingers as one shape and the thumb as another.

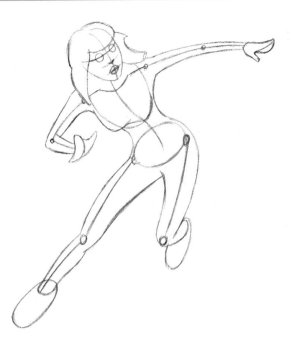

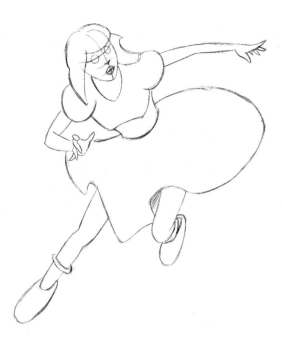

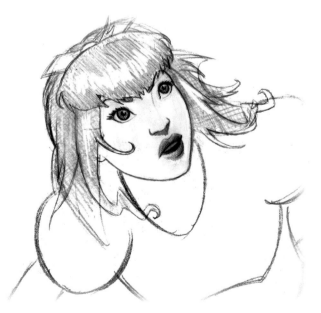

4 Facial Features

Pencil in the shapes of the facial features, following the guidelines. The horizontal aspects of all the facial features, such as the base of the nose and the space between the lips, run parallel to the eye line. For the eyes, draw two ovals on top of the eye line. Imagine a third oval of the same size in between them to give you the correct spacing. A small triangle positioned along the centerline will give you the tip of the nose, and an oval beneath that creates the lips. Rough in the hair with simple shapes that wrap around the skull.

5 She's Gotta Be Hip

Look for pictures of what teenagers wore in the 1950s. Books on the early history of rock-and-roll music are great for this. Hachi should look like she's trying to fit in; give her a fairly long pleated skirt and a form-fitting blouse with short, puffy sleeves. Start with the shapes. Since she's running, her skirt is billowing out around her in an oval shape and bends around her legs.

6 A Face of Distinction

Hachi's face may be the most vital step in the design process. Since you will be drawing this character more than once, design a face that is easily recognizable to the reader from many different angles. Her hairstyle may change, or she may be wearing a hat or helmet, so keep your design simple.

Make her eyes large and expressive, and define the nose simply with a small triangle of shadow beneath the tip. Look back to your photos of '50s teenagers for some hairstyles. Give her a tuft of bangs surrounded by shoulder-length black hair, bouncing with movement.

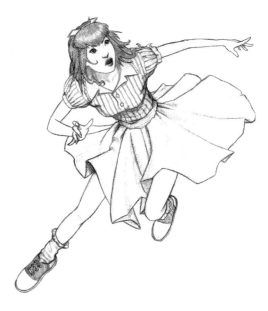

7 Making Her Real

Graceful lines that meet at the elbow joint define her arms; make sure they don't look like a string of sausage links. The same principle applies to her fingers. You don't have to show every knuckle. Her fingers should be feminine and expressive.

Give her shirt stripes and a wide collar with ruffles. Little details add to the authenticity of the character for her particular time and place.

8 Pleats, Please

Treat Hachi's legs as you did her arms. Avoid overly muscular legs and blocky knees. Convey the motion of the figure through the movement of her skirt. Some of the pleats will be moving forward due to the force of her legs. These will overlap other pleats that are hanging down due to gravity, or billowing out from the blowing wind. Make sure that her shoes and socks are period appropriate.

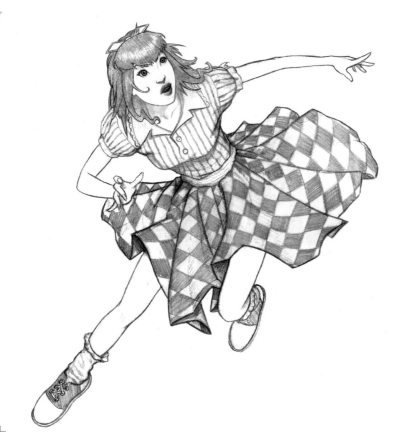

9 Diamonds Are a Girl's Best Friend

Create a diamond pattern for her skirt. This adds an important element to her character. Hachi is an outsider. She is trying desperately to fit in with her American classmates, but she misses the little details that they all take for granted, like knowing that you should never mix stripes with diamonds.

The skirt is bending and folding over itself, so you have to adjust the diamond pattern. The diamonds should be smaller where the skirt bunches up and larger where the skirt is spread out.

PAINTING

Print or photocopy your drawing onto a piece of 140-lb. (300gsm) hot-pressed watercolor paper, and mount it to a piece of Masonite by covering the back of your drawing and the front of the Masonite with acrylic gloss medium. Press the two together and remove all of the air pockets with a brayer. Cover the main characters with frisket paper. Frisket paper is like a clear, low-tack sticker that you place over areas you do not want paint to get on. Place the frisket over your subject and cut around its outline with a craft knife.

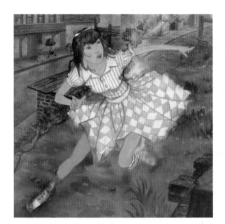

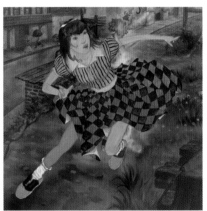

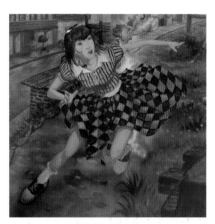

10 Local Color
Peel away the frisket on Hachi, and begin mixing local colors in oils for her skin and hair. Local color is an object's true color, its color without highlights or shadows. For her skin use Titanium White, Naples Yellow, Flesh Tint, Yellow Ochre, a very small amount of Cadmium Orange Light and Raw Umber. Raw Umber will gray the skin out enough to set it properly in the overcast scene without making it look cold and lifeless. Using a no. 6 filbert, fill in the exposed skin on Hachi. Mix Ivory Black, Raw Umber and a touch of Titanium White and fill in the hair.

11 Clothes Make the Lady
Apply local color to Hachi's clothing. Mix Cerulean Blue, Titanium White and a bit of Ivory Black for her blouse. Use Ultramarine Blue with a gray mixture of Ivory Black and Titanium White for the stripes on the blouse.

Alternate pink and black diamonds on the skirt, and cut them with gray as well. Black objects absorb light, and a common mistake is to paint them with black straight from the tube. Doing so upsets the tonal balance of the painting.

12 Mild Shadows
Since the lighting in the piece is diffuse, the shadows will not be very intense. Use a variety of grays for the shadow areas, warmer on the skin and cooler on clothing.

Even though it is not sunny, use cast shadows where Hachi's upper leg and skirt meet. This will provide separation between the two objects that will make it seem like the skirt is being whipped dramatically by the momentum of running.

Combining Acrylics and Oils

Complete the tonal structure for the entire painting in acrylic before you move on to oils. Once an area has oil paint on it, you cannot go back on top of it with acrylics. The water-based paint will not form a complete bond with the oil-based paint beneath it and will peel off and scratch easily. So keep this rule in mind: oil on top of water is OK; water on top of oil is not.

Glazes

Glazes are the application of thin, transparent paint achieved by adding a medium to them.

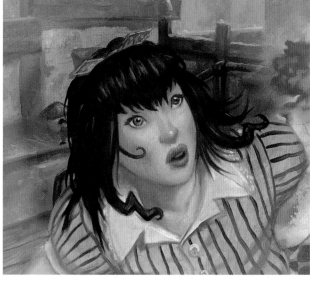

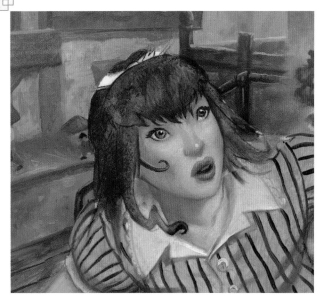

13 A Colorful Character

Bring one area of the main character to completion so that you have a solid foundation for everything else. The face is ideal for this. It gets you in touch with the character and allows you to establish a baseline for the level of detail you want throughout the figure.

Paint highlights on raised features, such as the bridge of her nose and cheekbones, by mixing more Titanium White, Naples Yellow and Flesh Tint to the local color mixture for the skin from Step 10. Use a warm gray to portray the areas where the planes of the face turn away from light into shadow. Add Cadmium Red Light to her cheeks and the tip of her nose.

Color is a great tool for bringing unique traits to your characters. For Hachi, green eyes will set her apart, for better or worse, as special in the almost exclusively dark-eyed Asian community.

14 A Flattering Hairdo

Paint Hachi's hair next. Her black locks act as a dark frame around her luminous face and will be the darkest part of the painting. Black hair absorbs an enormous amount of light and show only the strongest highlights. Lightly tint the black, and paint on top of the local color. Let the local color show through in some areas to bring some warmth to the hair. While the black is still wet, use a small round loaded with Titanium White to paint highlights along Hachi's bangs. Use small, repetitious brushstrokes so that the paint mixes with the black to make a gray area. Wipe your brush off and repeat the procedure, but use fewer, shorter strokes to establish the finished highlight for the hair.

15 A Tidy Outfit

Painting the patterns on the clothing is the hard part. Finishing them up is simply a matter of adding highlights on the fabric's peaks and shadows in the valleys. For the blouse use a blend of Cerulean Blue and Titanium White for the highlights, and strengthen the shadow areas with a shade of gray including Cerulean Blue and Raw Umber.

Add some more black and a small amount of Alizarin Crimson to the shadow mixture above, and paint it very thinly over the shadows on the skirt. This will give them depth. For the highlights add some Titanium White to your local color mixtures. Use a blue tint in selected areas for variety.

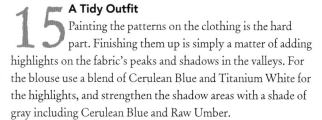

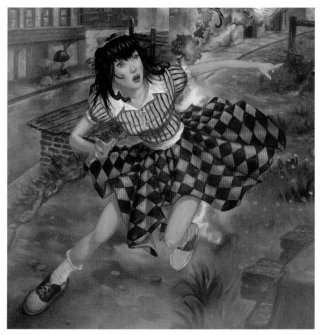

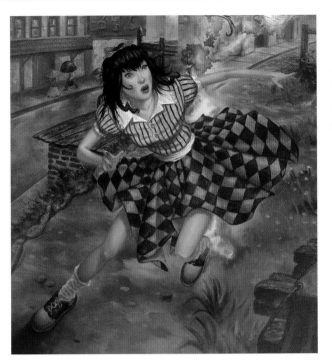

16 **In the Spotlight**
Paint Hachi's arms and legs the same way you painted her face, but gradually make the highlights and shadows darker the farther away from her face they are. Therefore, the skin on the lower part of her right leg should be the darkest on her body. When you are finished, the effect should be as though there is a mild spotlight on Hachi's face.

Tint, Tone and Shade

There are many ways to mix and adjust colors. A very basic method is through the use of tint, tone and shade. Tint means to add white to a color, tone means to add gray, and shade means to add black.

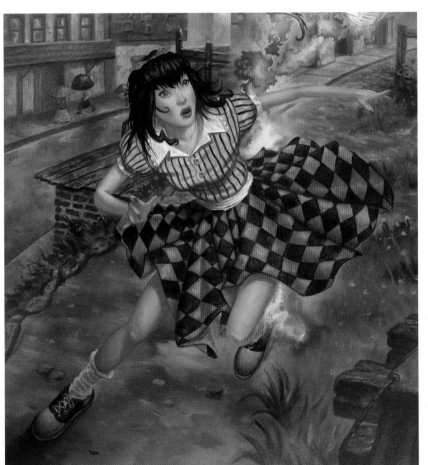

17 **Magical Connections**
The magic connecting Hachi and the fish is bright and warm, and is reflected on her clothes and skin. Once the figure painting is dry, brush directly on top of it with Cadmium Orange Light and Cadmium Yellow. These pigments are transparent, so what you painted underneath will show through and seem to be lit by the warm glow of the magic.

See the complete scene on page 27.

A Fishy Visitor

The second character in this scene takes the form of a fish that moves magically through the air. He is capable of talking like a person, so draw him with human features to give him some personality.

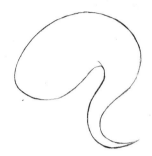

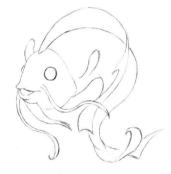

1 Magic Starts With a Line
Begin with an expanded and tilted S-shape. Sweep your pencil across the page to capture a fluid and exciting gesture.

2 It's Raining Shape
Give the S-shape some volume. Make the large, round head on the left. The body gets increasingly narrower to the endpoint on the right, where the tail fins will be. The basic shape looks like a twisted raindrop.

3 The Goofball Effect
He needs the correct human facial characteristics to express his goofball personality. Draw an oval-shaped mouth. Raise the oval's ends and pinch them for a smile. Rough in two large circles for eyes. Exaggerate the spiny feelers by his mouth into a long, swaying mustache and beard.

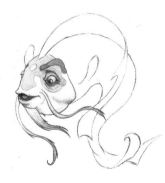

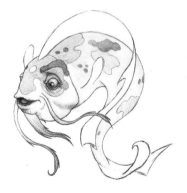

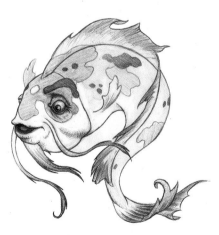

4 It's All in the Eyes
The eyes are the best means of conveying the human characteristics. Draw upper and lower eyelids to allow for the full range of human emotions. The pupils and irises should look human as well.

Koi have colored patterns on their bodies. Give him a pair of black splotches above his eyes that can act as eyebrows.

5 A Unique Pattern Emerges
Give the body some koi patterning. Draw random globular shapes on his body, letting some overlap, varying the shape and size. Add some small groupings of black dots. Use the side of your pencil to fill them in. Apply more pressure with your pencil to achieve darker shapes.

6 Complete the Drawing
This fish needs flashy fins to give him posture and attitude. They should move like hair in the wind. Carve into the basic shape with an eraser, and extend other areas so that they are long and rolling. Aim for an overall sense of movement that complements the lines of his body.

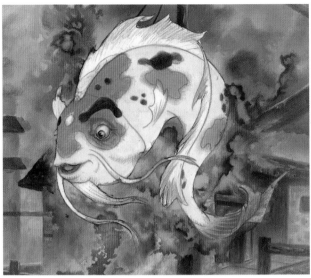

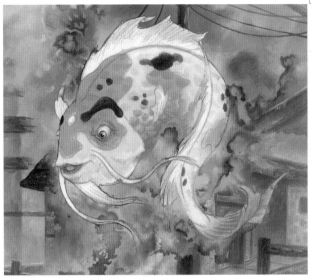

7 **Thinking Ahead in Color**
After painting the background (see pages 30–31), gently peel the frisket paper off of the fish. Using a no. 6 filbert and no. 2 round, quickly paint in the local color in oil. Paint his body Naples Yellow, his large spots Cadmium Orange and his small spots Ivory Black. This will provide enough variety in his color for him to stand out against any background.

8 **Cut Out the Cutout Look**
Using the rounded tip of a no. 6 filbert, paint scales along his body with Cadmium Yellow. Add scales to his orange spots with a darker orange mixture of Cadmium Orange and Cadmium Red Light.

Using a small round, bring some of the Radiant Green and Titanium White mixture from the magic color in the background (see page 30) into the koi's underbelly. This will tie him in with the background and avoid the "cutout" look that can occur when using frisket paper.

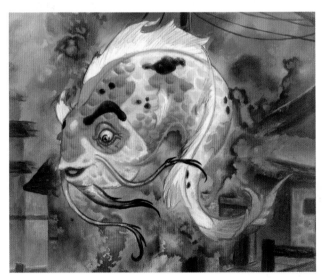

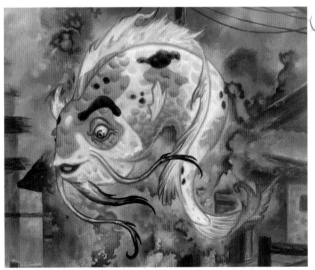

9 **Wet on Dry**
Let the painting dry overnight. Then, use Titanium White mixed with a small amount of Cadmium Yellow as a highlight color along the top of the fish's body and head. His body should have a nice color gradation from head to tail, going from yellow to white. To achieve this, scumble some of the highlight mixture over the tail-end of the body (see page 62).

10 **Now You're Fin-ished**
Using the same colors from the body, paint the fins. Use hard and soft edges to make it appear that the fish is swirling about in the magic. To create hard edges, use a detail brush to paint outlines around an object, or paint the background color thickly and opaquely up to the edge of the foreground object. To produce a soft edge, mix the colors of two elements into one another.

See the complete scene on page 27.

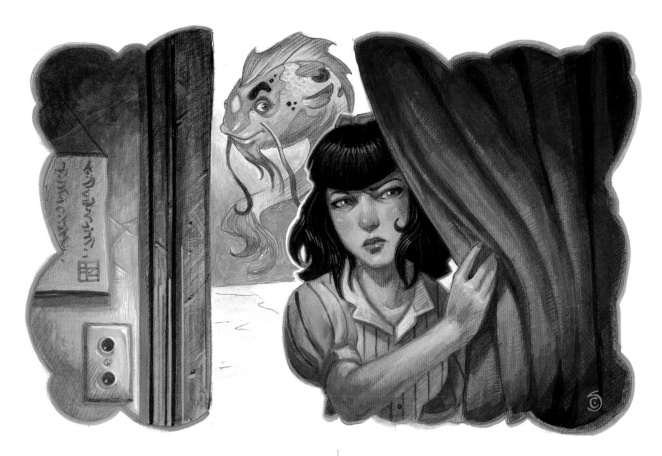

Continued from page 26.

"Plan?" I shouted. "Whose plan? What are you talking about?" I backed away from him and nearly stumbled over a rail spike. I looked around anxiously to make sure nobody was watching.

"No one else can see me," he said, "except you."

"I'm having a bad dream, right? That's all this is."

"No, but while we are on the subject, what do you dream about, Hachi?"

I was beyond confused. "What does that have to do with anything?"

"With one simple answer you could find out."

"Fine, we'll do this your way." I steadied myself. "I dream about living someplace where people won't make fun of me because my parents are different; I dream about being with my father and about being happy again."

"That seems reasonable." He nodded contentedly. "It's settled then. You will come with me. I will take you to meet my colleagues, who work closely with your father. Nobody will make fun of you, and everyone will be happy."

Frustrated, I yelled, "You're a liar! My father died in the war."

"Are you positive?"

"Of course I am. If he were still alive, he'd have come back to us."

"Perhaps his current circumstances would not allow that," the fish said with a touch of compassion.

"Quit playing games," I growled. "If my father is alive, prove it!"

"OK. We can go back to Hajime's and get this all sorted out."

"Hajime? What's he got to do with it? He's just a tattoo artist."

"Of course he is."

———————

The fish led the way. Apparently he was right about not being visible to others. People weren't staring at me—at least not any more than usual. We headed back to Chinatown, which was just coming to life again after the rain. The lights were dazzling, and the buildings glowed like paper lanterns.

"So, do you have a name, or should I just call you Fish, or Mr. Fish?"

"I'm glad you asked, my dear. My name is Noot."

"You're named after those slimy, creepy little lizards?" I mocked.

"Actually, newts aren't slimy, and those that I have encountered are not creepy, but quite shy and giving beings. That said, my name is spelled with two 'o's, not 'ew.'"

"That's wonderful. Then please enlighten me, Noot with two 'o's, how are your friends going to help me find my father?"

"My friends are able to travel through space and time, and they are going to teach you how to do the same," he said proudly.

"And I thought I was nuts."

"Aargh. Why me?" I didn't realize I had spoken aloud. "Why is this happening to me? All I wanted was a simple tattoo."

"You just answered your own question. This is happening because of the tattoo. It is the root of your power, and as you gain more tattoos, you will gain more power," Noot explained.

"You really are nuts! You think I'm getting another tattoo after what's happened with this one? And I don't have any power. If you knew anything about me, you'd know that for sure."

"Well, you are talking to a floating fish that no one else can see. I'd say that's one kind of power."

"Yeah, some great power," I said, kicking a rock into the gutter.

Back inside the tattoo shop, there was different incense burning, thick and nauseatingly sweet.

Hajime appeared from behind a long red curtain. "Ah, Hachi. I'm so very pleased to see you again." He glanced over my head. "And you have brought along a friend."

Stunned, I shouted at Noot. "I thought you said no one else could see you."

"Well, no other humans, that is, at least not in my present form." I didn't find that very reassuring.

"Do you know what he is?" I asked Hajime. "Do you know what's happening to me?"

"I do indeed."

"What about my father?" I demanded. "What does he have to do with all of this?"

Hajime's voice carried a tone of accomplishment. "I will leave the details to my employers. They are eager to make your acquaintance."

Out of a blinding circle of light, five creatures made their way into the cramped studio. They varied greatly in size and shape, the smallest no larger than a child, and the tallest stooping to keep from hitting his elongated head on the ceiling. One was so wide that he knocked over a desk and some chairs as he came in, and he didn't seem too apologetic about it. The tall one glared down at me. "Hachi Hachimitsu," he said in a firm tone, "we represent the five branches of the Order of Oru. You are one of us." The creature's last word wormed its way through my brain like a long hiss, and as it faded away, so did I.

What's that smell? It smells like honey. It smells like home.

What a relief. I'm going to open my eyes, and my mom's going to be standing over me holding a tray with hot tea and honey. She's going to tell me that I came home with a terrible fever and that I've been in bed for days. That's exactly what's going to happen.

"Aaaahhhh." It didn't happen. A blue creature buzzed past my head. "Who are you?" I asked as I sat up and nearly upset the tray in his hands. He had no feet and hovered around on a floating disk.

"My name is Phlox, and I've brought you some hot tea with honey. I hope you like it."

Even though his eyes were dark and beady, his gaze was comforting.

He continued, "I'm sure you have a gwisnark of questions, so why don't you drink this, get your thoughts together, and I will take you to see Brome."

I didn't really know where to begin. I drank the tea, which helped settle my nerves, and asked, "What is a gwisnark?"

"A gwisnark is an Orun unit for measuring quantity. It's slightly larger than your Earth 'million.'"

"And is Brome where you are from?" I asked.

"No. He's the one in charge. Tall, big-headed fellow." Phlox rose up on his disk to show how tall. "And he is quite impatient."

We moved out of the tiny room into a hallway. Flourishes of geometric and floral detail were worked dramatically into the walls. They met up gracefully with the beams and arches that fortified the hallway. All of it was bathed in a warm orange light. "What is this place?"

"You are on the *Yarrow*," Phlox said, "an E-class spacefoil, approximately 538.52 meters in length and 12,239,000 kilograms, or 12.2 gwisnark, in weight. It is capable of a top speed equal to eighteen times the speed of light and can of course phase through time with the aid of its quantum spiral pulse modifier."

"I'm not even going to bother asking what any of that means."

The story continues on page 43.

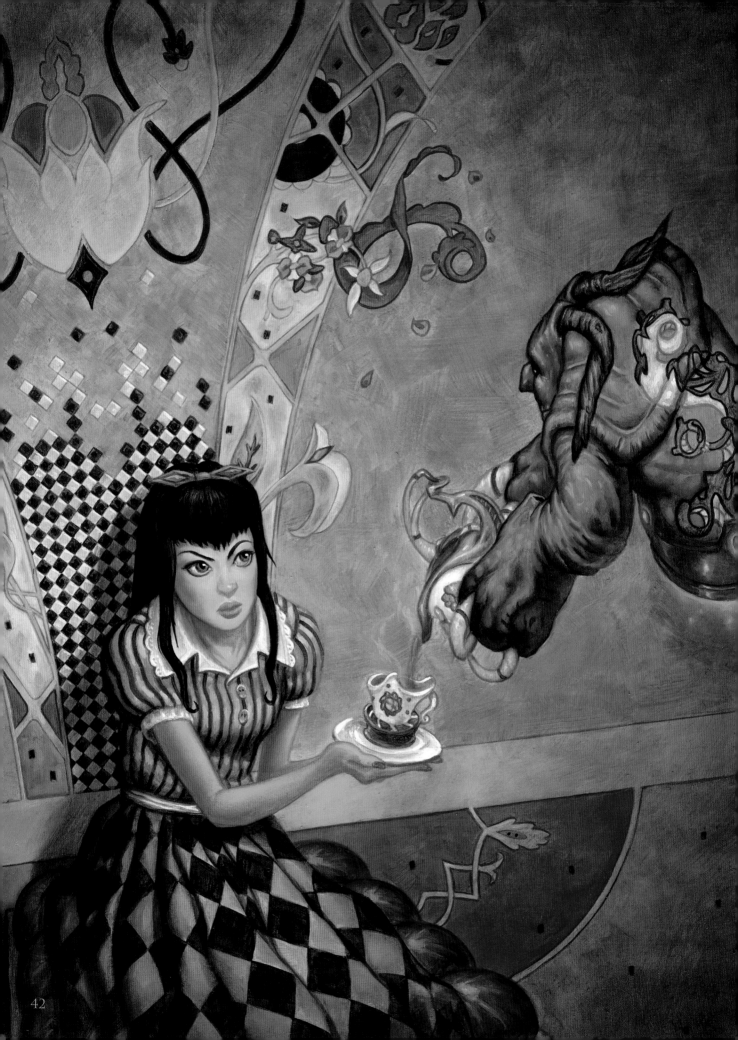

Continued from page 41.

Phlox brought me to a large door that flashed open automatically. Inside was a large control center with all manner of bizarre electrical equipment. The other beings that had confronted me inside Hajime's were waiting.

The tallest one, who was dressed in long, commanding robes, approached us. "Hachi Hachimitsu, it is good to see you feeling better. I apologize for startling you earlier. We are the selected representatives of the five branches of the Order of Oru. My name is Brome. You have already met Phlox, our engineer. Behind me is Draba, our weapons master."

On the other side of the room what appeared to be a female moved two pairs of arms in front of a brightly lit console. Behind her stood a figure in a shadowy hood. Brome gestured toward them gracefully. "Arnica is our pilot, and Linanthus is, well, an expert in many disciplines. Our Order is ancient, and its members possess great powers that manifest themselves through the tattoos that adorn our skin. You have witnessed a small but incredibly important aspect of this power through the tattoo that you received on Earth."

"You mean Noot?"

"Noot? Is that what he has decided to call himself this time? How can a being of such tremendous knowledge remain so juvenile? Well, the name notwithstanding, Noot is a very important being in our history. Locked within him are many of the secrets of the universe. He will enable you to travel through time and space without the use of technology. He will guide you through the terrain of the planets you will visit and allow you to talk to the local people in their own languages."

"So why don't one of you just get him tattooed on yourselves and leave me out of this?"

"Because he can be tattooed onto only select people, and you, Hachi, are one of them. Throughout millennia he has been tattooed on many beings in many forms, yet none of the bond pairs have been able to advance as far as our purposes require. Our hope is that you are the one who can complete the journey."

"What about my father? Is he part of this journey?"

"I cannot tell you of the specifics, for they are ever changing, but I can tell you of the goal, and that is to gain enough power to defeat the most destructive force in the universe, Lord Aru-Sen."

"You want me to do all of this? I couldn't even kill a bee. I don't want to hurt anyone. I've seen too many people hurt."

"Sometimes situations dictate the use of methods that one would rather not employ. Your world has seen a terrible war, with great destruction and loss, and technology that tears the very fabric of your skies apart, but that is nothing compared to the weapons that Lord Aru-Sen has at his command. He will soon be capable of enslaving the entire galaxy."

Time. Space. Aliens. I couldn't take any more. "I'm tired of hearing about plans and journeys. I just want to go home."

"Please, Hachi, let me finish."

"What makes you think I will agree to any of this?" I demanded.

Brome reached into his robe. From within he produced a tattered photograph and handed it to me. "Because your father wants you to."

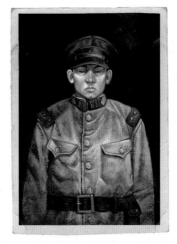

My father's proud eyes stared back at me from the photo. He was in his army uniform, shortly before he left us.

I barely heard Brome as he spoke to me. "Your father is one of the Order of the Oru as well. He is carrying out a very important mission, which is why he couldn't be with you. He gave me that photo to give to you. I believe he left you a message on the back."

I turned the photo over and read the familiar handwriting: "Hachi. My little honeybee. Time seems always to be against us. Some very strange things happened to me during the war, and I had to leave you and your mother behind. This has caused me much anguish and despair. I miss both of you tremendously. But if you follow the guidance of the Oru, someday we will be together again as a family. This I truly believe."

I wiped away a tear that had fallen onto the picture. I put the picture in my pocket, then looked straight up into Brome's eyes. He smiled slightly. My training was to begin immediately.

The story continues on page 58.

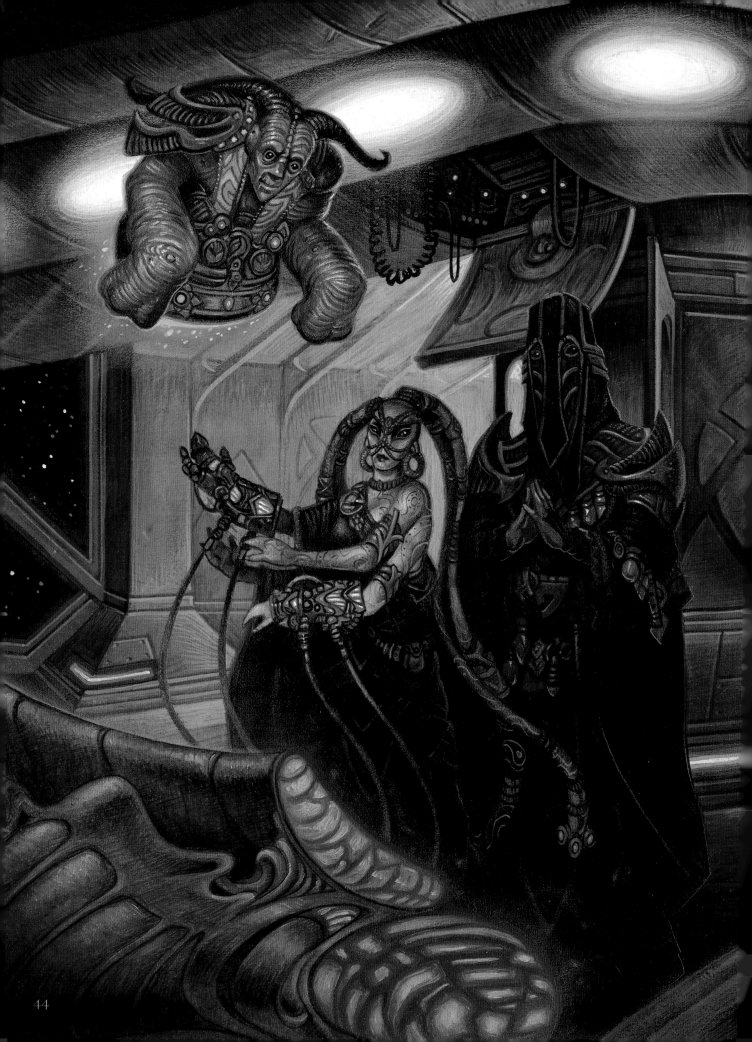

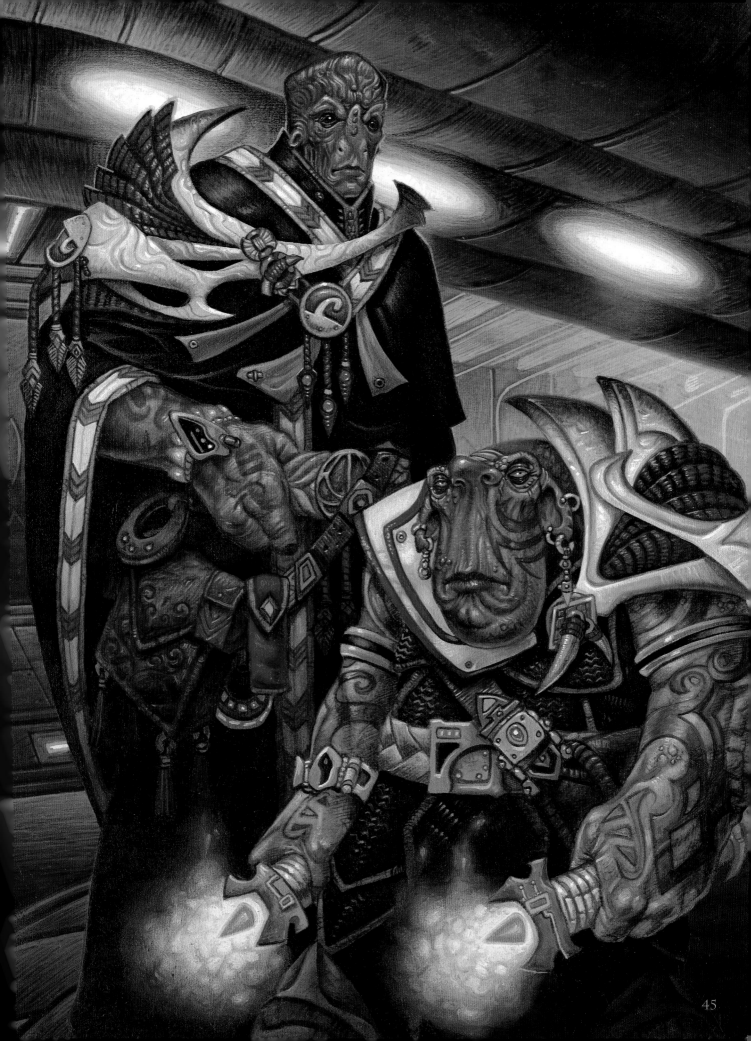

The Bridge of the *Yarrow*

Hachi is glad to see her father's face in a photograph. Just as a photograph shows only what the shutter has captured, so too the text of the story gives only what you need to know about the *Yarrow*. It's up to you, the artist, to convey what you think the *Yarrow*'s bridge might look like. With extra thought and imagination, you can help connect the dots for the reader and bring the story to life with your illustration.

1 Line Up
First construct the border of the page for a four-corner composition. Use a T-square and a drawing triangle to make sure the border's corners are at 90 degrees. This particular piece is 11" × 17" (28cm × 43cm). Use a ruler to draw the horizon line at the approximate center. Establish the vertical centerline at the exact center. Draw a vertical line 1 inch (25mm) out from each side of the centerline. This is called the *gutter* and represents where the book will fold. Avoid putting any crucial information of the story in the gutter, as it will get lost in the fold.

2 Vanishing Points
Establish the vanishing points on the horizon line. This sketch will be in two-point perspective (see page 21). Remember to make room for the characters. Draw the ceiling with three organic flowing lines at the top. Use a French curve to help keep your hand steady. Use a T-square and the top and bottom border as a guide to draw the vertical lines of the ship's walls. All the horizontal lines recede to the vanishing points. Next, draw the circular platform that Brome and Draba will be standing on. The parallel lines get closer together as they move back in space towards the vanishing point.

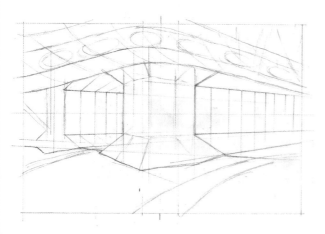

3 Hard Hat Required
Start to construct the walls of the ship more completely. Following the contours of the ceiling's center curving line, add oval shapes for the overhead lights. Using the established guidelines and a T-square, continue to draw the rest of the paneling with straight, vertical lines. The closer the lines get to the vanishing point, the smaller the distance between them.

> ### Don't Be Messy!
> Erase messy, unwanted lines before beginning each step.

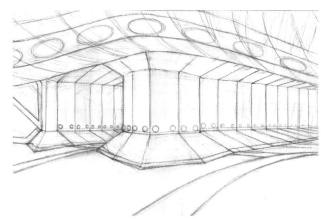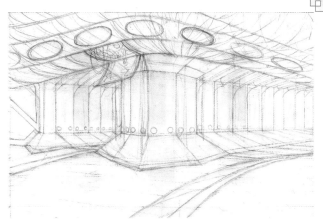

4 Swab the Deck

Use a kneaded eraser and lighten or remove any unwanted pencil marks. Draw the edge line trim on the bottom of the walls, receding to the vanishing point. Define the oval overhead lights, and start to think about how the ceiling's organic perspective will fall in space. Since it's on a totally different plane from the rest of the ship, the rounded form of the ceilings might not follow the vanishing point.

5 Freehand Details

Freehand extra accents such as paneling and a ceiling compartment. Use simple shapes to add some electronics inside the open compartment and maybe some wires hanging down. Continue to define the perspective of the ceiling panels. As long as it looks right and feels comfortable, have fun with it!

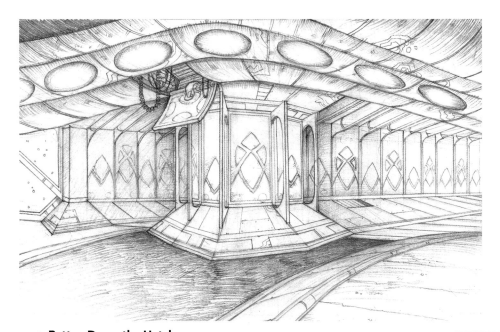

6 Batten Down the Hatches

Use a T-square and triangle to draw clean straight lines, following the lines you drew in Step 2–5. Edge lines and trim are good ways to show detail without having to draw too much. Add the lights on the bottom of the hallway along with extra edges, following the contours of the shape. Draw in the details of the ceiling panels. Add a design motif on the walls. These are floral in design but more geometric in style. Use crosshatching to draw some organic stains on the ceiling and carbon buildup around the lights.

Exercise

Following the story, pick a scene that Chris and Jim didn't illustrate. Take clues from the text and use the "Five Dubs" (see page 50) to help tell the story. Use these step-by-step instructions to create the characters in your scene.

PAINTING

Scan and print the completed drawing or make a nice copy at your local copy store. Remember, at this point you will have already drawn the characters (see pages 50–51 and 54–55) along with the background drawing (see page 30 for more on this process). Make sure the print is large enough to show the details clearly. Mount the printout or copy on a sturdy illustration board or Masonite.

Underpainting

An underpainting is an initial tonal rendering of a painting. It usually consists of a monochromatic scheme of browns or grays. It serves as a base for subsequent thin layers of transparent color. Light passes through the transparent color and allows the initial tonal scheme to remain intact.

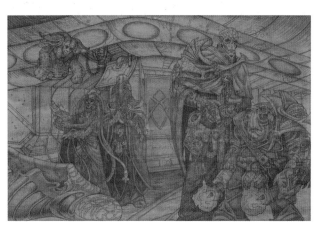

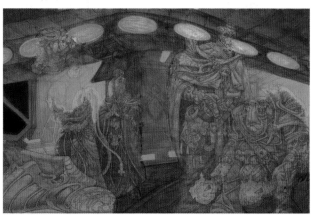

7 Warm Underpainting
Fix the drawing with workable fixative to prevent smudging when you apply wet paint. Apply four to five layers of clear gesso with a 2-inch (51 mm) flat, alternating layers of horizontal and vertical brushstrokes and letting it dry between layers. Let it dry thoroughly for twenty-four hours. Sand the gesso with 220-grit sandpaper to create a smooth finish. Apply a layer of diluted Burnt Umber acrylic paint. Let it dry or use a hair dryer.

8 The Blockade
Mask out the characters with clear frisket paper, using a craft knife to cut around tight corners. Remove the frisket from the background. Create midtone mixtures with acrylic Burnt Sienna, Burnt Umber, Yellow Ochre, Ultramarine Blue, Alizarin Crimson, Mars Black and Titanium White. Dilute the paint with water to create transparent mixtures. Block in the basic colors with nos. 4, 5 and 6 (or larger) flats.

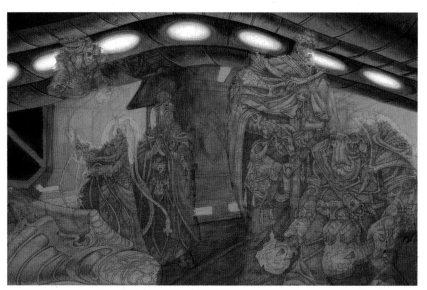

9 Drawing With Paint
Add lights and darks, starting at the top and working down in sections. Use the same colors from Step 8 and nos. 2, 3 and 4 rounds on the ceiling and lights. Mix Burnt Sienna, Yellow Ochre and Titanium White for the light areas. Follow the contours of the drawing with your brushstrokes. Do the same to add darks with a warm brown mix of Mars Black and Burnt Sienna. Apply pure Titanium White to the center of the overhead lights. Gradually mix in Ultramarine Blue, Alizarin Crimson and Titanium White to create a glowing purple, using less white as you work toward the edge. Use the purple for the accented backlight on the ceiling to show its rounded form.

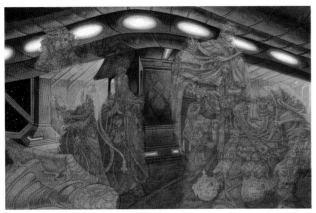

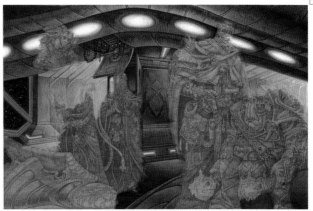

10 **Draftsman-Ship**
Continue to work the ceiling using the same color palette, pushing and pulling the lights and darks. Start blocking in the halls in the far background with Burnt Sienna. Mix the purple from Step 9 with more Titanium White and a bit more Ultramarine Blue to create a cooler light for the receding halls. Block in the floor lights with a mix of Ultramarine Blue and Titanium White, using a no. 2 round for the detail work. Create straight edge lines with a no. 2/0 liner, using a metal ruler to line them up with the straight lines of the drawing. Use this technique on all your edges.

11 **From Floor to Ceiling**
Use nos. 2, 3 and 4 rounds in this step. Start working on the foreground platform beneath Draba and Brome. Create a warm gray with Mars Black, Titanium White and a touch of Burnt Sienna. Follow the contours of the platform. Add a warm light on the floor between Linanthus and Brome with a semi-opaque mix of Yellow Ochre and Titanium White. Paint the overhead compartment near Phlox. Use Mars Black for the wires and dark recesses. Mix a purple with Ultramarine Blue and Alizarin Crimson and paint in the gizmos inside. Add blinking lights with Titanium White and Cadmium Red Light straight from the tube.

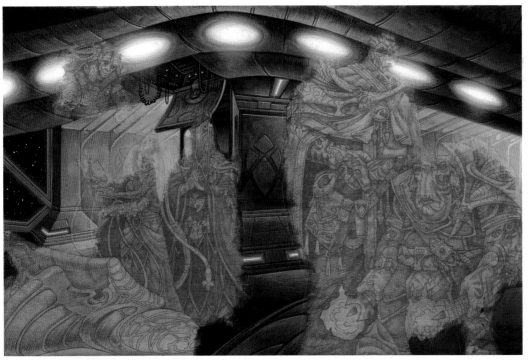

12 **Glowing Effects**
Switch to oil paint for this step. Using a no. 12 round, add a bit of Titanium White over the lights. This technique is called *drybrushing* or *scumbling*. Load a large brush with a little oil paint and rub it into the surface to create a glowing effect (see page 62). Use your finger or a paper towel to smooth out the glow.

See the complete scene on pages 44–45.

Brome and Draba

Beyond the pale glow of the stars, a small group of travelers seek to find the one who will save them and the rest of the universe from ultimate destruction. The Oru are powerful beings sent to retrieve Hachi and her special tattoo Noot from Earth and teach her the powers that are locked beneath her skin. Each member of the Oru has unique tattoo powers, or *Koru-Jinshi*, that they will teach Hachi. In the following two demonstrations you'll learn how to draw and paint these characters in groups.

Let's start with Brome and Draba in the foreground.

The "Five Dubs"

To tell a story with art, think about the *who, what, when, where* and *why* of your illustration—the "Five Dubs." When you can answer all of them, you'll have given the viewer all she needs to read your illustration quickly and completely.

Who? The Oru
What? Greeting Hachi after she awakes
When? Shortly after they retrieve her from Earth
Where? On the *Yarrow* in space
Why? To introduce the viewer to each character

Next Step: Thumbnail
After you've answered the "Five Dubs," draw a thumbnail.

1 Stack 'Em Tall and Wide
The tall one is Brome, the wide one is Draba. Start by drawing two crosses, one for each character. This will establish approximately where the shoulders rest and how their heights compare.

Construct the basic shapes of the bodies with circles for the main joints. Use egg shapes for the head, trunk and pelvis area. Draw a centerline cross on each head to place the eyes and center of the face.

2 Muscle Up
Fill out the figures with muscles on the arms and legs. Use elongated egg and capsule shapes for the arm muscles and Brome's thigh muscles. Draw small circles on eye lines to establish the eye sockets. Draw Draba's legs in one continuous shape. This will establish where his hips are behind his big belly.

3 Face to Mace
Use a kneaded eraser to remove unwanted pencil marks. Draw curved lines to establish the mouths. For Draba's nose, draw an oval with two small circles for the nostrils. Draw curves for the chin. Create Draba's plasma maces with two parallel lines and a circle for the plasma. Consider how these characters relate to each other and where their lines intersect.

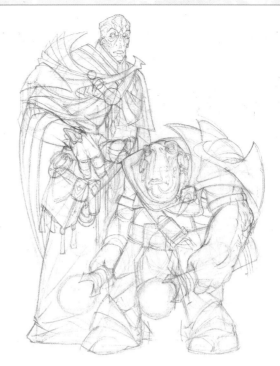

4. The Armory

Lighten the pencil marks with a kneaded eraser. Draw sweeping lines in a boomerang shape for Brome's right shoulder pad. Draw a high collar around his neck and long, flowing robes. Draw a square shape for his belt buckle and a rectangular shape for his belt. Draw a pouch at his side for his data pad.

With smooth, sweeping lines, draw Draba's shoulder pad armor, following the contours of his shoulder. Add extra rounded triangles on top of the contour. Draba wears a tunic of tight scales; create this by drawing trapezoid shapes in front and on the sides of his hips. Draba also wears leg braces; create these with triangles on top of his two-toed feet.

5. Pencil and Polish

Remove unwanted pencil marks with a kneaded eraser. Work out some of the main details, following the basic shapes. Use clean, tight lines to finish their faces, clothes and armor. Add buckles to the sashes and ornamentation to their chests. Draw armbands and wristbands, following the contours of the arms. Add some extra triangle shapes to the ends of the plasma maces to keep them from overheating.

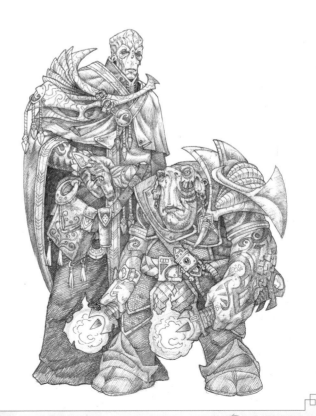

6. Out of This World Details

Render the characters with crosshatching or any techniques you like (see pages 18–19). Start at the top and work your way down. Pay attention to the little extras, such as seams, bolts and the edges of the small details. Think about how the armor and clothing were crafted. Keep your pencil sharp. Establish the main light source coming from the top of the scene. Then, when you paint, you'll have a better understanding of how light and shadow fall on the characters. Looks like Brome and Draba have things under control!

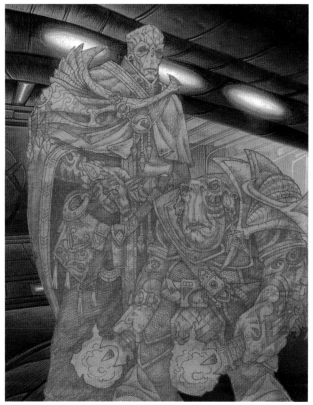

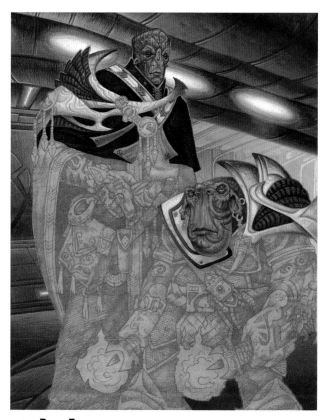

7 Still There?

Once the background is complete (see pages 48–49), gingerly remove the frisket paper to reveal Brome and Draba. Use the acrylic Burnt Umber wash as the ground for painting. Now switch to your oil paint palette.

Tips for Painting Character Groups

- Work all the characters to completion at the same time.
- Push and pull the space with dark glazes and highlights.
- Paint the base color first, then add highlights and darks, using the wet-into-wet technique.
- Use the right brush size for each area.
- Create a color scheme with dominant, subdominant and subordinate colors.

8 Base Face

Use nos. 2 and 3 rounds, depending on the size of the area. Create a midtone glaze for Brome's face with Yellow Ochre, Indian Red and a touch of fine detail medium. Switch to a no. 0 round to add the lights and darks. Add Titanium White to the base tone for a light color. Add a touch of Cadmium Yellow Light to warm up the highlights. Add Dioxazine Purple to create the darks.

Create a glaze for Draba's base flesh tone with Viridian Green, Indian Yellow, Burnt Umber and a touch of fine detail medium. Block in the glaze with a no. 2 round. Add Titanium White to the base color for the lights. For the darks, add Dioxazine Purple. For Draba's nose, add Cadmium Red Light and blend into the base tone with a no. 0 round. Mix an almost white tone with Titanium White, Viridian Green, Indian Yellow and Burnt Umber, and add highlights with a no. 0 round.

Use a no. 2 round to lay in the base tone of the clothing with Mars Black and Phthalo Blue. While the paint is still wet, work in the lights and highlights with Titanium White. The cloth becomes darker away from the light source. For the armor, use Titanium White, Burnt Umber and Dioxazine Purple. Add more Burnt Umber for the warm white. Mix Phthalo Blue, Cerulean Blue and Titanium White for the bright blue ornamentation on the armor.

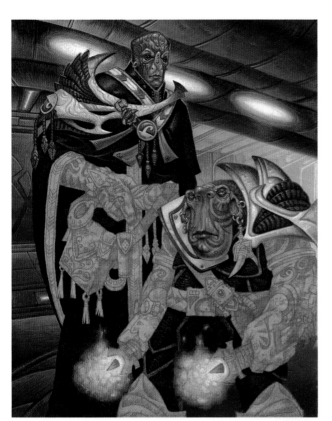

9 **Plasma Maces**
Continue painting the clothing with the same colors from Step 8. For Draba's plasma maces, use various mixtures of Dioxazine Purple, Magenta, Cadmium Red Light, Cadmium Yellow Light and Titanium White. Use a no. 2 round to apply a purple mixture to the outside, and work gradually to a warm yellow near the base. Soften the edges by blending them into the wet clothing. Push and pull the highlights by continuing to add more white to the base tone of the faces. This will bring these foreground characters forward in space.

10 **Alien Accents**
Complete the flesh tones on the characters' arms. Paint the gold metal accents with a glaze of Indian Yellow, and add a touch of Dioxazine Purple for your darks. Add a bit of Titanium White for the highlights. Add Cadmium Yellow Light to some of the gold metal parts, such as Draba's earrings, to make them pop forward. For the steel or silver metal accents, use Mars Black, Titanium White, Dioxazine Purple and Raw Umber. Mix these colors at varying degrees to create warm silver or cool steel colors. Add highlights with Titanium White. Continue filling in the accents with a no. 0 round. Finish the maces with a dry-brush application of Dioxazine Purple, Magenta and Titanium White. This will make the plasma mace glow a bit stronger. Draba looks a little skeptical about Hachi's potential.

See the complete scene on pages 44–45.

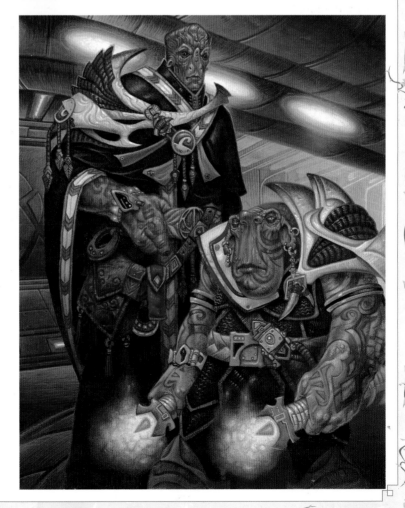

Phlox, Arnica and Linanthus

Let's talk about the middle ground characters: Phlox, Arnica and Linanthus. These characters are set back behind the *Yarrow*'s control console. What we know so far is that Phlox is the first to greet Hachi to the *Yarrow* with some nice, warm honey tea. Delicious! Let's get to know the others!

 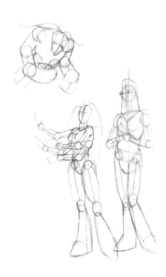 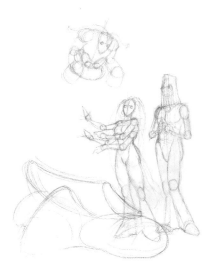

1 A-Cross the Galaxies

Draw three crosses in varying sizes to determine the height of each character and their placement in relation to each other. The cross floating in the air is Phlox. Use the horizontal crossbars as a guide for placing the shoulders. The center cross has two horizontal crossbars because Arnica has two sets of arms.

2 Round 'Em Up

Add egg shapes for the chests and heads. Draw centerline crosses for each face. Use circles for the shoulders, limb joints and pelvises. Phlox doesn't have legs or a pelvis, so draw an egg shape for the floating disk he cruises in. Use lines to attach the leg and arm joint circles. Arnica's and Linanthus's weight is centered on the vertical line of each character's respective cross from Step 1.

Add the muscles and volume. Phlox's arms are straight and bulky, similar to elephant legs. (Use photos of elephants for reference.) Arnica and Linanthus have humanoid forms. Draw their arms, forearms and legs with rounded capsules. The length of the foot is usually the same as the length of the forearm. The width of the thigh muscle is about the same width as the head.

3 The Control Console Shape

Add circles for each character's eye sockets. Start to think about the edge lines and the negative and positive shapes that they make on your figures. Add the ship's control console. It's in front of Arnica, overlapping her lower legs. Overlapping is a great way to show depth. Draw a flat banana shape cut in half for the curved dashboard of the console. Draw overlapping bean shapes for the lower part of the console. This gives it an organic feel, almost like it has a life of its own.

Tips for Drawing Groups

- Use overlapping to show depth.
- Use scale to place characters in the foreground and middle ground.
- Don't be afraid to draw through a character to get the anatomy right.
- Be aware of tangent lines.
- Follow your vanishing points.

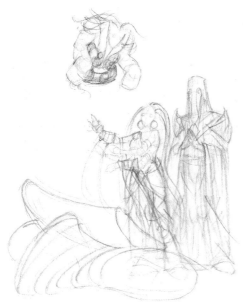

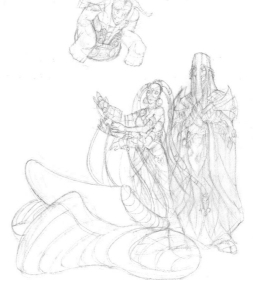

4 Gear Up!

Phlox has an encasement on his hover disk. Add circles for the lights on his disk and a vest flowing down from his shoulders, tucked into the disk.

Draw Arnica's head braids flowing down to the ground. Add circles for earrings and rounded bands on her arms. Add gauntlets on her upper and lower arms with small stacked trapezoids. Draw parallel lines from her gauntlets to the console. She uses her unique *Koru-Jinshi* (see page 50) to pilot the ship.

Draw Linanthus's head covering and long robes with sweeping, flowing lines that reach the ground. Add a triangle for his shoulder armor. Linanthus is in tune with the elemental magic side of his *Koru-Jinshi*, so he wears lightweight armor.

Add sweeping lines in the center structure of the control console.

5 A Sharp Pencil for Your Thoughts

Follow the basic sweeping shapes with a sharp pencil to tighten the drawing. Draw Phlox's brow ridge with horizontal rounded lines. His horns attach here. Draw his nose with an upside-down 7-shape and his mouth with a line that curves up at the corners. Add a pointy chin. Using circles and triangles, add small potion bottles on Linanthus's chest and arm and around his belt. Draw rounded bands following the contours of Arnica's four arms. Add a small hip pouch and a circular brooch on her sash.

Draw a caterpillar shape along the side of the dashboard. Use rounded circular shapes in succession to give it form. Draw in a window on the corner of the console. This will house the powers Arnica uses to control the ship.

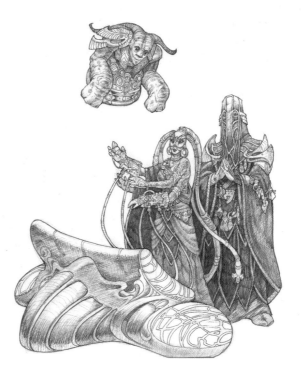

6 Rendering Details

Use crosshatching to render the details. Start at the heads and work down to the legs and feet, finishing at the control console. Shade in the light source. Since these characters are in the middle ground, the light source might not be as harsh as it is on Brome and Draba in the foreground. This will help establish the space between them, particularly when we get to the painting stage.

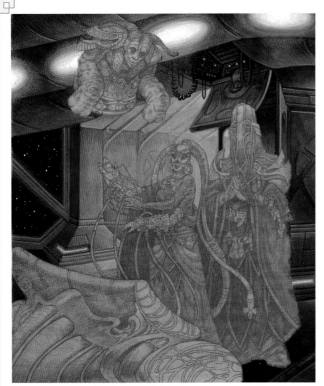

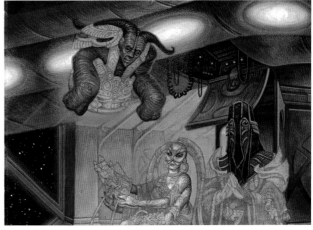

Block Heads

8 Bring each character up to a finish at the same time, starting with the heads and working down. Using oils, start to flesh out the secondary group of characters. For Phlox, mix a warm blue with Cobalt Blue and Burnt Sienna. Create lighter tints of this mix with Titanium White. Using nos. 0 and 2 rounds, work in the medium and light tones. Work from a medium tone, adding lights, highlights and darks on top. Use Raw Umber and Titanium White for Phlox's horns. Continue building up the characters, picking a color that is unique to each member of the Oru. They are aliens, after all, so have fun with it!

What Lies Beneath

7 Remove the frisket paper from the characters. The warm underpainting of the acrylic Burnt Umber wash you laid down in Step 7 of the background (see page 48) will act as the underpainting for the characters, too.

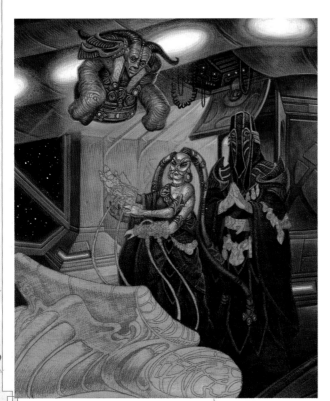

Orun Blue

9 Finish painting the flesh tones, and start to think about the clothing. I chose blue for the Oru's color. Add a little fine detail medium to each color mix. Using nos. 2 and 3 rounds, paint Arnica's and Linanthus's robes with a mix of Mars Black and Phthalo Blue, adding Titanium White for the highlights. The lightest parts of the cloaks are closer to the heads; the rest falls in shadow. Use Burnt Sienna as an accent to help separate the characters from the background. For Phlox's hover disk, mix Mars Black, Titanium White and Viridian Green to create a cool steel color. Use a no. 0 round to draw the details with paint, following the drawing. Add green lights on the hover disk with a mix of Cadmium Yellow Light and Viridian Green. Use the same mix for the green emissions from the hover disk. Use a dry-brushing technique to fade the edges into the background.

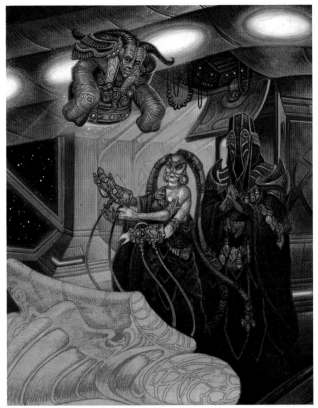

10 Drawing With a No. 0 Round

Use a no. 0 round and Viridian Green, Mars Black and Titanium White to block in Arnica's control gloves. Mix a darker version with more Mars Black and draw with the paint, following the drawing linework. Add more Titanium White and add highlights to the glove. Add the humming lights on the control gloves and the extra lights on Phlox's hover disk with a mix of Titanium White and Viridian Green. Mix Yellow Ochre and Burnt Sienna for the bands that flow over Phlox's shoulders and down into his hover disk. Add a little pure Cadmium Yellow Light to the glow of the hover disk, and paint the sparks that fall from the disk with a no. 0 round. Finish Linanthus's potion stashes with any colors you choose. Block in the medium tones first, then add the linework and highlights.

11 The Control Console

Finish the control console using Burnt Sienna as the base glaze. Add highlights with a mix of Cadmium Yellow Light and Burnt Sienna. Add a little Titanium White to punch the highlights forward. For the console lights, use Phthalo Blue, Viridian Green, Dioxazine Purple and Titanium White. Add highlights with Titanium White and Viridian Green between each section of the lights. To move the console forward, apply a Mars Black glaze to some of the dried characters. Move Linanthus back the most and Arnica back a little. Keep Phlox the same.

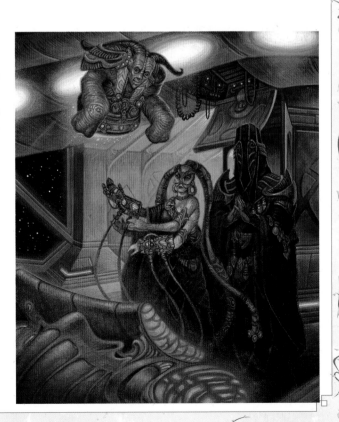

12 Electric Haze

Mix Phthalo Blue, Viridian Green and Dioxazine Purple with Titanium White, and use a no. 5 round to drybrush the cool glow around the control console. This will push the console forward.

See the complete scene on pages 44–45.

CHAPTER THREE

FIRST QUEST:
Doona

Continued from page 43.

I thought that I would be able to start jumping through time and space with Noot right away, but that wasn't the case. Mastering the powers of the tattoo took practice, and up until my departure for a planet called Doona, the best I had been able to do was transport myself to different places on the *Yarrow*. So, for my first quest, I had to use a huge piece of Orun technology called a Cross-Temporal Bounce Corridor.

I braced myself for a painful experience. I doubted that hurtling through time and space would be pleasant, but the only pain I felt was when I stumbled blindly out of the Bounce Corridor, tripped over a rock and fell on my butt. I forgot that pain quickly, though, when I became aware of my surroundings.

The landscape was smooth and rolling, dotted with rock formations that reminded me of pieces on a chessboard. Light sputtered and flashed through colorful clouds like a smoldering fire. It was clear to me that I was on another world. For all I knew, this world could be in a different galaxy, in a time millions of years in Earth's past or future. On top of it all, I was on a quest of cosmic importance.

I took off my necklace, which bore a stone fish amulet, and began to twirl it around as Brome had instructed me. The fish started thrashing around frantically, and Noot's voice exclaimed, "What in blazes are you doing, child?"

"Brome told me that twirling the necklace around really fast would summon you."

"Yes, and I'm sure he's enjoying a good laugh over that one." The fish remained stone, but I could hear Noot's voice clearly. "While I'm in the necklace, you need only speak and we can communicate. Twirling me around will just serve to make me nauseous. Besides, I'm in this blasted thing only because some alien species can see me in my true form, and that could be a problem for you, since, quite frankly, I'm a bit of a celebrity in many parts of the universe."

"Well, aren't you special. I'll keep the nauseous thing in mind, if you're nice. Now, you have the map of this world in your head, right? So just point me in the direction I need to go to get my next tattoo."

"No 'Hello, Noot. It's good to talk to you again'? Just right down to business, eh?"

I pointed toward the horizon. "Look, the sun is going down. At the very least we need to make camp."

"One sun is setting, true, but what you don't know is that a second sun will be rising in a couple of hours, and a third not long after that. So why don't we have a snack now, and then head west a bit. There's a fantastic, hot Meldon spring in that direction, and I could desperately use a good soak."

I talked Noot out of his hot spring dip by threatening to keep the necklace in my shoe, then he directed me southeast to a wooded area. I found a good spot to set up camp and started a fire. It was almost dark, and even though Noot said it would be dark for only a couple of hours, I thought it would be a good idea to try to get a little sleep. Time travel is tiring, after all, and I had a long journey ahead.

Noot insisted on being set on a large rock near the fire so he could enjoy the warmth. I began examining the gadgets on my belt, mentally going over the descriptions Arnica had given me for each of them. I ran my fingers over the leather handle of the light rod, wondering in what kind of situations I would need to use it. I laid my head on my bedroll and looked up at the night sky. Streaks of purple wound through the pinpoints of the stars. Before I shut my eyes, I turned to tell Noot to keep watch.

The necklace was gone.

The story continues on page 68.

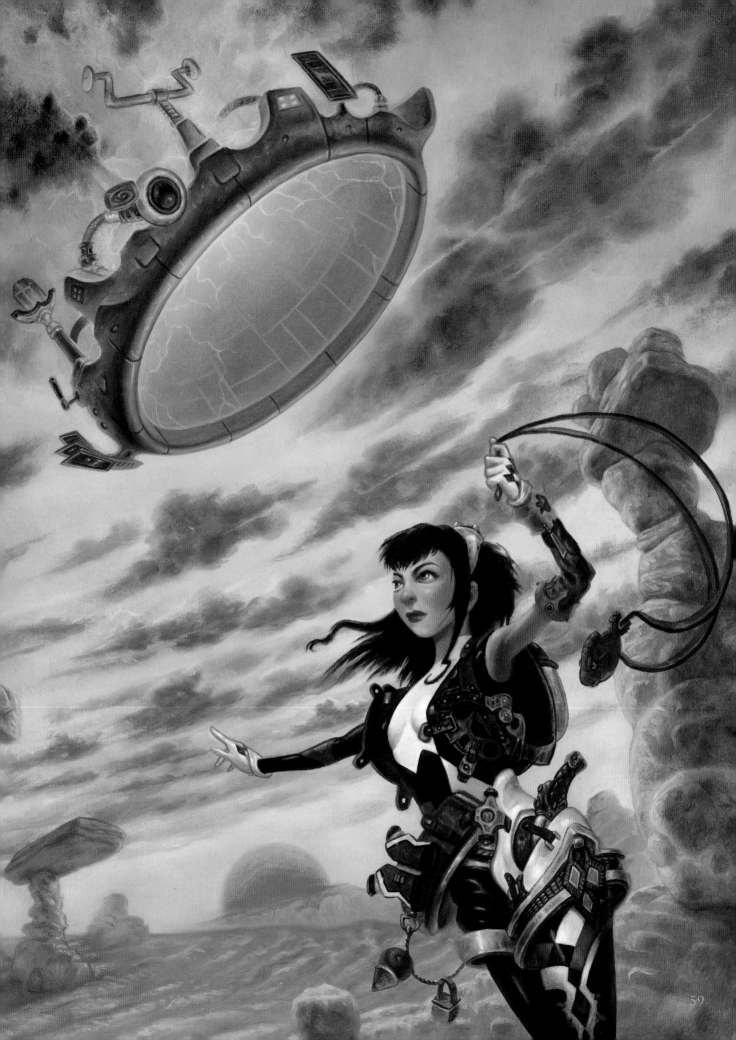

Doona

Hachi raises her head and casts her eyes upon the landscape of Doona. She sees a desert expanse of gently rolling hills. Rocky outcroppings, scattered sparsely about, cast long shadows from the setting sun.

Tilted Horizon Line

7°

Standard Horizon Line

1 Tilting the World

This setting poses a challenge to you as an illustrator. You need to make this landscape, which has no epic mountain ranges, lush vegetation or roaring river, exciting to look at. One way to do this is to tilt the horizon line. By slanting everything in the composition anywhere from 5 to 35 degrees you can create diagonals that give movement to the landscape.

6°

14°

2 Degrees of Angles

Draw diagonal lines to indicate the softly rolling hills of the desert. The lines in the foreground should have a steeper angle. As you move back toward the horizon, decrease the angle of the mounds. Alternate the direction of these lines. For example, the line in the foreground, which represents the ground plane where Hachi is standing, should move rather steeply from the lower left up through the right side of the page. The hill behind should sweep at a lesser degree from right to left.

3 Balancing Act

Use basic shapes to plot out Doona's unique rocky markings. They should be large pillars of rock with a single sheet of thick rock resting precariously on top. It should be a mystery to the viewer how these monuments occur naturally on such a barren landscape. Have them curve and point toward the center.

4 Cloudless Sky, for Now

Render the rocks using crosshatching and small circular marks to express texture and larger cracks. Since the sun is setting, the stone pillars will cast long shadows. You don't need to draw in the clouds. I find the randomness of clouds is best captured in the early free-form stages of painting. Drawing clouds in rigidly at this point can detract from the spontaneity of the watercolor stage of the painting.

PAINTING

This time we won't use frisket paper to mask off the figure. There are several ways to approach any given situation in a painting. Frisket gives a nice clean edge to work with, but just letting the paint fly allows some of the background colors to work their way onto the foreground objects, which helps unify the color in the finished piece. Neither way is right or wrong, just a matter of preference. Remember, at this point you will have already drawn Hachi and the corridor (see pages 64 and 66) along with the background (see page 30 for more on drawing everything at the same time).

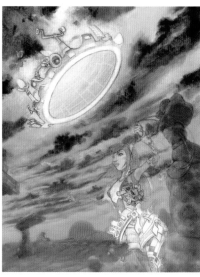

5 Clouds at Last

Print the drawing on watercolor paper and adhere it to a board. Establish the colors with watercolor.

For the clouds, lay in billowing rows of diagonals with Violet and a ¾-inch (19mm) flat. Mix in True Blue for the clouds near the top, which are closest to the viewer and have greater contrast.

The sky behind the clouds is a mixture of Titanium White and Turquoise. Paint the sky quickly and loosely, using a spray bottle to allow some of the colors to blend together naturally.

Fill in the setting sun with a mixture of Flame Orange and Crimson Lake.

6 One of the Setting Suns

Set up your oil palette and begin to bridge the sky and the land. Scumble a mixture of Cadmium Orange and Cadmium Red Light over the sun and onto the mountain ridge where it meets the sun. Paint sunlight reflections on the bottom of the clouds with Light Red and a no. 6 flat.

Paint a blue tint of Cerulean Blue and Titanium White along the mountains at the horizon. While this is still wet, paint Cadmium Red Light directly into the blue to create a neutral transition into the desert in the middle ground (in Step 9).

7 Blue Shadows

Continue building up the shadow areas in the far background with the blue tint. Bring up the lights with Raw Sienna, Cadmium Orange and Cadmium Red Light. The ground and rock formations closest to Hachi require greater contrast than those farther away, so paint the highlights in these areas with Yellow Ochre, and mix a little French Ultramarine Blue into the shadows.

8 Horizon Haze

Mix Titanium White with a bit of Cerulean Blue and Yellow Ochre. Paint this mixture thickly around the sun and along the horizon line. Add more Cerulean Blue as you work your way up. Towards the top, add French Ultramarine Blue.

Add Cadmium Orange highlights to the bottoms of the clouds nearest the sun. Paint a mixture of Cobalt Blue and Cobalt Violet on the cloud areas away from the sunlight and into the reflected skylight.

Scumbling

To scumble, load a little paint on a rough bristled filbert or bright brush, and scrub it in a circular motion over a dry area. It is excellent for making color gradations because the scrubbing motion allows the color underneath to show through.

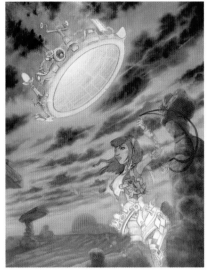

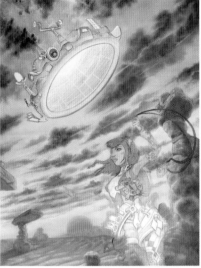

9 Highlight, Midtone and Shadow

Apply a basic color scheme to finish the middle ground. Cover the objects receiving direct light in Raw Sienna. Add the brightest highlights with Yellow Ochre and Titanium White and a small round. As light gives way to shadow, add Cadmium Red Light, then turn the form sharply with French Ultramarine Blue (this is called the *form shadow*). Use the blue tint from Step 6 for the cast shadows. Add Cobalt Blue here and there for variety.

10 Integrating Elements

Work on the area around the Cross-Temporal Bounce Corridor so that it doesn't look cut out and pasted in. Brush green-gray into the area behind it, blending it smoothly into the clouds and sky. Then paint sparks of energy with Cinnabar Green Light and a small round. These lines of energy hug the edge of the Corridor and the clouds like static electricity.

11 Cloud Edges

For a more realistic look, make some of the cloud edges soft and others hard. Create soft edges by gently blending wet-into-wet. Use a medium filbert to push the light blues of the sky into the purples of the clouds and vice versa. To create hard edges, paint a firm line with the background color around the cloud. Load the brush with plenty of paint for complete coverage.

12 Close and Vibrant

To finish, intensify the area closest to Hachi. Bring up the contrast by strengthening the highlights with a bright mixture of Titanium White and Yellow Ochre. Intensify the shadows by laying in glazes of French Ultramarine Blue. Add color variety to help bring this area forward. Brush some Cobalt Turquoise into the areas receiving light, and glaze Burnt Sienna into the shadows.

See the complete scene on page 59.

Atmospheric Perspective

Atmospheric perspective describes the effect the atmosphere has on the contrast and color of objects as they get farther away from the viewer. On Earth, distant objects begin to take on some of the blue from the surrounding sky. They become less intense in color and contrast. Mimic this in your art to help indicate distance.

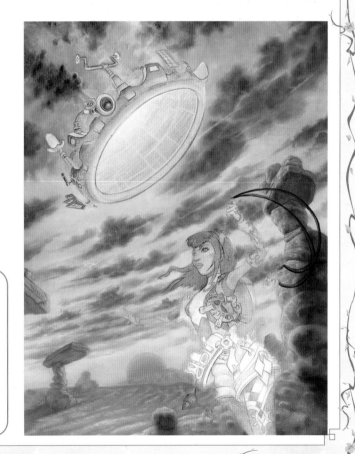

Hachi's Gadgets

Hachi has been given a wide variety of gadgets by the Oru to aid her on her first quest. Some of them are mentioned specifically in the text, and others are only suggested. It is up to you to create these items visually, and, in doing so, set the tone for what Orun design will be like throughout the story.

1 What's the Purpose?
Gadgets and tools need to be attached to their user in some way. They can be placed in pouches, backpacks and pockets, or connected to straps and belts. In this example, you will be drawing the items Hachi has equipped on her belt and shorts. Begin by drawing the shapes for the shorts and belt. Draw tapered cylinders for the shorts and a wide rectangular belt wrapping partially around the shorts. The belt is strictly for carrying items, so it will not look like a regular belt that is used for support.

2 Shapes Now, Details Later
Break the cylinders of the shorts into armorlike segments. This will provide spaces where you can tuck objects such as the Orun light rod. Pencil in rectangular shapes on top of the belt for binoculars and small storage pouches. Draw a curved line coming off the edge of the belt, and a couple of unique shapes hanging from it. The key at this stage is getting shapes that you think help define the look of an Oru. You can work out the specifics of each device as you get further into it.

3 Connections
Consider how things are attached to one another. Look around at the cables on construction equipment and the buckles on belts and shoes in fashion magazines. Incorporate some of these things into your designs. For instance, the buckle attaching Hachi's belt to her shorts can be cross-shaped and can even be a gadget of its own, such as a light or a compass.

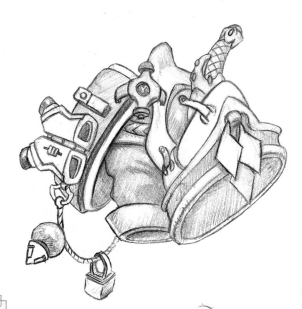

4 Patterns and Textures
Add pattern and small details to everything. Draw a criss-cross pattern on the handle of the light rod and an adjustable slider on the binoculars. Shade parts of the belt and shorts with hatch marks to indicate color variations. You can also use different mark-making techniques to create textures. For example, an evenly spaced crosshatch will look like fabric, while smudging a crosshatched area with your finger and bringing out a highlight with your eraser will appear as a smooth, hard surface such as plastic or metal.

5 Accent Colors

We designed Hachi's outfit in black and white so that it would stand out against any background, but black and white can be boring, so let's add lots of color to her gadgets.

Hachi's gadgets are made of a wide variety of materials, including shiny metal, hard plastic, leather and brass. Paint in local colors to distinguish each material: Cool Gray for metal, Mars Violet or Raw Umber for leather, Raw Sienna for brass and Sap Green and Cobalt Blue for the tech parts.

6 Light Isn't Always White

Begin adding shadows and highlights. Don't simply use white for all of the highlights. For colors like Mars Violet, try adding Cadmium Red Light, Radiant Violet and Cerulean Blue for the highlights. More than a century ago the Impressionists perfected the technique of placing warm and cool colors next to each other. It will add vibrancy and life to your painting.

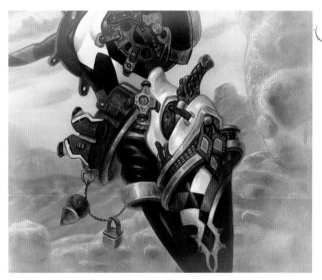

7 Patterns and Details

Start working out all the technical details of the gadgets. Paint the criss-cross pattern on the handle of the light rod, and make a grid pattern on the blue area at the bottom of her leg armor. Detail the Sap Green items with Radiant Green.

Add Cadmium Red Light to the edge of the items on Hachi's left side to capture the reflection of the sunlight.

8 Different Materials, Different Highlights

Finish the details with a no. 0 round and fine detail drying medium. Add highlights to the pieces of brass with Yellow Ochre and Titanium White. Brown leather absorbs most of the light that hits it, so paint the highlights on those objects with Light Red or a medium gray mixture. Paint a blue tint of Cerulean Blue and Titanium White into the hard white plastic and the metal. This will help unify the foreground and background.

See the complete scene on page 59.

Corridor

The Cross-Temporal Bounce Corridor is a short mechanical tube located on the *Yarrow* that allows anyone who walks through it to travel through space and time. When you enter it you are on the *Yarrow*, but when you exit you are at a pre-programmed location and time. The exit of the tube is visible at the new location for a brief time until its user reports that she is safe.

1 Ovals in Space

Since the Corridor is a tube, its exit, which will be visible in this illustration of Hachi's arrival on Doona, should be circular. The Corridor should be set at a diagonal to emphasize the tilted horizon line. Draw a line rising from left to right at about 45 degrees. This will establish the centerline of the length of the Corridor. Do the same with a perpendicular line for the width. Use these guides to draw a large oval. This oval represents the tilted opening of the Corridor in perspective.

2 Alien-Made

The Corridor is a highly sophisticated piece of scientific equipment. It should have a variety of panels, plates, tubes and antenna worked into its design. Give the Corridor width by drawing a duplicate line above the top edge of your oval. Connect its endpoints to the edge of the oval. Draw shapes to represent the tech add-ons. These should be fairly geometrical to imply that they are man-made (or in this case alien-made).

3 Form and Function

Refine the parts of the Corridor. This is where you as an illustrator can add to the story by thinking carefully about the function of each part you are drawing. For example, a circular element can be a video relay so that the controller on the *Yarrow* can see what's happening on the other end. Other elements can act as power relays, force field emitters or data collectors.

With a light hand draw curved metal panels above the far edge of the oval as the inside of the Corridor tube.

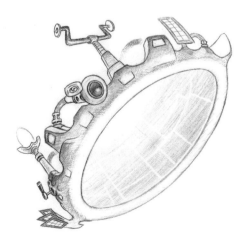

4 Light at the End of the Tunnel

Use the crosshatching technique (see page 19) to shade the Corridor. There is a strong light source above it from the force of it tearing through space, and there is a milder light source coming from within the tube itself. This means that the areas on the side of the Corridor receive the least amount of light, although they are not in strong shadow because of the natural light from one of the three suns of Doona.

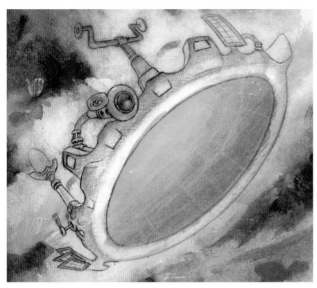

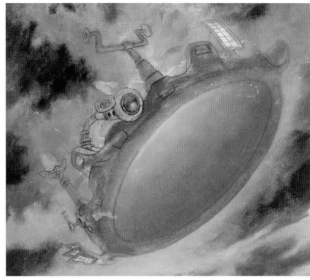

5 Toning Down the Intensity

Establish the colors with watercolor. Fill the inside of the Corridor with Light Green, creating the lighting effect of the energy radiating from within. Use a large flat to apply a series of gray washes to tone down the green. The gray should be strongest near the bottom edge of the oval so the light source fades in intensity.

6 The Color of Metal

Switching to oils, mix a cool gray with Lamp Black, Titanium White, French Ultramarine Blue and Cobalt Violet. Apply the gray loosely over the metal parts of the Corridor. Don't worry about applying the paint evenly. Metal reflects various light sources and shows shadows in a random way, so an uneven coverage will help you create variety in later steps.

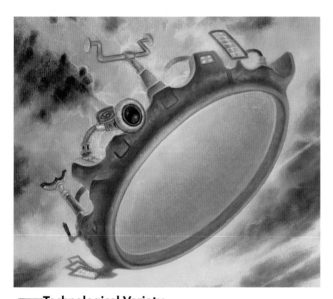

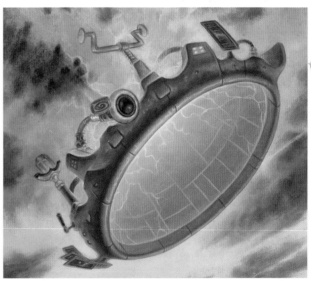

7 Technological Variety

Paint a dark gray around the lip of the Corridor opening. The inside of the lip reflects the green light from within the Corridor, and the outer surface reflects the blues from the sky.

Paint brass accent metals with Raw Sienna. Paint the hard white plastic items with a gray mix of Naples Yellow, Raw Sienna, Cobalt Blue and Light Red mixed with a touch of the surrounding colors. Add white highlights.

Glaze the power crystal on the lower left with Viridian Green. Extend the paint past the edge of the crystal so that it appears to glow.

8 The Spark of Energy

Paint Viridian Green on the edges of the power crystal with a fully loaded small round. Mix in some Titanium White to create highlights within the crystal. Bring up highlights throughout the piece with a mixture of Titanium White and Cerulean Blue.

Using a no. 0 liner, apply Cinnabar Green Light mixed with fine detail medium to create crackling energy within the Corridor. This will make the inside of the Corridor glow.

See the complete scene on page 59.

Continued from page 58.

"Noot!" I called out for him over and over, but there was no answer. I dashed behind the rock where I had set the necklace, thinking maybe it had fallen off and Noot wasn't answering out of spite because we didn't go to the hot spring. I found nothing. Could it be an ambush? I stayed hunched behind the rock. I felt helpless without Noot at my side. Noot had said that while he was in the necklace we'd be able to communicate, but what if he was far away? What if someone had traveled through time and taken him?

Thinking the worst was doing me no good. I settled my nerves and scanned the area. I noticed a peculiar set of animal footprints leading to and from the rock. They looked fresh, so I grabbed my gear and followed them into the forest.

After a short distance I came upon what must have been the creature's abandoned campsite. It was a mess, littered with garbage and bizarre little trinkets. The creature had fled in haste, and left a clear trail that I could follow. The path was enormous. Tree branches had been snapped as high as eight feet up, and the tall grass had been flattened wider than I could spread my arms. I became frantic, thinking that the small creature had a hulking companion, but I could see only the same small footprints that I had seen earlier. My stomach knotted. I had no choice but to follow the path.

I hadn't been following the trail for very long when the new dawn began to break and shafts of light pierced the forest. Sunlight wasn't necessary to follow this trail, though; besides the giant tunnel of broken plant life the creature had created, little gadgets and packages littered the ground. This could be a trap. I knew that, but I had no choice but to keep going. To turn back now meant failure, and I wasn't going to fail on my very first quest.

Soon I noticed the smells of food cooking. Then a distant buzz of voices filled my ears. I broke off from the trail and headed into the woods, keeping my head low. The forest thinned and gave way to a grassy slope that led down into a small valley. I hunched down and with a pair of telescopic glasses looked out over the valley. Colorful tents and stalls sprouted like wildflowers as vendors prepared to open for business. The sights and sounds reminded me of the streets of Chinatown, except this market was filled with outlandish creatures. I watched a three-armed being with a broad, flat, hairless head and a purplish complex-

ion artistically slicing up a green, spotted fruit. Around the corner, a massive, bulbous beast pulled a cart loaded with wood through the street.

Out of the corner of the glasses I saw something emerge from the woods, hefting an enormous balloonlike pack. Below the enormous burden I spied a small creature covered with reddish fur. It had a cheerful bounce to its step, despite the fact that the pack was at least three times its size. Gadgets and doodads were pouring out of the pack. Dangling from the creature's belt was a necklace with a fish-shaped pendant. I had found my thief.

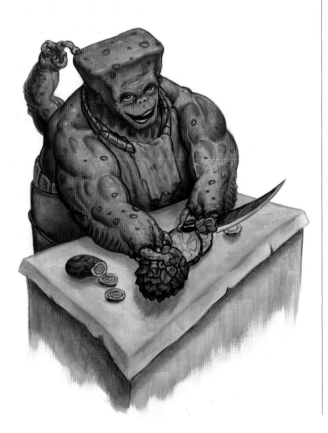

The creature approached two substantial sluglike brutes that appeared to be guards. They bowed and escorted the furry bandit through the thick crowd in the market, using brute force to speed their way to a ramshackle structure made of junk and debris. A great mob of otherworldly beings waited around the house, waving and shouting greetings. My prey moved through the crowd, shaking hands and chatting briefly before disappearing through a large door. It dawned on me then that the unsightly pile of parts was the creature's home.

I had to get Noot back.

I made my way down the path that led to the entrance, where the two slug guards waited. They smelled like a rotten cabbage I had once unloaded at my aunt's grocery store and looked at me menacingly through the bulbous eyes on top of their heads. They were covered in black, shiny armor and carried long pikes that crackled with energy. I was about to make a break for it when one of them asked, "What is your business here, human?"

Knowing that they had seen humans before calmed me down a little, and I was able to come up with a response. "I'm here to buy stuff," I said, then put an edge to my voice. "Why else would I be here?"

"What have you to barter, little girl?"

The only things I had of value were the tools that the Oru had given me, so I took out the light rod and showed it to the less smelly guard.

Their eyes widened with what looked to be terror, but their eyes were weird to begin with, so I couldn't be sure.

"Please forgive our rudeness, my lady. We were unaware that you were a representative of the Oru."

I went on the offensive. "My forgiveness doesn't come cheap, buddy. I'd be in a much more forgiving mood if you'd take me to see that furry guy with the giant backpack who just came strolling through here like he owned the place."

"He does own the place," said the smellier guard. The first guard jabbed him with a pike, and a jolt of electricity sparked from the end.

"Forgive his rudeness, my lady. We should have antici-pated that you would want an audience with the Supreme Huckinworth, Pigweed. I'm sure he will be delighted to have the opportunity to do business with a member of the Oru."

"I'm sure the Supreme Huckinchuck will be ecstatic to see me."

"That's Huckinworth, ma'am."

"Whatever."

The story continues on page 71.

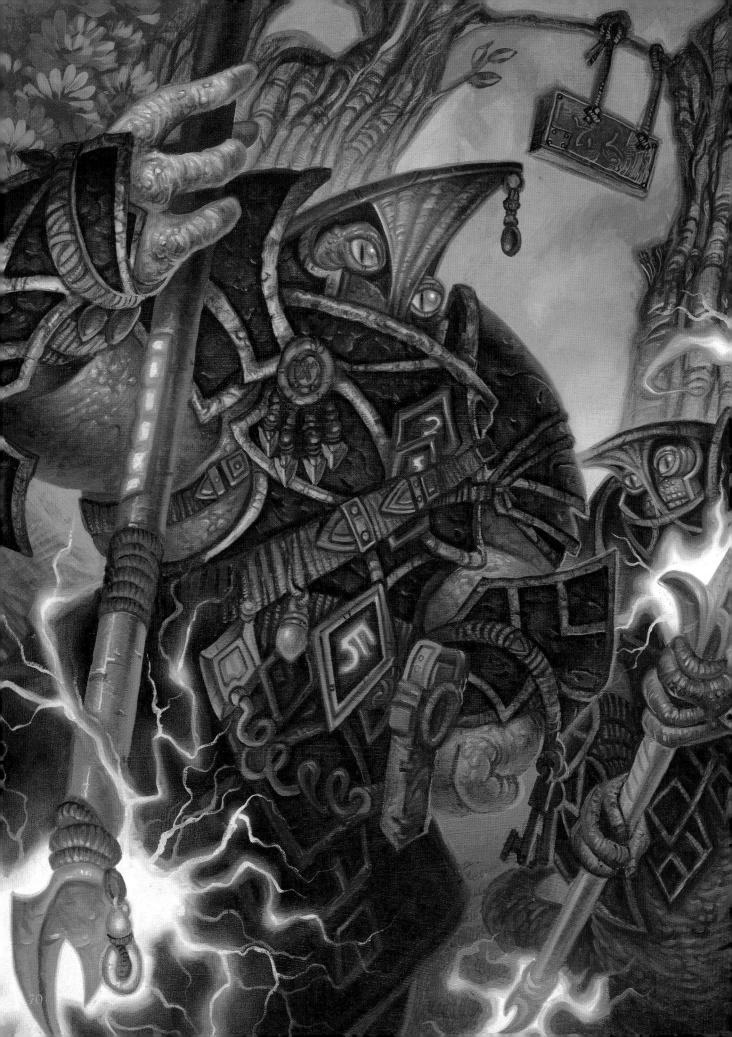

Continued from page 69.

The guards guided me through the throng to the front door of the massive ramshackle house and then announced, "Supreme Huckinworth Pigweed, a member of the Order of Oru wishes an audience with you."

A nervous high-pitched voice, barely audible over the crowd, responded from inside. "Tell her I'm busy."

How did he know I was a she? Because he saw me when he stole Noot, that's how. "Hey, jerk, you better let me in or else you'll, ah, hmm, feel my wrath. That's right, you heard me, full-blown Orun wrath." The crowd backed up a bit on hearing my threat, as weak as it was, and the door creaked open slightly.

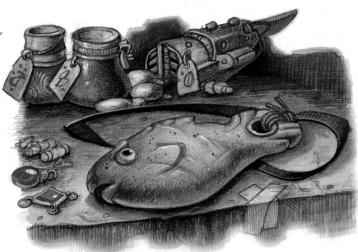

"Wrath, you say?"

"Yes, wrath, and lots of it." I glared at him and lowered my voice. "You better let me in there right now before I embarrass you in front of all your customers."

He stepped out of his house; he was wirier than he looked when carrying that huge pack. He motioned for me to lean down, and then he whispered, "I'll let you in, but you must do something to make me look good. I have a reputation to uphold around here."

"Oh, all right." I stood up straight and said in a loud voice, "Most honorable Huckinslaw Pigsnout, please allow me to enter into your glorious home so that we may conduct a business transaction, which I'm sure you will come out of on top."

He furrowed his brow. "Eh, good enough. Come in then." He waved away the guards and led me inside.

Once inside, I slammed the door and grabbed a fistful of red hair. "Give me back my necklace, furball."

I heard Noot's voice: "Hachi, please calm down and let my little friend go."

"Your little friend?" I released Pigweed and picked up Noot's necklace from a cluttered table. "He stole you from me. What would I have done if I couldn't find you? I could have been stranded here forever."

"Hachi, you need to know that I will always find my way back to you," Noot said. "We are linked, you and I, and will be so until the time of your passing from the physical plane. Did it not strike you as odd that even without me, you were able to understand the alien language of these people?"

Frustrated, I ignored his question. "Why didn't you answer me when I called out to you?"

He was silent for a moment. "I apologize for that, Hachi, but I needed to see how you would do on your own. Beings that I paired with in the past often became too reliant on my guidance and ultimately failed."

"You mean *died.*" My voice trembled.

"Yes," he said.

His voice became upbeat. "But you did magnificently on your own, and here we all are, you with your necklace back, and me with my new friend. Pigweed and I had a nice little conversation on the way here."

"Yes, Noot was telling me of your quest and that you were seeking out the Orun Master on our lovely planet. I can help you find him. Nobody knows his way around as well as I do."

"So, one minute you are stealing from me, and the next you're going to help me on my quest?"

"For the record, we frown on the word *stealing* here. It's more of an elaborate system of barter that we've developed over many generations." Pigweed flashed his salesman smile. "And, yes, I would be interested in helping you. Noot mentioned that the Oru would be quite pleased with me if I took you to our Master, and that perhaps a reward would be involved for such bravery and risk taking."

"Noot talks too much, but I suppose if you helped us out we could find something of value for you."

"Splendid. Once I conduct a little business outside, we can leave. It should take only about ten hours; the crowd's light today."

"We leave now," I said.

He flinched at my tone. "Of course. Let me get my pack."

"You mean you're going to lead us through the countryside lugging that thing along?"

"It's just my light pack. I don't go anywhere without it. One never knows when a fantastic business opportunity might present itself."

The story continues on page 86.

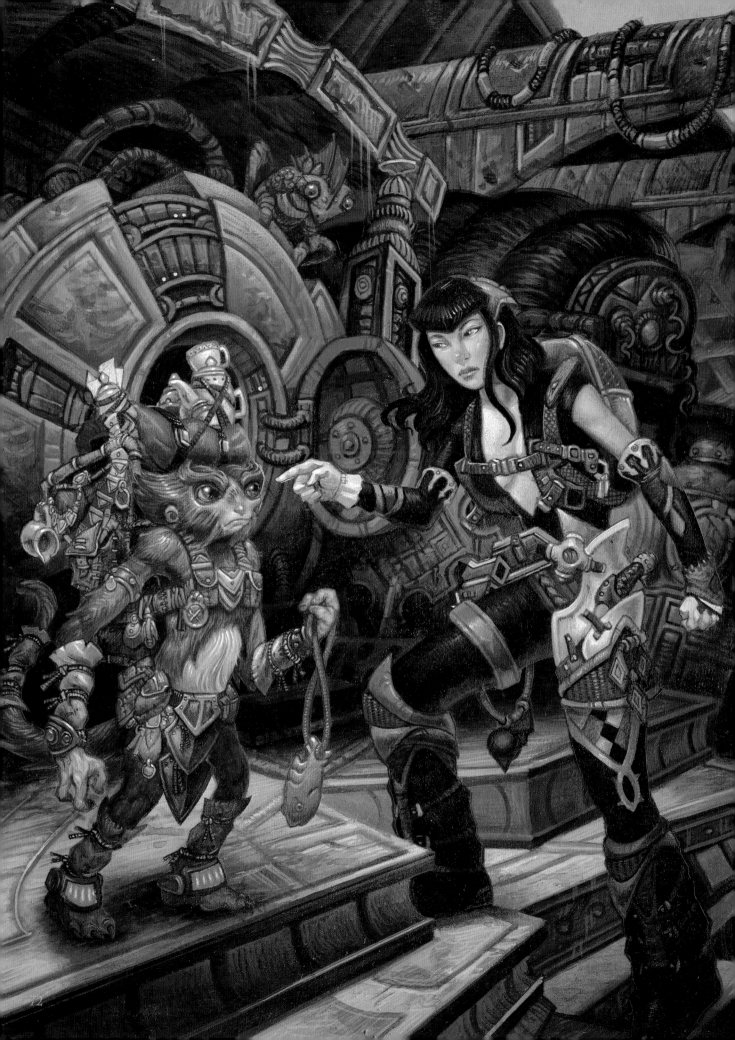

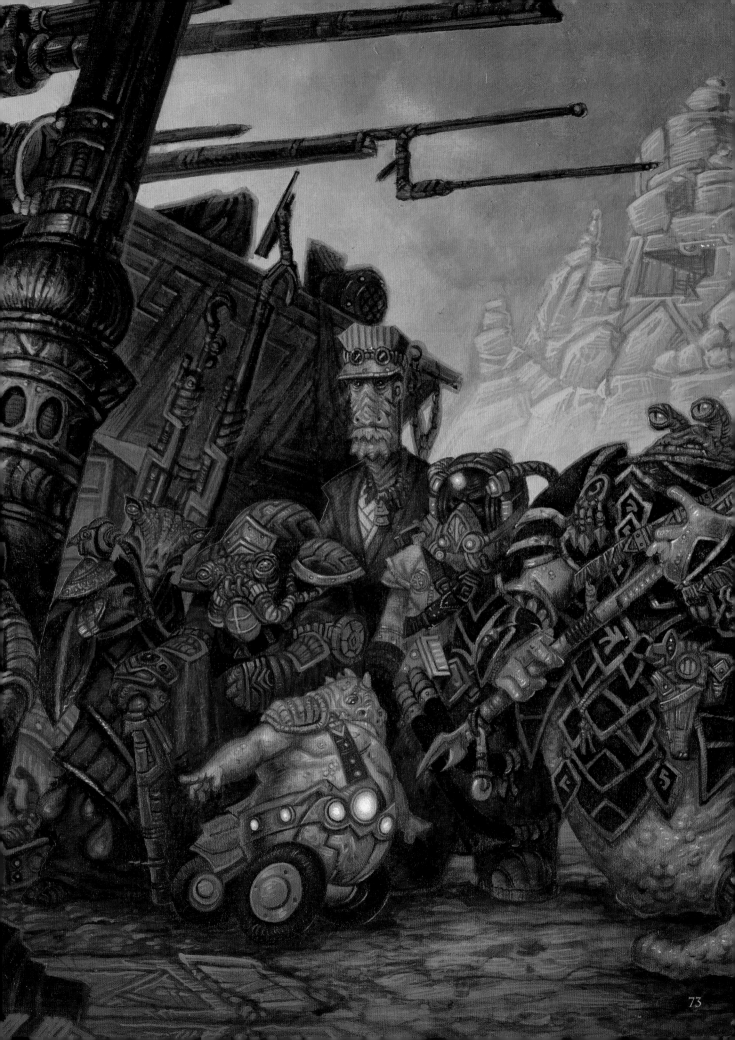

Pigweed's House

Now let's talk about the background and Pigweed's house and its role in conveying the story. Pigweed's house is described as a pile of space junk, so it's going to be a bit dingy and cluttered. He is the head trader of goods on Doona and very proud of his contributions. In this step let's construct Pigweed's house and its surroundings!

<div style="border:1px solid">

The "Five Dubs" of Illustrative Storytelling

Who? Hachi, Pigweed and trade patrons
What? Hachi confronts Pigweed
When? During one of Doona's sunrise/sunsets
Where? Pigweed's house
Why? To get her necklace back

</div>

Designing a Garbage Dump

The idea behind the design is that Pigweed scavenged wreckage from crashed spacecrafts and assembled them piecemeal to create his domicile. The story doesn't provide much description, so this is your chance to add extra flavor. Work up a thumbnail to get a sense of the structure. For inspiration, look at photos of garbage dumps and artwork made from garbage.

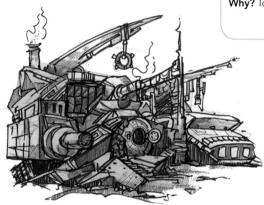

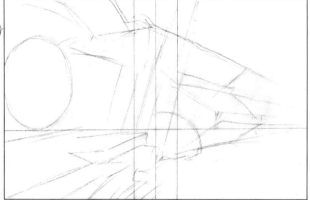

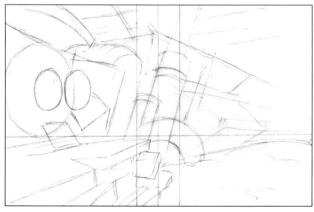

1 From the Ground Up

Use the sides of the paper and a T-square as a guide to draw the borders (11" × 17" [28cm × 43cm]) and the exact centerline. Use the T-square to draw two more lines, each 1 inch (25mm) out from the centerline, for the gutter. We don't want any of our main action in this area, as it will get lost in the folds of the book spine. Draw the horizon line about a third of the way up from the bottom, then draw the vanishing points, which fall off either side of the paper (see pages 20–21).

Block in the basic linework and shapes, following the thumbnail design. Work freehand for this step. Follow the lines back to the vanishing points. Pigweed's house is constructed from space junk, so it should feel a little haphazard, without perfect corners.

2 A Shapely Dump

Continue adding shapes in a random fashion. Draw small trapezoids next to the door opening and on the ground to help give the sense of clutter. On the large oval shape on the left, add two ovals of similar size for the portal and door. Following the thumbnail, draw several slanted horizontal lines on the top of the structure. These will be large communication antennas for Pigweed's intergalactic trade business. Add a curved awning above the portal door with two curved parallel lines. I like to work freehand for this step to achieve the feeling of a randomly put together structure. In the later steps use a ruler to tighten up the linework, but for now, have fun with it!

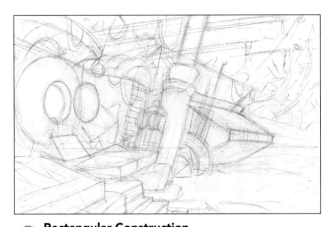

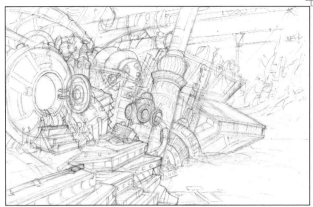

3 Rectangular Construction

Draw a curved line following the contours of the oval portal entrance of the door. Draw a trapezoid leading to the steps to the door. Use rectangles and squares for the rest of the structure, including the patio. With three suns, Doona gets pretty hot, so create a cooling unit by drawing a square, then draw half circles that go back in space. Draw hanging wires with clean, rounded lines. Rough in the large antennas with simple lines, then draw the hanging wires with clean, rounded lines. Rough in the far background with simple shapes and lines.

4 Clutter

Add wires hanging out of the portal door and computer gadgets lying around on the patio. Detail the large antenna in the center by drawing long ovals in succession. Draw the steps in front of the portal door with rectangular shapes, leading back to the vanishing point. Add random wires and tubes flowing into and out of the house. Draw small circles as rivets on the haphazardly constructed patio steps, and add edge lines. Detail the larger objects like the door with angular shapes, almost like steel plating. Make sections of the door open so that you can see the mechanics underneath, almost as if panels have been removed or lost. For fun, add a small native lizard creature hanging out on top of the door.

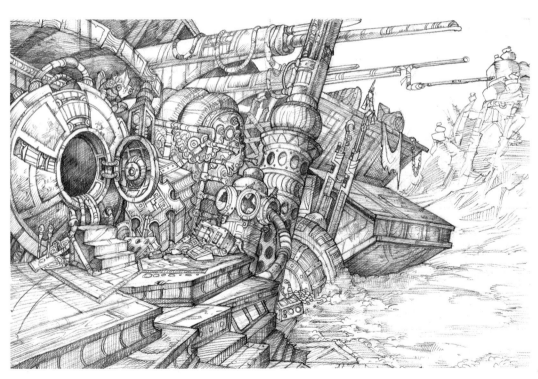

5 Open for Business!

Use crosshatching to establish the lighting. Add rivets and edge lines to the metal objects. Create a distressed look by crosshatching in a random pattern. Broken glass is also a great touch. Get some reference of rusty metal or weather-worn objects for inspiration. Finish the far background with the stony rock formations of Doona. Add a hovercraft port in the center for the use of out-of-town patrons. Don't worry too much about the details in the background. A little crosshatching will give the impression of form.

PAINTING

Think of Pigweed's house as a character in this scene. It's just as important as the main characters in telling the story. Your color choices will help set the mood for this tension-filled scene. Remember, at this point you will have already drawn the characters (see pages 78–79 and 82–83) along with the background drawing (see page 30 for more on this process).

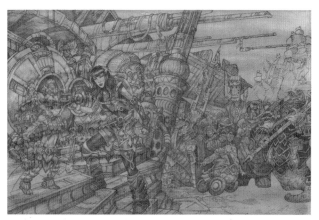

6 Umber Painting

Mount the drawing and prepare the painting surface (see Step 7 on page 48). Apply diluted Burnt Umber acrylic paint with a 2-inch (51mm) flat. This will cover all the white of the drawing and serves as an underpainting (see page 103).

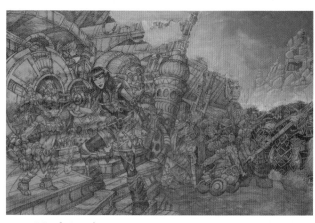

7 Mask Dealer

Mask the painting with frisket paper, breaking down the background into different sections. Remove frisket paper as you work. For this step, remove the paper from the far background. Continuing with acrylic paint, mix Yellow Ochre and English Yew Green and block in the sky with a no. 6 flat. Add Titanium White and more Yellow Ochre and less green as you go. Slowly mix Eggplant Purple into the upper corner. Use the same colors with more Yellow Ochre for the stony rock formation, blocking it in with a no. 2 round. Add more Titanium White with the tip of the same brush for the highlights. Block in the foreground dirt with Burnt Sienna and Yellow Ochre and a no. 5 flat.

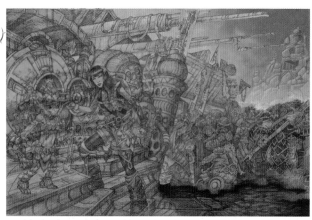

8 Far Beyond

Mix diluted Titanium White and glaze over the lower part of the far background with a no. 6 flat, adding more water as you work up. This will give you a nice separation between background and middle ground. Add a bit of Titanium White to every color mix in this section to diffuse the color. The low contrast will make these elements seem farther back. After the paint is dry, remove the frisket paper from the middle ground section of Pigweed's house. Continue to work in the dirt ground and shadows of the trade patrons with Burnt Umber, Mars Black, Titanium White and English Yew Green. Paint dirt in a horizontal fashion, keeping the shapes random.

My Background Color Palette

Here's the palette I used to paint this background. I like to use Delta Ceramcoat paints, but you can use any brand of good-quality acrylic paint. For backgrounds I like to stick with one side of the color wheel. This time I chose purple, blue and green. I used Yellow Ochre to warm up the colors and Mars Black and Titanium White for darker and lighter variations. Eventually I added Bright Red. If you keep the colors muted at the beginning, adding a bright color later, say for the characters, will make them pop!

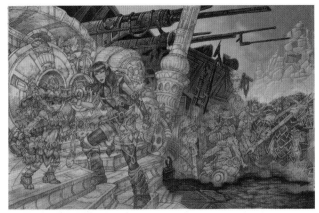

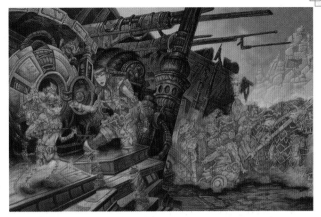

9 A House Is a Home

Start working the first section of Pigweed's house. Glaze in the entire area with diluted Mars Black and a no. 5 flat. Use a no. 3 round for the tighter areas. Working your way down, add a Bright Red glaze. Using a no. 4 round, block in the midtones with an opaque mix of Mars Black, Nightfall Blue and Titanium White. Add a bit of Eggplant Purple and English Yew Green to snap this section in place, keeping it in shadow. Add glazes of Mars Black if necessary. Using Bright Red, add highlights for the other elements that will be hit by eerie light. The closer the larger antenna is to the main action in the foreground, the lighter and more detailed it gets.

10 Section by Section

Remove the frisket paper from the foreground elements. Using the same color palette, continue with the same technique, blocking in the colors over the dark glaze. Push and pull the space, knocking back elements with a Mars Black glaze or bringing them forward with warm highlights. Direct the brightest part of the painting toward the focal point. Warm up the highlights with English Yew Green to bring the composition together from far background to foreground.

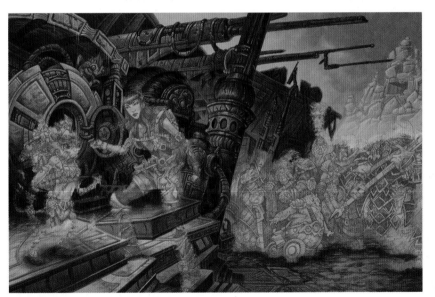

See the complete scene on pages 72–73.

11 Twinkle

Since the background is complete, switch to oils. (Once you paint with oils, you can't go back to acrylics.) Add small lights throughout the structure with a mix of Viridian Green and a touch of Titanium White and pure Cadmium Red. Add the green and red conservatively so that the house doesn't look like a Christmas tree! Push the back part of the house, the antennas and the center spire back with a glaze of Mars Black and a high percentage of medium. Warm up the sky with a glaze of Yellow Ochre and a high percentage of medium. Pigweed's house is open for business!

Pigweed

According to the text, Pigweed is covered in reddish brown hair from head to toe and carries a large pack on his back. I decided early on that his anatomy would be inspired by a combination of primates. His long arms and short legs will give him abilities like jumping and climbing that will aide Hachi in her quest.

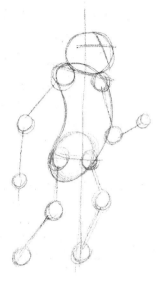 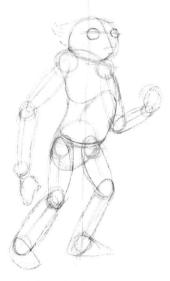 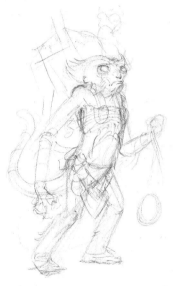

1 The Merchant's Line

Draw a cross, slanting the horizontal line slightly at an angle. This represents the shoulders. Draw a large bean shape for the body. Add two circles for the shoulders. The back foot lines up with the original vertical line. Draw a circle for the pelvis and smaller circles for the hip joints. Add small circles for the elbow, knee, wrist and ankle joints. Connect all these circles with lines for the limbs.

2 Adding Ovals

Draw long ovals for the upper arms, forearms, thighs and calves. Rough in the rib cage with a squished W-shape. The center of the torso is at the center of the W. Draw a cross on the face and two circles on either side for the eyes. Pigweed's eyes are large for better night vision.

3 A Smooth Transaction

Clean up the drawing. Smooth out the limbs and define the musculature by following the contours of the ovals. Draw a long worm shape for the tail. For the hair, draw feathered lines that follow the form on the head and body. Draw the tunic with stacked triangular shapes. Add small pouches on his hip. Loosely draw the basic shape of the loaded backpack. Use smaller circles for the pupils of the eyes. Draw an upside-down 7 for the nose. Add hairs on the top of his nose with little check marks. Draw a line that curves down on one side for the mouth.

Tips for Drawing the Characters in This Scene

- Make sure the eye lines of interacting characters meet.
- When drawing a group, use overlapping to stack the characters back in space.
- Use large shapes and work to smaller shapes.
- Use reference for inspiration.
- Use your favorite rendering techniques and have fun!

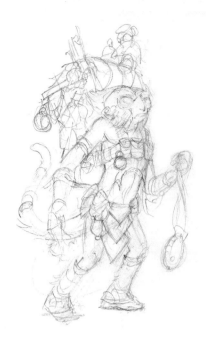 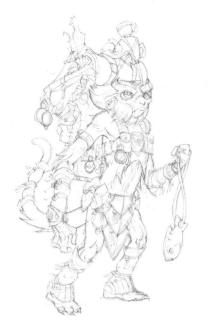 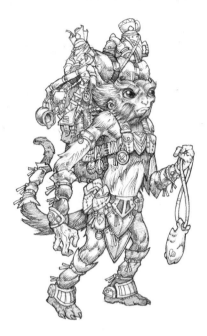

4 Wearable Gear

Draw the gear, following the contours of the body. The wrappings covering the forearms and calves are actually pouches to store small gadgets. Draw three rectangles for the small pouches on his chest that make up the strap for his pack. Draw a circle hanging down below one of the rectangles to break up the space. Add Hachi's necklace by drawing a tear shape and a triangle for the fish tail. Draw a small circle for Noot's eye.

Draw the gadgets on the pack. Start with loose shapes and define them as you go. On the top of the pack, create a rolled-up sleeping rug with a cylindrical shape. Draw the strings, following the contours of the rounded form. Rough in teacups and a teapot on top of the sleeping rug with stacked cylinders and ovals.

5 These Gadgets Aren't for Sale!

With clean, flowing lines, redefine the shapes of the gear and Pigweed's anatomy. Add edges and rims by following the contours of the shapes. Add bits of string hanging from the tunic and limb wrappings. Add bands around his wrists, arms and ankles.

Refine Pigweed's eyes. Draw a small circle for the pupil, then draw a second small circle for the glint. Draw check marks above his nose for a hint of hair. Draw lines out from the center of his face for the rest of his hair.

Finalize the pack. Draw oval shapes for the cups and teapot. Add a spout. Add pouches to hold more gadgets and buttons to fasten the flaps of the pouches.

6 Hands on the Merchandise

Use crosshatching to shade with clean, accurate lines. Draw hair in the shaded areas, such as the armpits and belly. This will establish a light source in the upper right.

Tighten up the edge lines and clearly define the shapes of the gear. Add small rivets and screws to the tunic to hold everything in place. Draw designs on the smaller items to give them an otherworldly feel. Decide what his pouches and pack are made of. I drew stitching to show they're made of a Doonunian creature's hide.

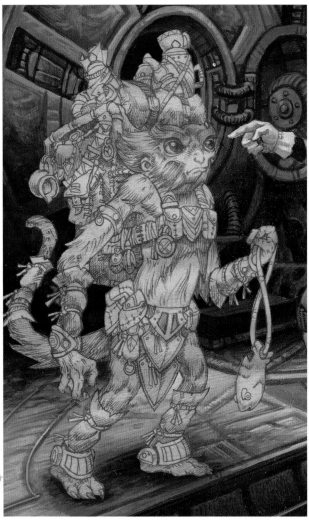

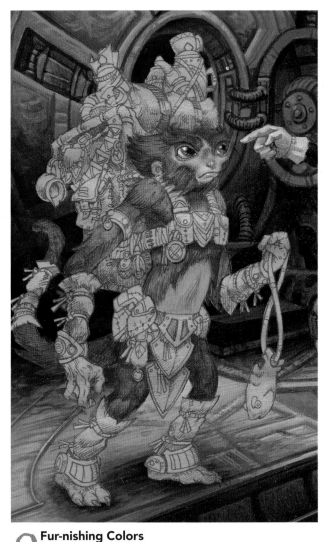

7 Uncover Underpainting

Remove the frisket paper from Pigweed. The Burnt Umber acrylic wash that you laid down before painting the background (see Step 6 on page 76) will serve as the underpainting.

8 Fur-nishing Colors

Switch to the oil palette to finish Pigweed. Using a no. 3 round, block in Pigweed's red hair with a transparent mix of Burnt Sienna, Indian Yellow and fine detail medium. Add darks to Pigweed's fur with Dioxazine Purple. Cover the areas thoroughly with the washes to avoid Burnt Umber wash showing through. Paint Pigweed's flesh tone with a no. 0 round and Yellow Ochre, Alizarin Crimson and Titanium White for lights and highlights. Add a little Cadmium Red Light to the flesh tone mix for his cheeks and nose. For Pigweed's bright eyes use Mars Black for the pupils, Cadmium Yellow Light and Viridian Green for the irises, and Burnt Umber and Titanium White for the eyeballs. Highlight the eye with Titanium White and a no. 00 round.

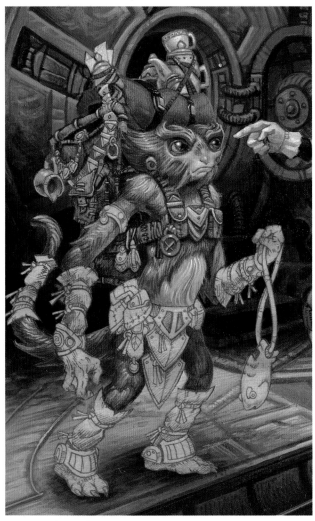

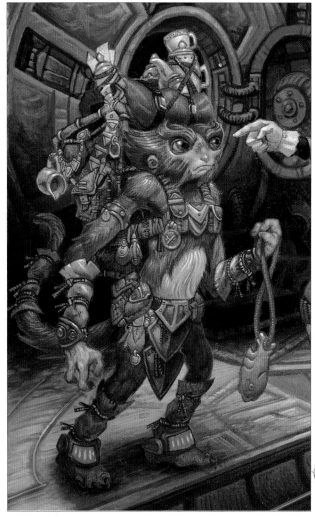

9 Back to the Pack

Add the highlights to the fur with a no. 0 round and a mix of Yellow Ochre, Burnt Sienna and Titanium White. Feather out Pigweed's individual hair strands on his head and shoulders and other parts of his body. Add a little more Titanium White to the mix for the tufts of hair on his tummy.

Add fine detail medium to all the mixtures you create for the pack. For the pack straps, mix Indian Yellow and Viridian Green. Glaze in the base color and add Titanium White for highlights. For the rolled-up sleeping rug, apply a mix of Cadmium Red and Dioxazine Purple. Block in the rest of the pack with a mix of Burnt Umber and Viridian Green. Continue to work in details with a no. 0 round.

10 Layers of Glaze

Mix Burnt Sienna with fine detail medium to create a glaze. Using a no. 2 round, apply this warm tone over the highlights and detail work in the fur. This will punch up the color, warm the highlights and knock the value back a step. Using a no. 0 round, add highlights to Pigweed's shoulder and head and anywhere light hits the fur. Finish the detail work with a no. 0 round.

Add a glowing green color to the gravity stabilizers around Pigweed's ankles with a mix of Titanium White, Viridian Green and a touch of Yellow Ochre. This glowing color is brighter and more chromatic than the rest of Pigweed's legs. Push and pull the space with glaze and highlights to make the stabilizers pop.

Finish the Noot necklace, using Cadmium Red, Cadmium Yellow Light and Magenta for the midtones and Cadmium Yellow Light and Titanium White for the highlights. Noot doesn't look too happy to have been stolen!

See the complete scene on pages 72–73.

Pigweed's Trade Patrons

On the planet Doona, alien creatures of all shapes and sizes come to trade unique goods. Pigweed has a steady stream of customers who are eager and willing to trade top gadgets for the hottest items found only at his shop.

As the Supreme Huckinworth, Pigweed keeps his customers happy by stocking his shelves to the brim. In this demo we'll draw Pigweed's trade patrons.

1 Who's Next in Line?

Draw six crosses in varying sizes. The horizontal lines mark the shoulders for these alien creatures. These lines will give you a sense of how tall or short the patrons are. Mix it up so that they're all different. Your grouping should have a dominant (large), subdominant (medium) and subordinate (small) design.

2 A Shapely Alien Group

Draw circles for the shoulders. Make all (or most) of the characters face the action of the scene, which is happening in the foreground. Draw their bodies at varying sizes with large ovals. Use rectangles, triangles and circles for their heads. Draw circles for the elbows and wrists, and connect them with lines for the arms. Think about the overlapping patrons. If necessary, draw through the characters to help better understand the overlap. Make a variety of thick and thin creatures.

3 I'm All Eyes!

Draw the smaller shapes that make up the faces and clothing. Sketch a small cross shape on each of the heads. Add circles for the eyes, varying the size for each alien. Draw in the basic shapes for their clothes and gear, using flowing lines that follow the form. Make a hat for the tallest patron with two mirroring trapezoids. Draw elongated ovals for the arms and forearms, and connect them to the circles for the wrists, elbows and shoulders. Make some larger than others. The more you mix and match shapes, the more interesting your group will become.

4 Trading In Your Used Shapes

Define the muscular structure by following the contours. Draw the slug guard's armor with a rounded triangle for the shoulder pads and trapezoids for the chest plates. Draw sausage shapes for his chubby fingers. Draw horizontal lines around his waist for a belt. This will also start to round his form. Give each character a different look. Add smaller design elements, such as tubing, clothing folds and shoulder armor. Add breathing tubes on two characters. They can't breathe the air on Doona, so they have their own air supply.

5 Searching for That Perfect Item?

Quickly rough in the gear placement. On the little chubby guy in the front, draw a shoulder pad with quick, round strokes that follow the contours of his shoulder. Draw the hubcaps on his wheels with ovals. Draw smaller circle and oval shapes for lights and button switches around his waist. Think about the kinds of straps, armor, jewelry and other gadgets these characters might be wearing.

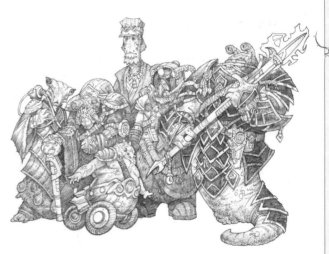

6 A Clearer Exchange

Add smaller details like skin texture or a fishy chin. Add small circles to their skin in a random fashion for a warty, bumpy texture. Give the second patron from the left wrinkled skin. Draw his walking cane with parallel lines running horizontally across the surface to give the impression of a rounded form. Draw small tubes that go into his nostrils and attach at the oval ventilation sack. Follow the contours of the sack and draw vertical rounded lines to give it form. Give this type of detail to each patron.

7 Ready to Make a Deal

Add rims and edges to the shapes that you want to be raised on the surfaces of the hubcaps, armor and gadgets. Draw wrapping and small studs on leather items, larger bolts on metal items, and patterns on clothing and armor. Start with the head (the most important part) and work your way down. Use crosshatching to establish the light source overhead. Keep four or five pencils sharp so that when one gets dull you can easily grab another. The trade patrons on Doona look ready to make a deal!

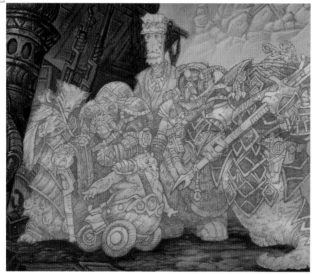

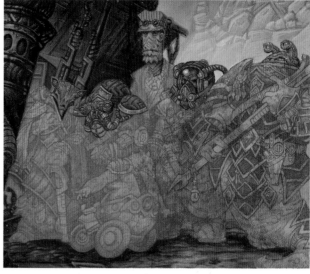

8 Curiosity Behind the Frisket

Remove the frisket paper carefully to reveal the drawing underneath. To get started, use the tip of a craft knife to shimmy underneath the edge of the frisket paper. Take care not to cut the sketch. The Burnt Umber acrylic wash from Step 6 on page 76 will serve as the underpainting.

9 Extra Wash of Color

Continuing with acrylics, knock these curiosity seekers back in space so they are more in line with the middle ground. Apply a wash of Bright Red and Noir Black over the Burnt Umber underpainting. Place the Bright Red closest to the red light source, and fade it to a wash of Noir Black farther away from the red light. This will place the characters in space and give you a head start on completing the characters. Bring all of the characters up to completion at the same time.

10 All Eyes Glazed Over

Switch to oils and start adding the clothing and armor. For the slug guard's armor use an opaque, muted green mix of Mars Black and Yellow Ochre. Use Yellow Ochre for the armor highlights. Block in the rest of the characters' clothing with a glaze. Build up the paint to an opaque state with either Mars Black, Burnt Umber or Dioxazine Purple. Use a no. 2 round to get into the cracks and crevices. The smaller the brush, the more accurate you will be with the edges. Use the Burnt Umber underpainting as a medium tone, letting it show through on the characters on the far left with more transparent paint. Continue to build up the glazes.

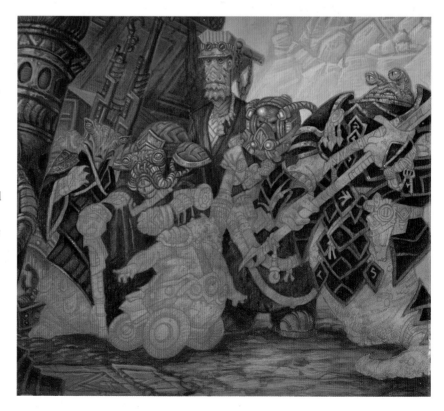

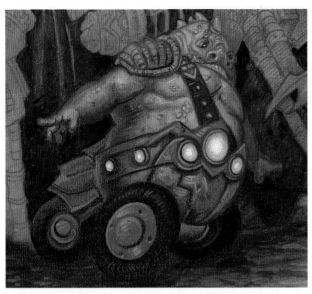

11 Bumper Belt Boogie

Block in the skin tone of the little guy up front with Yellow Ochre and Alizarin Crimson, adding Phthalo Blue for the shadows and Titanium White for the lights. Follow the contours of the drawing with a no. 2 round. Add smaller details such as bumps and warts with a no. 0 round and darker tone such as Burnt Umber and Dioxazine Purple. For the armor and trike, mix a warm steel color with Mars Black, Viridian Green, Indian Yellow and Titanium White. For the tires, use Mars Black and a touch of Titanium White for the highlights. For the bumper belt lights, use Cadmium Yellow Light, Cadmium Red and Titanium White. Add a touch of Cadmium Red to Cadmium Yellow Light to fade the light to orange. Blast the center of the light with opaque Titanium White. Continue with the other aliens, adding details with a no. 0 round.

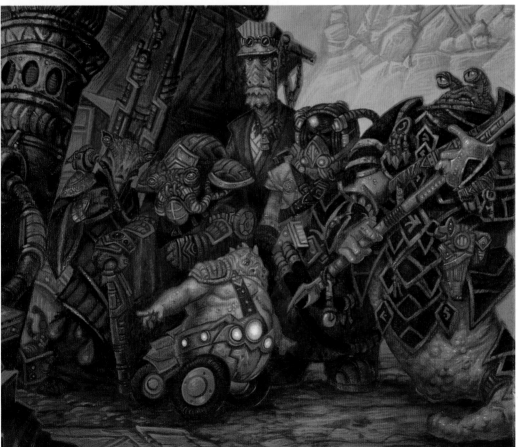

12 A Spike in Sales?

Finish the details such as the gadgets with a no. 0 round using muted tones. Use Mars Black to mute bright colors such as Dioxazine Purple and Viridian Green. Add Titanium White for highlights on edges and rounded forms. Finish the slug guard's slimy tail with mixtures of Yellow Ochre, Dioxazine Purple, Raw Umber and Titanium White. Knock back the heads of some of these guys in shadow, particularly the slug guard and the Doonanaut (with the helmet) with a glaze of Mars Black and fine detail medium. This will make the highlight on his helmet pop. Clearly these guys are looking for a show! I wonder if Pigweed's sales will spike after this confrontation?

See the complete scene on pages 72–73.

Continued from page 71.

It felt good to have Noot back around my neck. We walked for many miles, but Pigweed never seemed to tire, even with that huge sack of trinkets on his back. He pointed out many of the fascinating sights of his home world, and, all in all, made a pleasant traveling companion.

As the second sun began its descent toward the horizon, we came upon a large canyon. Pigweed pointed to a small cave opening in a large mass of rock on the other side. "The Orun Master lives in there," he said.

It was a treacherous climb to the bottom, and I was amazed at Pigweed's agility on the descent. We sat down to eat dinner once we reached the bottom. Pigweed had all the trimmings for a feast tucked away in his pack—meats and cheeses and some of that speckled green fruit. Noot told hilarious stories of his encounters on alien worlds, and we laughed so hard bits of food flew out of our mouths.

Our laughter was suddenly interrupted by a violent tearing of thunder that shook the ground.

"Is that a storm?" I asked.

"That's not a storm, but we need to find shelter. NOW!" Pigweed shouted.

He gathered up everything with lightning speed, and we ran toward a large outcropping of rock. The floor quaked again. "It's getting closer," I yelled.

"Just keep running for the rock," Pigweed screamed as he removed some items from his pack. Another explosive vibration ripped through the canyon and knocked me to the ground. I scrambled to my feet and ran harder than I imagined I could. A gigantic monster rumbled toward us on a host of legs like the masts of ships. The legs ended in ferocious-looking crablike claws, which it slammed into the ground and against the canyon walls to send its prey scurrying. Unfortunately for us, Pigweed and I were the prey.

The sun was nearly below the horizon, and the canyon walls cast shadows that blanketed our path. I took the light rod from my belt and lit it. I knew it would make me an easy target, but if I fell again I would get squashed for sure. I dodged left and turned my head to see the creature's position. All I could see were waves of motion, then suddenly bursts of light started to go off like fireworks near the beast's head. It teetered and rocked unsteadily. A blur of fur and burlap whipped past me, and Pigweed chuckled, "I'd think a member of the Oru would be smart enough to keep running when its enemy has been stunned."

As we approached the base of the rocky outcropping, a massive spike leg shattered the rock. We were exposed. I yelled out to Pigweed, "How are we going to get up to the cave before that monster crushes us?"

"Don't you Oru have powers?" Pigweed cried.

"I can talk to fish. Any suggestions?" I asked Noot.

"Be brave," he said.

I peered up at the cave opening, feeling hopeless. I thought of my father. I couldn't fail on my first quest. I turned and faced the oncoming monstrosity. If I was going to die, I would die fighting.

Arnica had told me that the light rod could do some serious damage if used as a weapon. I was planning my attack when a streak of blue light shot from the cave mouth and slammed into our foe. The impact smashed the creature up against the far canyon wall. The light pinned the monster there, and it quivered, trying to get away. Then the light acted like a catapult and flung the creature far into the night sky.

Pigweed was gasping for breath. "Wow. Nice trick."

I looked up at the cave. "I wish I could take credit for it."

The story continues on page 100.

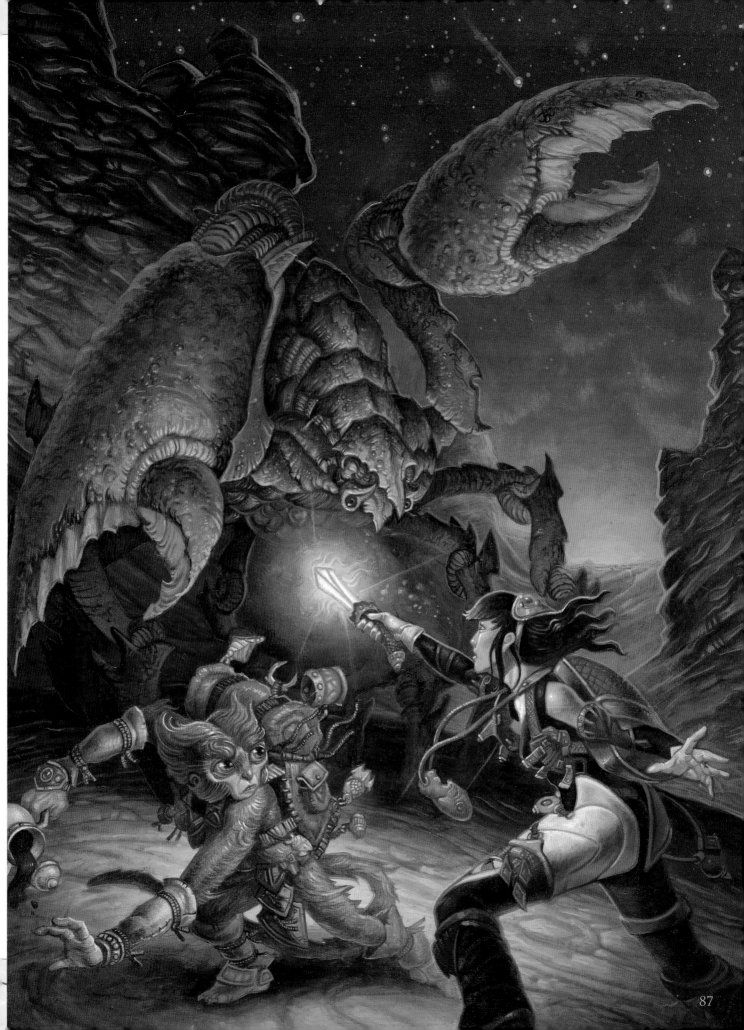

PAINTING

Painting an action scene is similar to painting other scenes, but keeping the viewer's eye focused is key to keeping the composition tight. Making elements in shadow or out of focus will help to determine the focal point for the viewer's eye. Remember, at this point you will have already drawn the characters (see pages 92–93 and 96–97) along with the background drawing (see page 30 for more on drawing all the elements at once).

Color Study
Try doing a color study before painting. It may change once you begin to paint, but it will give you a dry run with the colors you want to use. Print a smaller copy of the drawing and don't worry about perfection. Quickly block in the basic colors with colored pencils. The main action will be in a high-contrast yellow, and the rest will fade into oranges and purples.

6 Preparing for an Ambush
Mount the drawing and prepare the painting surface (see Step 7 on page 48). Apply diluted Burnt Umber acrylic over the entire surface with a 2-inch (51mm) flat.

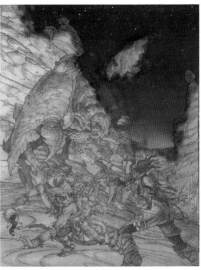

7 A Fading Sky
Mask the major elements with frisket paper, trimming out each element with a craft knife. Remove the frisket paper from the sky. Block in the sky with acrylic Purple, Liberty Blue, Titanium White and Noir Black. For the sunlight fade use Black Cherry, Cadmium Red Light and Cadmium Orange. Mix your colors to fade from a cool purple to a chromatic orange. Use a no. 8 flat to cover the surface with paint. Add the stars with a no. 2 round, using a mix of Liberty Blue and a little Titanium White and a separate application of pure Titanium White.

Watch and Learn!
You can watch Chris start the background of this painting in the enclosed DVD.

8 Blocky Rocks
Remove the frisket paper from the canyon rocks. Block in the rocks with Burnt Umber and a no. 5 flat. Work loosely to make cool rocky effects with the edge of your brush. Block in the foreground with Liberty Blue, Yellow Ochre, Purple and Titanium White, using a no. 5 flat.

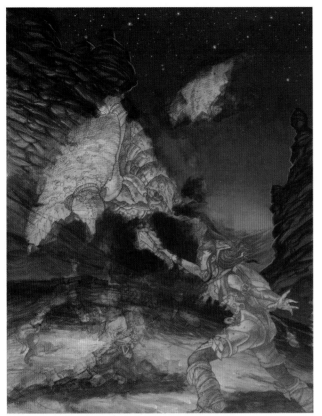

The Canyon Floor

10 Starting at the curved horizon line, glaze Noir Black over the higher ground of the canyon floor with a no. 4 flat. Dilute with more water so that it fades as it gets closer to the light. Mix a bright warm color with Titanium White, Burnt Sienna and Yellow Ochre, and paint the spotlit canyon floor with a no. 2 round. The more intense light is directly below the light rod. Mix a little Burnt Sienna and Yellow Ochre and add some orange colors in and around the lit ground. Continue adding highlights to the floor, adding more Yellow Ochre and Titanium White. Use a no. 2 round to hit the cracks and bumps with light, then add darks to the cracks. Add the shadows beneath Pigweed and Hachi.

Stony Surface Details

9 Add details to the rock formations, following the drawing as best you can. Mix a warm midtone with Burnt Sienna and a little Yellow Ochre. Working from the top of the rock formation, add warm highlights to the rocks farthest away from the light source. Add more Yellow Ochre as you work your way down with a no. 4 round. Switch to a no. 2 round to draw in the cracks and crevices of the rock formation with diluted Noir Black and Purple. Continue down to the canyon floor. Mix Liberty Blue, Purple and Titanium White and add the backlight from the night sky to the tops of the rocks with a no. 2 round.

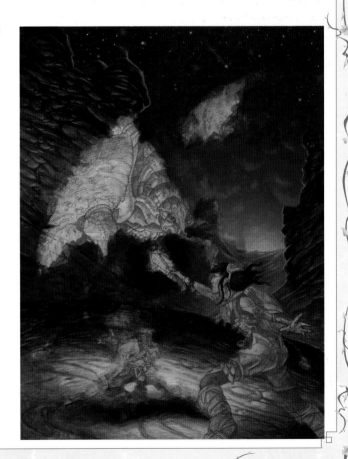

Oil and Water

11 Now switch to your oil palette. Add purple and orange rim lighting to the canyon walls. Mix the orange with Cadmium Yellow Light and Cadmium Red. Mix the purple with Alizarin Crimson, Phthalo Blue and a touch of Titanium White. Use the same mix for the light coming from the purple-colored sky. In this instance the rim light is coming down onto the rock rather than from the side. Using these mixtures, scumble in a subtle glow and wispy puffs of orange in the sky. It's the perfect setting for a surprise attack!

See the complete scene on page 87.

The Cragg Beast

Outside the comfort zone of Pigweed's merchant settlement, creatures lurk in every corner. Hachi and Pigweed stumble upon the cragg beast, a giant armor-encased creature that's looking for a meal. Pigweed and Hachi look like two juicy turkey legs, too irresistible to pass up. Let's draw the cragg beast rearing its giant claw to splat Hachi and Pigweed into jam!

Tips for Drawing an Action Scene

- Place the main action in the center of the page.
- Keep the background simple.
- Use energetic gestures.
- Keep the action tight and focused.
- Tilt the horizon line for a more dramatic feel.

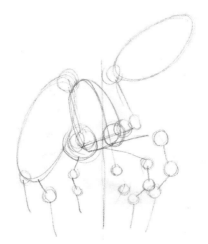

1 Crossing Paths
Draw a vertical cross shape; the horizontal line marks where the shoulders will be. Draw a curved line that intersects the cross. This will be the beast's hunchback and helps establish the location of the center of the head.

2 Connect the Cragg
Draw three large ovals, two for the giant claws and one a bit smaller for the hunchback. Follow the contours of the curved line to draw the hunchback. Draw circles of similar size for the shoulder and wrist joints. Draw smaller circles for the elbow joints and even smaller circles for the multiple knee joints. Draw a large circle for its belly. Connect all the joints with lines to form the legs and arms.

3 Basic Shape Bashing
Draw two triangles on top of each other for the basic shape of the head. Add rounded lines for the hunchback's armor plating. This will also help establish the round form of its body. Draw the claws on each arm with a swirling tear shape. Draw rectangles for the sections of the legs.

4 A Refined Beast

Lighten the drawing with a kneaded eraser. Follow the contours of the basic shape with a pencil, smoothing out the shapes and defining the anatomy. Add rounded armor plates to his hunchback, following the round back form. Use your eraser to pull out lights and keep your drawing clean.

5 Inspiring Crabs

Continue to redefine the anatomy and armor. For reference, look at pictures of giant coconut crabs and horseshoe crabs. Add spiky barbs to his hunchback armor and at the top of each of the leg plates. Add small circles inside the belly. Maybe these are glowing bioluminescent eggs. Uh-oh! Don't upset Momma Cragg or you'll be dinner!

6 Texture and Armor

Add more barbs and spikes all over the creature's body. Add growth ridges in a wavy pattern on each plate of armor. The beast frightens its prey by slamming its giant claws on the ground, so look at reference of hammers for inspiration. Add double prongs (like those of a hammer) on the lower leg joints and blunt elbows behind the giant grabbing claws. Add small circles and C-shapes to give the giant claws a bumpy surface. Draw the knee joints, following the circle contours from Step 2. Add texture with rounded horizontal lines.

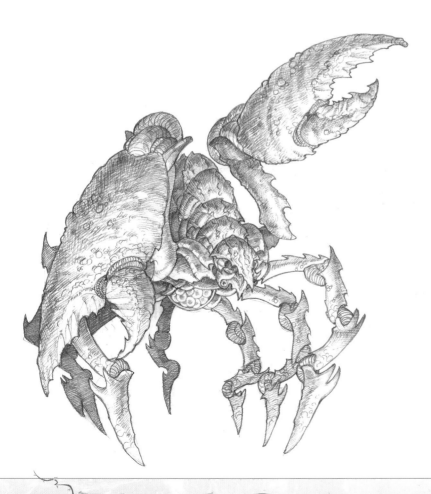

7 Light Source and Final Details

Keep your pencil sharp for this step. Define the light source in the lower right, and use crosshatching to render the monster. The darker shaded area is on the top of the armor and head. The far back legs are in shadow. Add clusters of small circles and C-shapes around the claws and legs. Continue adding horizontal rounded lines at the knee joints to create stringy muscle texture poking out of the armored leg casings. Do this on all the areas where muscles show through, such as the claw and elbow joints. Hachi and Pigweed better get out of the way because this beast is ready to splat them into putty!

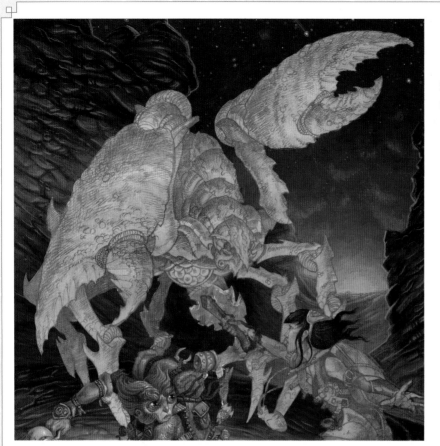

8 Discarded Shell
Remove the frisket paper from the cragg beast. The Burnt Umber wash from Step 6 on page 90 will serve as the underpainting.

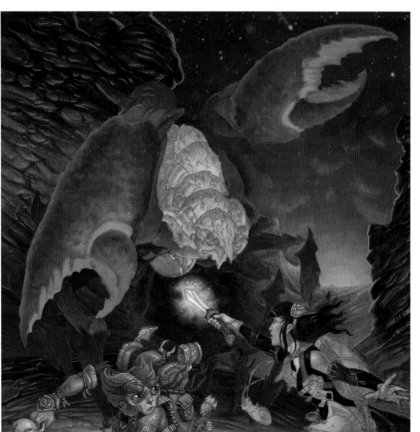

9 Large and in Charge
Switching to oil paints, use a no. 5 round to quickly block in the giant claws with Yellow Ochre, Indian Red, Phthalo Blue, Dioxazine Purple and a touch of Titanium White. These colors will help to situate the beast in the background. At this stage, cover the surface without worrying about the details. Block in Hachi's Orun light rod to establish the brightest element in the painting. Establishing the light source will help you push the beast into the background. Continue blocking in the legs with a no. 3 round, keeping the value dark so that the focus will be on the upper portion of the beast, which is being hit with light.

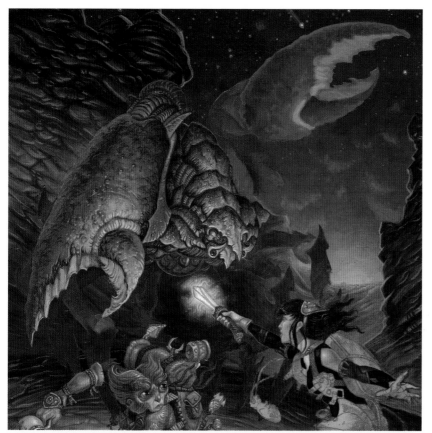

10 Headed for Disaster?

Using a no. 2 round, block in the beast's face with Venetian Red, Indian Red and Yellow Ochre. For the darks use Dioxazine Purple and Burnt Umber. Add highlights with Yellow Ochre and Titanium White. Continue working to the hunchback, refining the details. The head has the most highlights and brighter colors. These push the head forward in space and send the rest of the body back. The large front claw is also close to the light rod (the main light source). Working wet-into-dry with nos. 0 and 2 rounds, add darks with Mars Black, Dioxazine Purple and a touch of Viridian Green. Add highlights and details to the front of the claw with various mixes of Yellow Ochre, Indian Yellow and Titanium White. Make rounded strokes for the highlights. Tweak the purple backlight to push the claw forward.

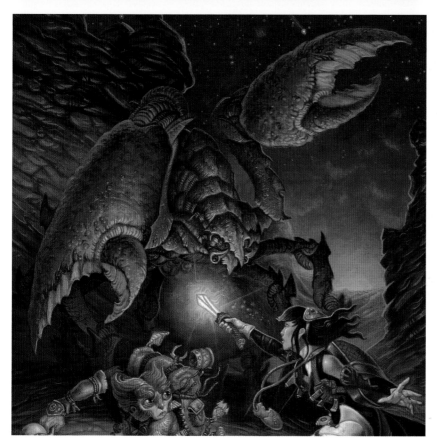

11 Crab Legs

Use the same colors from Step 10 to finish the beast. Use less contrast as the light fades upward to make the head pop forward. Add highlights and details to the legs with nos. 0 and 2 rounds. Add darks with a glaze of Mars Black, Dioxazine Purple and fine detail medium. Add orange backlight from the setting sun to help pop the legs from the dark background. Add lights and highlights to the legs closest to the Orun light rod's burning light. If necessary, let this layer of paint dry, then knock it back with a warm glaze of Burnt Umber to separate Hachi and Pigweed in the foreground from the beast in the middle ground.

See the complete scene on page 87.

Pigweed in Action

Pigweed can be pretty light on his feet. His anatomy can do things Hachi's just can't. Even with a heavy pack on his back, he can jump and climb with ease. He's more in tune with his senses and can react to a situation based on his instincts. This ability to read a situation quickly comes in handy when he's trying to trade a worthless stone for priceless gold. Let's draw Pigweed in an action pose!

1 Action Swoop
Draw a tilted and swooping cross for the centerline of Pigweed's body. The swooping line will follow his action gesture, and the horizontal line marks where his shoulders will rest.

2 Energetic Gesture
Draw a bean shape for Pigweed's body on the vertical swooping line. Add two circles on the horizontal line for the shoulders. Draw a stout tear shape that tapers to the back for the head. Draw circles for the hip, knee and elbow joints. Follow the lower part of the swooping line for that leg that's kicking out from under his body. Draw the back leg that's holding the body weight directly down from the head. Connect all the joints with lines.

3 Dodgy Ovals
Define Pigweed's musculature. Draw long oval shapes for the arm, forearm, thigh and calf muscles. Attach them at each joint, overlapping the joint circles. Draw a cross shape on the head to establish the center of the face. Draw two circles for the large eyes. Pigweed was getting his fifth helping of tea when the cragg beast interrupted their meal. Draw the teapot in his hand, using a circle with a smaller oval for the spout.

4 Smooth Escape
Redefine Pigweed's anatomy. Follow the contours to smooth out the established shapes. Look at yourself in the mirror for reference or use an anatomy book. Draw two circles inside the larger eye shapes. Pigweed's eyes are looking back to the main action. Draw in his pack by following the shoulder line so that it will look like it's resting on his back. Loosely draw rounded shapes for the sleeping rug and oval shapes for the trinkets flying off. Roughly draw Pigweed's tail as it swoops below his body. (See the Pigweed demonstration on pages 78–81 for more on drawing his gadgets and gear.)

5 Action Gizmos and Gadgets

Let's define Pigweed's gear. Use oval and triangle shapes for gadgets flinging around on his pack. Draw them at a diagonal rather than hanging down to give the impression of movement. Draw Pigweed's tunic with three overlapping triangle shapes that get larger as they move down over each other. Rough in his furry face with quick, large and small C-shapes that move in the opposite direction his body is jumping. In the eyes, draw larger circles for the irises and smaller circles for the pupils. Rough in his arm and leg wrapping (see pages 78–81).

6 A Clean Getaway!

Clearly define the gizmos with smaller circles, ovals and triangles. Add small buttons on his pouches and a bit of string to hold his objects and gear to his body. Redraw and define his hair and face with smooth lines. To add stitches to his pouches, draw a line down the side of each pouch with small horizontal lines over the vertical line. Add edge lines to the tunic to give it more form by following the contours of the shape, creating a double line.

7 Detailed Action

Establish the light source and begin rendering with crosshatching. The light source hits Pigweed harshly on his left side. Objects become darker the farther they are from the light source, so Pigweed's right side is in shadow. Sharpen your pencil and dive into detailing Pigweed's gear. Add small stitching on his pack and braiding to the ties to hold his gear down. Create glints from Hachi's light rod on his eyes. Draw two circles, one larger than the other, on opposite sides of his giant pupils. Looks like he got out of the way of the cragg beast just in time!

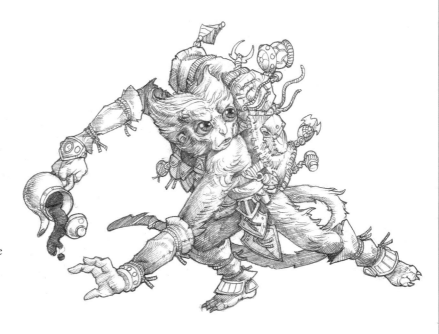

PAINTING

Pigweed has been in this kind of situation before. Just like getting out of a tight situation or making a clever trade, practice makes perfect. The more you paint, the more your instincts will take over and the easier painting will become. So put down your pencil and let's paint Pigweed.

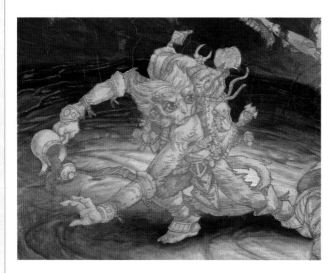

8 Seen and Not Seen
Remove the frisket paper from Pigweed. The Burnt Umber acrylic wash that you applied before beginning the background (see Step 6 on page 90) will also serve as the underpainting for Pigweed. The frisket paper preserved the nice, clean edges.

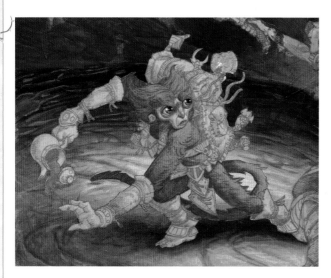

9 Furry Block and Skin Tone
Switching to your oil palette, block in Pigweed's reddish brown fur with a mix of Burnt Sienna and Dioxazine Purple. Using a no. 3 round, dip the brush tip in fine detail medium and block in the dark areas. Block in the lighter areas with a mix of Burnt Sienna, Permanent Orange and a bit of fine detail medium.

Using a no. 2 round, block in the flesh tone with a mix of Yellow Ochre, Alizarin Crimson and Titanium White. Switch to a no. 0 round, to blend the colors at the edges. Change the ratios to create mixtures that are more yellow, red or white. Continue using the no. 0 round and mix a shadow color with Burnt Umber, Dioxazine Purple and Cadmium Red. Apply this mixture to the eyelids. Use a mix of Titanium White and Burnt Umber for the milky white eyeballs and a mix of Yellow Ochre, Viridian Green and Titanium White for the irises. Block in the pupils with Mars Black. Add the highlights with Titanium White and a no. 00 round.

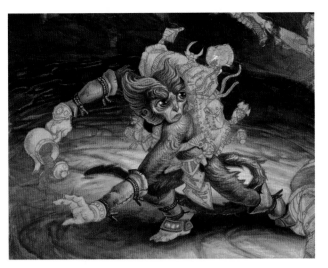

10 Out of the Way!

Use a no. 0 round to work in some of the fur details. Mix Titanium White, Yellow Ochre and Burnt Sienna to create warm, light tan. Add highlights on Pigweed's left shoulder, arm, hip and leg. Following the drawing, add highlights to the head. Use Titanium White and Dioxazine Purple for the backlight on the legs and tail. Paint around the tail with a no. 2 round and Burnt Sienna to create a blurry sense of motion. Push the hard edges on parts that are moving forward, such as his left arm. Paint the arm and leg wraps with Titanium White, Burnt Umber, Raw Umber, and touches of Yellow Ochre and Dioxazine Purple. Add a bit of dirt to the wraps with Burnt Umber. Finish the ties with Burnt Umber.

Add the glowing gravity stabilizers to the ankles. Use a no. 0 round and mix a cool midtone with Titanium White and Viridian Green for the squares. Mix a lighter green and create four small glowing lights in the middle of the squares. Blend the edges for a glowing effect.

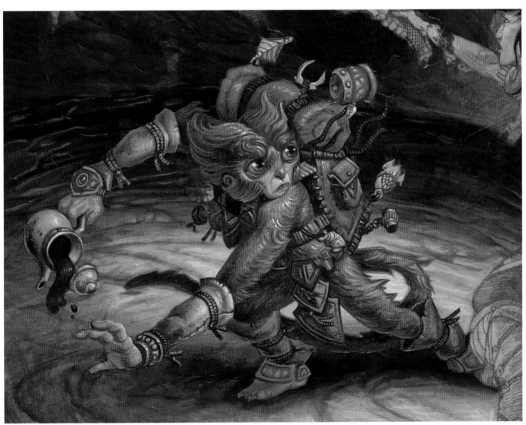

11 Right Out of the Pot!

Use a no. 2 round to finish the fur with a warm red glaze of Burnt Sienna and fine detail medium. Add highlights to the shoulder and head with a no. 0 round and a mix of Cadmium Yellow Light, Titanium White and a touch of Burnt Sienna. Finish the sleeping rug with Cadmium Red and Magenta for the darks. Mix in a bit of Cadmium Yellow Light for the highlights. Use Indian Yellow glazes for the trinkets, then add highlights with a no. 00 round and Titanium White. Let the details of the drawing show through. Finish the teapot with Cerulean Blue, Raw Umber and Titanium White. Hit the teapot with a warm light of Titanium White and Yellow Ochre. Paint the spilling tea with a no. 0 round and Mars Black and Burnt Sienna. Looks like the cragg beast scared the tea right out of the pot! Yikes!

See the complete scene on page 87.

Continued from page 86.

We were so full of nervous energy from the battle that we made it up to the cave entrance in no time. As we neared the cave, I marveled at the ruins surrounding us. Pigweed told me a massive Orun temple had once stood here.

"The caves were abandoned ages ago," Pigweed added. "No one lives there now—except one."

"What happened?"

"Lord Aru-Sen," Noot said.

"But this happened so long ago. How could that be?" I asked.

"That explanation will have to wait," Noot responded coolly. "Let's go inside."

We entered beneath pillars worn with age that looked like huge fangs biting into the hardened ground. Noot began to glow softly. The amber light he was giving off revealed a tall, cloaked figure before us, hovering inches off the ground. The Orun Master! Beside him, what looked to be a pile of moss-covered rocks gave a low growl. I guessed it was his pet.

I bowed deeply. "I am Hachi of the Oru. I come seeking the gift of your great skills, Master." He motioned for us to follow him. He did not walk, but floated down a long corridor covered with beautiful artwork and arcane symbols. His pet waddled behind us. It was uncomfortably quiet. "Thank you for saving us from that monster." There was no answer.

Noot's voice was quiet in my ear. "Master Vetch does not speak."

The corridor fed into a large living chamber. Iridescent light filled the room, born from devices of Orun design. Master Vetch led me to a soft, cushioned chair and prepared his tattooing materials.

I waited anxiously for the procedure to begin. A faint humming sound came from beneath Master Vetch's hood. His cloak swayed back and forth in a ghostly dance. Unexpectedly, the cloak swirled up and over his head and fell gently to the ground. I expected to see a tall, thin man before me, but instead saw a small boy floating in the lotus position. Light emanating from the white shimmering tattoos bathed his features. He stared at me intently and began to work. When he was done, he held up a mirror for me to see what he had created. I let out an embarrassing yelp of excitement as I saw my second tattoo. On my left shoulder blade there was now a delicate feather of the subtlest color.

We gave Master Vetch our thanks and headed out of the canyon.

Pigweed anxiously prodded me. "What do you think the Oru will give me for such selfless service?"

"Brome, although not known for being the most gracious individual, will make sure you receive a reward worthy of your contributions," Noot said. "Something of the finest Orun design or maybe treasure gathered from the farthest reaches of the universe." Pigweed's eyes grew huge as he imagined the possibilities.

"*Or*," Noot continued slyly, "you could accompany us on our journeys, help Hachi gather the power she needs, and expand your customer base." Pigweed's greedy eyes twitched. "You could barter for treasures from different galaxies, and even different times. You could become the greatest Supreme Huckinworth this planet has ever known. But you're probably not up for all of that adventure and risk."

Offended, Pigweed replied, "Are you implying that I lack initiative? My trading empire covers more than half of this planet."

"Yes, I am aware of that. But what if it could cover much, much more?" Noot teased.

"And you wouldn't want any portion of my business proceeds were I to accept your proposal?"

"Of course not. I wouldn't dream of insulting you in such a manner. Although, if you did come across any Maglian rock pies that you could acquire for me, I would be forever in your debt."

"Agreed." Pigweed turned and shook my hand.

"Excellent," Noot replied. "Pigweed will be joining us, Hachi. Isn't that marvelous?"

I shook off Pigweed's hand. "It's glorious," I said, but my sarcasm didn't translate because Pigweed's face split from ear to fuzzy ear in a smile that even I couldn't resist.

The story continues on page 112.

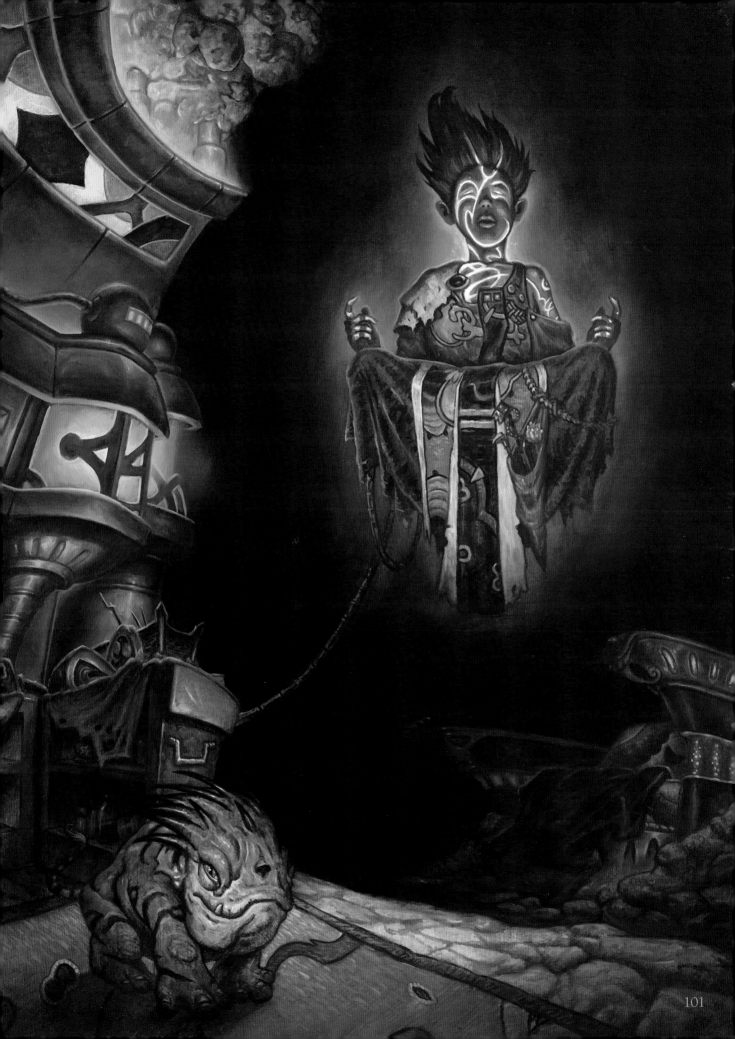

Vetch's Cave

Even though Vetch's living space is enclosed within a cave, it is still a complicated area filled with furniture, cabinets, lights, support structures and his tattooing equipment. It is a good idea to make a few small thumbnails of the layout so that things make sense spatially in your composition. You can even go as far as to make a rough floor plan such as architects use.

Thumbnail

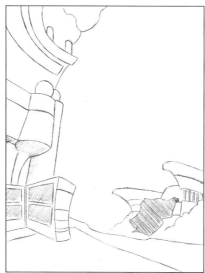

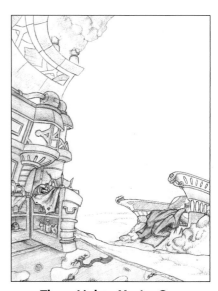

1 Grouping Objects

Using your thumbnail as a reference, draw the large elements and groupings of objects. If you envisioned several small individual items close together in your thumbnail, it is best to treat them as a group at this early stage. Once everything is rendered and painted, the viewer's eye will see them as a group at first glance. By treating them so from the start you can make sure they are arranged in a way that is pleasing to the eye.

2 Nature and Technology

Now you can start breaking up the groups into their individual elements. We know that Vetch lives in a cave, which means there will be plenty of organic, curving lines to describe the rocky cave floor and walls. But Vetch is a member of the Oru, a very technically advanced society, so there needs to be an equal amount of straight edges and carefully crafted curved edges.

Continually think back to the story. Immediately before the scene you are drawing, the long dark robe that covers Vetch's true identity swirls off of him and floats to the ground. A dark mass of wrinkled cloth on the chair to the right will give a visual cue to the viewers, which will bring them into your picture more.

3 Three Lights, You're Out

It's a good idea to use no more than three strong light sources. Vetch's tattoos will be one major light source. Create two more in the cave. The curved rectangular shape in the upper left will work well as one light source, and the circular columns beneath could act as high-tech lanterns. Since the columns are so close together, they will read as one light source.

Use the same design principles as Vetch's clothes (see pages 106–109) on all of his possessions. The fabric on the chair and the rug in the foreground should have the same kind of patterning as his robe. Architectural and furniture designs should look futuristic, but include some flowery ornamentation as in other Orun designs.

PAINTING

This time let's work on all parts of the painting at the same time, instead of completely finishing the background, and then moving on to the foreground objects. One approach isn't necessarily better than the other. Try them both to find which one works best for you. Remember, at this point you will have already drawn the characters (see pages 106–107 and 110) along with the background drawing (see page 30 for more on this process).

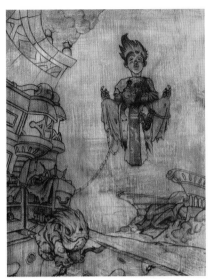

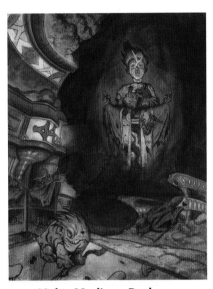

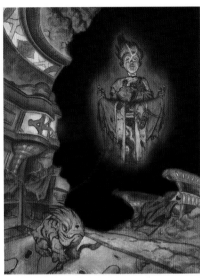

4 The Base Coat

Prepare your drawing for the painting stage. Squeeze out a large quantity of Burnt Umber and Raw Sienna acrylic paint onto your palette. With a 1-inch (25mm) flat, mix equal parts of the two colors to make a medium brown. Wet a 2½-inch (64mm) flat and load it with the brown mixture. Paint the color evenly over the entire drawing. Use plenty of water so that the paint is transparent and you can still see the drawing underneath. (See page 48 for more about underpainting.) Let it dry.

5 Light, Medium, Dark

Add Naples Yellow to your palette and begin to work out the tonal structure of your painting. Naples Yellow will be the lightest value and Burnt Umber will be the darkest. Use a large flat to fill in the background with Burnt Umber. Thin the paint with water as you get closer to Vetch. This will let the ground color show through and make Vetch look like he's giving off a faint glow. Use Naples Yellow to set up the light sources on the left side of the painting. Mix Naples Yellow with Raw Sienna to paint midtones throughout. Add washes of Burnt Umber to build up shadows in the foreground.

6 The Darkness

On to the oil paint (see page 35 for more about combining acrylics and oils). Using a no. 12 flat, fill in the background with Lamp Black. Apply the black thickly around the edges, thinning it out with medium as it gets closer to Vetch. This is similar to what you did with the acrylics and will allow the warm brown of the underpainting to show through, adding to the glowing effect.

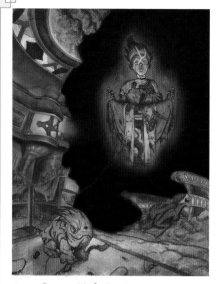
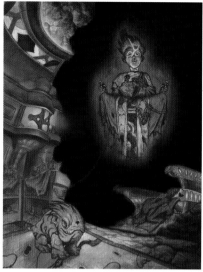
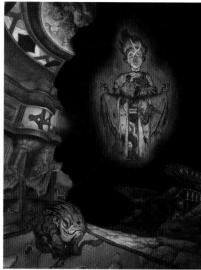

7 Stage Lighting

Work color glazes into the light sources. Mix Phthalo Turquoise and Viridian to create an intense blue-green for the lanterns near Vetch's knee. Use Indian Yellow for the stained glass inset above.

Scrub in Warm Gray on the metal structures on the left of the painting with a coarse flat. Mix in some of the blue-green in the areas near the lanterns and Cadmium Yellow near the stained glass to account for the effect the lights have on the metal.

8 Moss Grows in Caves?

Scrub Sap Green in random shapes on the rocky areas at the top left and bottom right. The rocks on the upper left are receiving a lot of pale light from the mechanical structure beneath them, so the moss there should have a midtone of Permanent Green Light and a highlight of Cinnabar Green Light. The rocks on the lower right are receiving much less light, so their highlight color should be darker than the halftone color of the lit rocks. A mixture of Permanent Green Light and Sap Green should work well as their highlight.

9 Cloak and Chair

The chair is the farthest object from the main light sources, so it will be on the dark end of the tonal scale. To achieve this, mix Burnt Umber into your colors for warmer dark values and French Ultramarine Blue for cooler dark values. For the body of the chair, add a mixture of Alizarin Crimson and French Ultramarine Blue. These transparent colors will allow some of the warm browns beneath to come through, giving a nice variety of color temperatures to the chair. Use Phthalo Green to paint the glowing rods within the chair.

Paint Lamp Black directly from the tube onto Vetch's discarded robe, which is draped over the chair. Build it up in thin layers so that the underpainting will show through in some of the folds of the cloth.

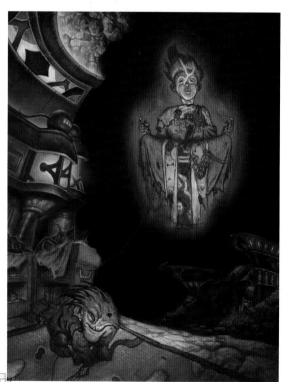

10 Tighten Up

Tighten up the edges around the stained glass with thin lines of Yellow Ochre. Do the same around the lanterns with a mixture of Cobalt Turquoise and Titanium White. The light from the lanterns reaches the cabinet in the foreground, so paint an edge of Cobalt Turquoise along the tops of the items there. Scrub some Alizarin Crimson onto the outside of the cabinet.

Create short, thin brushstrokes with a no. 2 round to add both color and a weave texture to the carpet in the foreground. Go back and forth between Naples Yellow, Raw Sienna, Cadmium Orange and Cerulean Blue, letting the colors blend on the canvas. Let the strokes fade out as they get farther away from Vetch's pet.

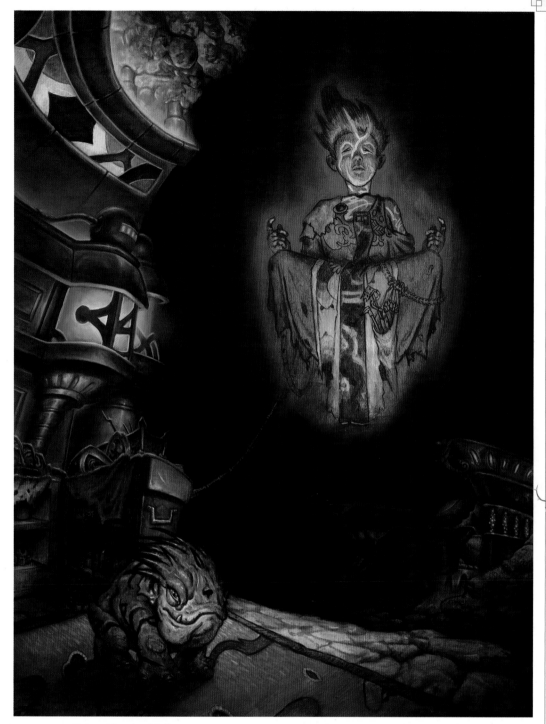

11 Bring Up the Lights

You'll often hear artists say, "Bring up the lights and darken the darks." This means that a portion of a painting is nearly done, with all of the midtones and textures established, and all that's left is to touch up the final highlights and intensify the areas that need to be the darkest with a final glaze.

That can be done here by bringing up the highlights on the red metal with Cadmium Red, and intensifying the shadows cast by Vetch's pet and the cabinet with a mixture of French Ultramarine Blue and Raw Umber.

See the complete scene on page 101.

Vetch

At first Vetch presents himself as a tall, mysterious, robed figure, but we learn that beneath the robe he has the appearance of a young boy. When Hachi first sees Vetch as he really is, he is floating about four feet off the ground in the lotus position, a cross-legged meditation position found in many Eastern cultures.

1 Floating Lotus

Normally, to start drawing someone in the lotus position you would draw a triangle to describe his shape, but Vetch will be wearing a long, draping garment that hangs down in the front, so begin by drawing a diamond shape instead. You want Vetch to fit symmetrically within the diamond shape to give him a feeling of harmony and tranquility. Draw a vertical and a horizontal line through the tips of the diamond to help keep Vetch centered.

2 From Bottom to Top

Move into the clothing earlier on Vetch since its shape defines the majority of the figure. His entire lower body can be described by drawing a large piece of cloth with a slight downward curve at the top where it would fall over his crossed legs. With five curved lines you can lay out his torso and upper arms. Because the viewer is looking up at Vetch at such a steep angle, his forearms will not be visible, but you can draw two small ovals to show his hands resting gently on his knees.

Use the vertical line through the diamond as the centerline for Vetch's head, and arch his eye line upward to compensate for the viewer's point of view. Finally, draw a big hair shape that sweeps upward. This will show that Vetch is emitting a powerful energy.

3 Older Than He Looks

Begin to develop Vetch's character through his clothing and facial characteristics. Vetch is a very solitary figure and has lived in his cave for a long time. The bottom of his robe should be ragged, but he is still a member of the Oru, so his clothing design should be similar to the designs you created for the other members of the Oru.

Since Vetch looks like a young boy, drawing his facial features requires special attention. A young person's nose and mouth are smaller and closer together than an adult's, yet the eyes and ears seem large in comparison. Vetch's eyes should be open very narrowly to emphasize his state of tranquility.

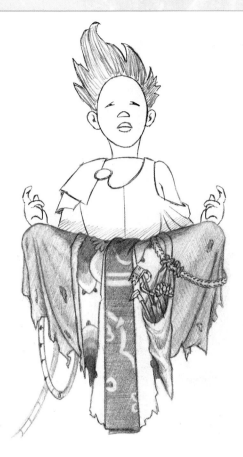

4 Orun Garb

Use crosshatching to define the tones of the various materials covering Vetch's lower body. Add some holes to the cloth to give it age. Look at Japanese screen-printed cloth to give you some inspiration for Vetch's garments. Add some elements of storytelling, such as tattooing needles in the triangular shaped pouch hanging from his leg and thin tubing coming from behind him that can be hooked up to his tattooing equipment.

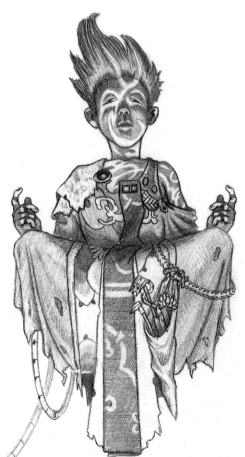

5 Magical Ink

Apply similar clothing designs to the garments covering his torso. Add some pieces of white cloth to cover his right shoulder. He would use these to wipe off excess ink while he is working.

The final step is drawing in Vetch's tattoos. They should sweep and swirl around his body. Since Vetch's skin is dark and his tattoos are light, use your pencil to shade in the areas around the tattoos. Darken the areas on the tops of his nose, cheeks and forehead the most so he looks like he is being lit from below.

PAINTING

Vetch is a mysterious character. He doesn't speak, and he may be hundreds of years old even though he looks like a young boy. His skin is dark and so is his cave. Use his brightly glowing tattoos to define his character and to set up a unique lighting that will allow you to set a dark figure against a dark background.

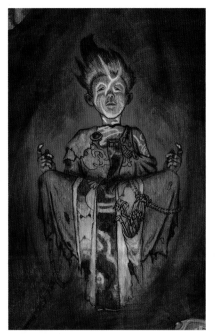 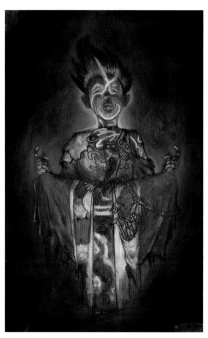 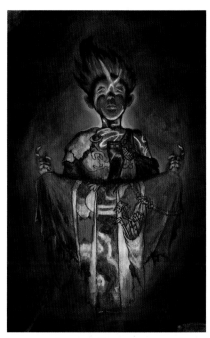

6 Again in Acrylics

As with the background (see Step 5 on page 103), complete a tonal rendering of Vetch in acrylic with Naples Yellow, Raw Sienna and Burnt Umber. Paint Naples Yellow thickly over his tattoos, which will be the brightest part of the painting. Brush Raw Sienna around the edges of his body with a no. 6 flat to begin establishing the glowing light that emanates from him.

7 Unifying Colors

Switching to oils, mix a neutral gray with Lamp Black, Titanium White, Raw Sienna and Cobalt Violet, and apply it thinly over all of his clothes and skin. This will function as a transition color between the more intense colors you will apply later and the browns already present in the underpainting. Use French Ultramarine Blue to darken the edges of Vetch's hair. Create a thick shape of hair rather than individual strands that fly everywhere.

Paint a rim of Turquoise Blue light from the lanterns on the lower left of Vetch's robes. This will tie him in with the rest of the painting, keeping him from becoming an isolated floating form.

8 Is That Really His Hair Color?

Paint Vetch's hair with thick layers of Cadmium Red Light, which will serve as a warm base for a more neutral color to be applied later. This will achieve the same effect as the underpainting, but with more intensity.

Add Burnt Sienna and Flesh Tint to the gray mixture from step 7. Apply this color thinly over Vetch's skin.

Add to the glowing effect around Vetch with layers of Warm Gray and Yellow Ochre.

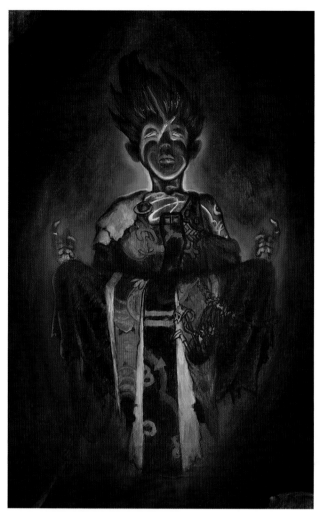

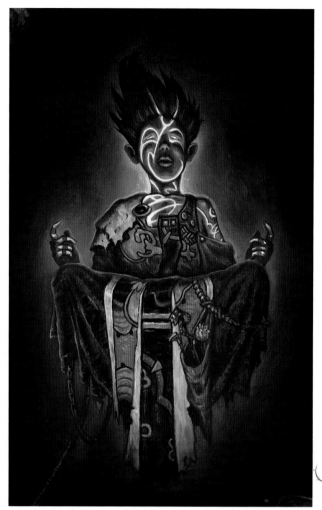

9 A Little Bit of Everything

Start adding local colors to Vetch's clothing. Mix Indigo Blue and Cerulean Blue for his robe. Use a wide range of colors for the accent designs. You can use some from all of the primary and secondary colors if you like. They will help draw the viewer's eye to Vetch.

Add Cobalt Violet to the flesh mixture from Step 8 and add it to the fleshier areas of Vetch's body, such as his cheeks, the tip of his nose, his shoulders and his chest.

Finally, cover the intense red of his hair with tints and shades of Cobalt Blue and French Ultramarine Blue. Allow the red to show through in a few areas for variety. Paint the small slits of his eyes with the same Cobalt Turquoise and Titanium White mixture that you used as the light source for the lanterns (see Step 10 on page 104).

10 The Brightest White

Add fine detail medium to Titanium White and paint Vetch's tattoos and a highlight in each of his glowing blue eyes. This will establish the brightest and most important part of the painting.

Continue lightening your flesh mixture with more Flesh Tint and Cadmium Red Light. Use this as the highlight color for all of Vetch's skin. Finish his hair with a glaze of French Ultramarine Blue, and some Cobalt Violet for highlights.

Complete the glow around Vetch with a mixture of Titanium White and Yellow Ochre. Paint a hard edge of this color around his shoulders, neck and head so that he pops forward from the background.

See the complete scene on page 101.

Vetch's Pet

The story gives a brief description of Vetch's pet, leaving a lot to the reader's imagination. Imagination is where you come in. It's up to you to come up with a design that challenges the reader. You want the reader to be so blown away by your design that she can envision nothing else for that pet than what you've created.

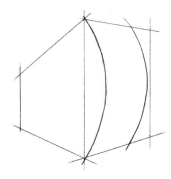

1 Stubborn as a Bulldog
Vetch's pet is very compact, kind of like a bulldog. Draw a rectangle in two-point perspective (see page 21) to define the basic shape. Then draw a couple of curved parallel lines on the front plane of your rectangle to set up the curvature of the creature's head.

2 Caricature Techniques
Vetch's pet could be described as an alien watchdog, but you don't want it to look too vicious. Use some of the techniques of a caricature artist and exaggerate the size of the creature's head to make it more playful. The head should make up about half the size of the pet. Follow through with the caricature in the face. Draw in big ovals for eyes, a small triangle for its nose and a long squiggly line for its mouth. Look at photos of dogs and rough in legs and a tail.

3 Good Boy
Put thick spines on the top of the pet's head. Have them lie flat so that they don't seem too menacing. It should look like you could pat the creature on the head and you wouldn't get hurt. Keep playing up the exaggerations. Draw in heavy eyelids and a lone tooth poking out through its lips, as well as a big floppy ear. Its feet end in stubby round toes instead of fierce claws.

4 Tail and Toes
Finish by shading in the underside and the far leg of the pet. Crosshatch the spines on its head so that they get darker toward the tips, then take out your plastic eraser and erase highlights back into them. A final exotic touch can be added by drawing tiger stripes on its body and tail and by adding human-looking toenails. Hopefully what you have achieved will bring a smile to the reader's face when she comes across your illustration.

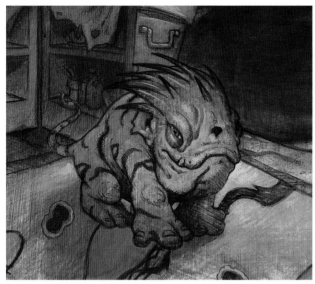

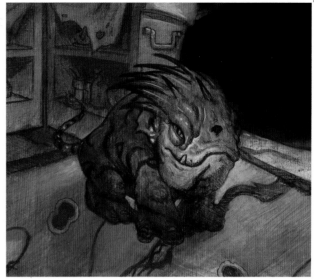

5 One More Time
Again, work up the underpainting of Vetch's pet in acrylic (see Step 4 on page 103). Use washes of Burnt Umber to create shadows on the underside of the creature's belly and on its paws. Use the same Burnt Umber thickly on its stripes and the end of the spines on its head to create contrast. Use the Naples Yellow highlight sparingly for details around its face.

6 Everybody Loves Green Fur
Continue working with acrylics on top of your underpainting. Dilute Phthalo Green with water and cover the creature's body, working in some Ultramarine Blue as you get near its paws. Work Phthalo Green onto the top of its head as well. Make some areas thinner than others so that the warm colors of the underpainting show through.

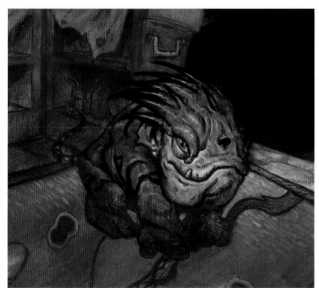

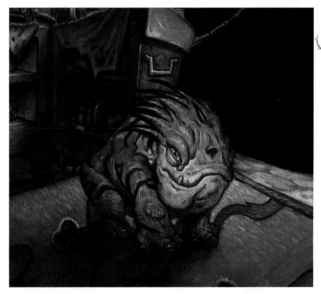

7 Better Than Hair Gel
Switching to oils, use a small round brush to bring some highlights up on the beast's head with a mixture of Cerulean Blue and Titanium White. Let the underpainting colors show through completely around the creature's mouth and strengthen the highlights in this area with Raw Sienna and Titanium White. Outline the spines on its head with Lamp Black. This will create a nice hard edge against the red of the cabinet behind the pet and will create some distance between it and the background.

8 Growl!
Add highlights of Permanent Green Light on top of the Phthalo Green on its upper body and head. The paws should remain fairly dark, so create their highlight with a mixture of Cerulean Blue and Phthalo Turquoise.

Use your smallest round brush to add some intense highlights of Naples Yellow to the beast's eye and tooth.

See complete the scene on page 101.

CHAPTER FOUR

SECOND QUEST:
Tussoc

Continued from page 100.

Living aboard a spaceship had become my life, yet eating and sleeping while hurtling through space seemed less alien than my life in San Francisco. My quarters were enormous compared to my old room above my aunt's grocery store. My space was decorated with accents befitting a splendid palace, and my bed was as soft as a bed of flowers. My new hosts, while strange, treated me with respect and kindness. If it weren't for the fact that I was constantly getting lost in the beehive of hallways, I would say that I was beginning to feel at home.

It had been three months since we had returned from Doona. Every day I tried to harness the powers locked within my new feather tattoo, the grand result being a change in my hair color. Could I defeat the evil forces of the universe through the power of a new hair color? I doubted

it. If so, I could have saved everyone a lot of trouble and just bought some hair dye.

Apparently some of the bad guys were really smart, so I had to do a bunch of studying in preparation for our battles. I studied maps, physics, alien customs, all kinds of stuff. But I put up with it because between learning about the mechanical properties of the Cordylian lift gate and the bizarre eating customs of the inhabitants of Guara, I got

to train in the Orun fighting arts with Draba. Four times a week I studied Orun weaponry, hand-to-hand combat and military strategy. Draba said that true power would not come from the tattoos, but from the force of my will and the strength of my body. I looked forward to our sessions more than anything, although I'm not sure that Draba felt the same. I guess it didn't help that Pigweed was always with me trying to barter for weapons.

Phlox taught me all about mechanics and engineering, and detailed every inch of the ship. We were walking along a platform overlooking the sprawling cargo bay. Well, I walked and he hovered as he explained, "The long arm of the cargo loader can move an object weighing up to seventy-three Stagerns to any position within the bay and place it with as little as .00023 Arbits variance."

"This equipment is all so huge. No offense, but how are you able to make repairs on these things at your size?" I asked.

"I have never let my size limit my abilities, Hachi. When I work on large parts of the ship, I sit at the helm of my graceful giant Lily."

"There's a giant on board? How come I've never seen her?"

Phlox buzzed down over the cargo hold. "Allow me to clarify. Lily is a massive robot I designed that allows me to work with the heaviest of equipment. While enclosed within Lily, I can even work outside the ship in deep space."

"Can I see it?"

"Soon, very soon. I am having the suit upgraded. Brome felt the upgrades were unnecessary, but when three of his bathroom appliances mysteriously malfunctioned, I was able to make him see the logic of my argument. So the suit is now being given the royal treatment on Tussoc."

"What is Tussoc?"

"Tussoc is a planet in the Uypon Nebula. The surface of Tussoc lurches with lava flows. Great cities of industry cling to volcanic rock like barnacles on a ship. Because of its unique mineral composition and extreme temperatures, Tussoc has the best metals in all the galaxies. The forges there run day and night."

"So when are we going to Tussoc?"

"*We* are not going. You are. The rest of us have a brief matter to attend to. You and Noot will go to the Mugwort Metalworks to pick up Lily and wait for us to pick you up."

"What? I'm supposed to get tattoos and master new powers, not run errands."

"We all run errands for someone, Hachi," Phlox said as he zoomed away.

The story continues on page 114.

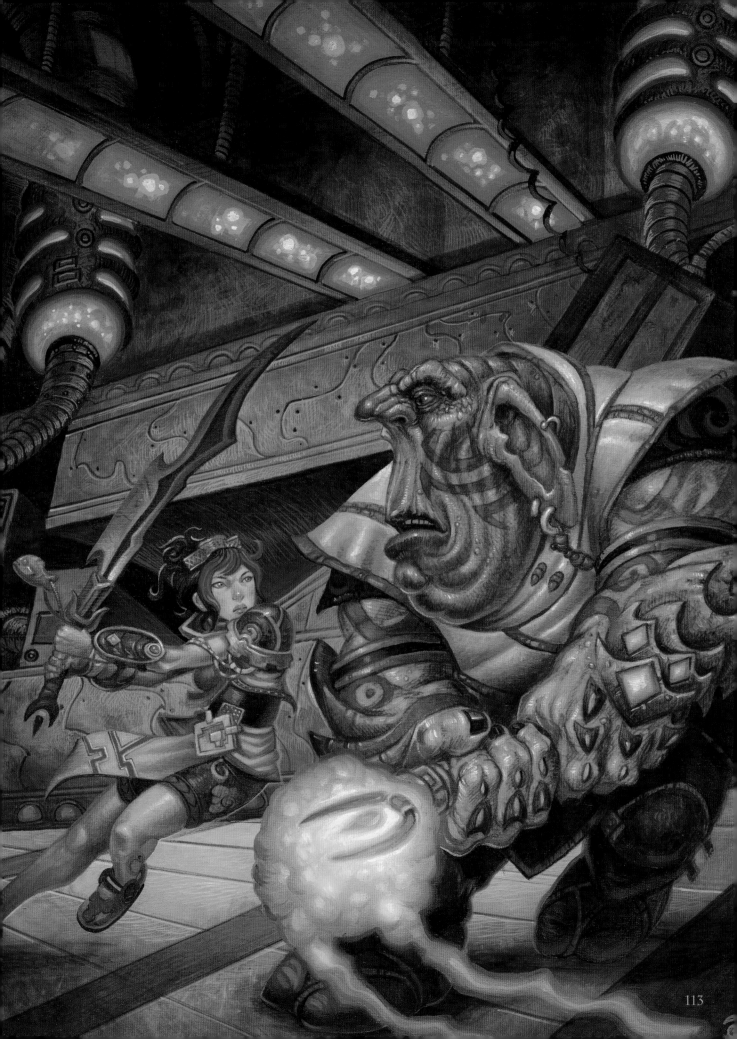

Continued from page 112.

I complained to Brome, but he ignored me. He said some common tasks performed outside the ship would help me become a more well-rounded member of the Oru.

The temperature on Tussoc hovered at a blistering 180 degrees Fahrenheit, so Linanthus fitted us with specialized heat suits complete with helmets. Pigweed insisted on coming once he heard I was going to Tussoc. He couldn't wait to get his hands on some of the legendary metals.

Our landing on Tussoc was smoother than on Doona, and Pigweed hit the ground in a blazing sprint toward the metal works. Mugwort Metalworks was an intimidating structure. A multi-limbed specter of metal and stone, the building seemed to be stretching upward, trying to release its hands from the porous lava rock that bound them in place. A heavy blanket of smoke kept the phantom pinned to the ground, but a great fire burned at its heart.

The heat was oppressive, even through the suit, and I was building up a sweat. My heat suit was specially designed with a place for Noot's amulet. I had noticed just before stepping through the Bounce Corridor that Noot had changed into a glass figure of a rabbit.

"Why'd you change into a bunny?" I asked.

"Why did your hair change color?"

"I wish I knew."

"Exactly," he said.

I caught up with Pigweed inside the large industrial plant. We asked for the plant manager, Nilton. He emerged from a crackling pit of sparks and noise that reminded me of a New Year's celebration gone out of control. He gestured wildly and yelled at his co-workers. He was covered from head to foot in soot, except for two clean streaks by his eyes. Had he been crying?

His voice was raspy and sputtering. "The yak has spit, and the yoke has cracked," he said. "Heat to the sheets three hours past."

"Is your translator on the fritz?" I asked Noot. I had no idea what Nilton was saying.

"He's speaking in old Tussoc metaphor. He means that lava pirates have struck and made off with something valuable. Apparently it happened three hours ago."

"Is he saying they stole Phlox's suit?"

"Indeed," said Nilton, his eyes staring into the fires.

"Why didn't you contact the ship?"

"A stone in the fire will shatter. The girl of Oru will save for the toes of Sweetree."

Noot translated, "He wanted to keep the incident quiet. The reputation of his plant is tremendously important to him. He says if you would be able to retrieve the suit, he would offer to take 10 percent off the bill."

"What do you guys think we should do?" I asked.

Pigweed took a step forward. "Loss and retrieval of an order is due an 18.75 percent discount where I come from."

With a pitiable sadness, Nilton nodded his head.

The story continues on page 128.

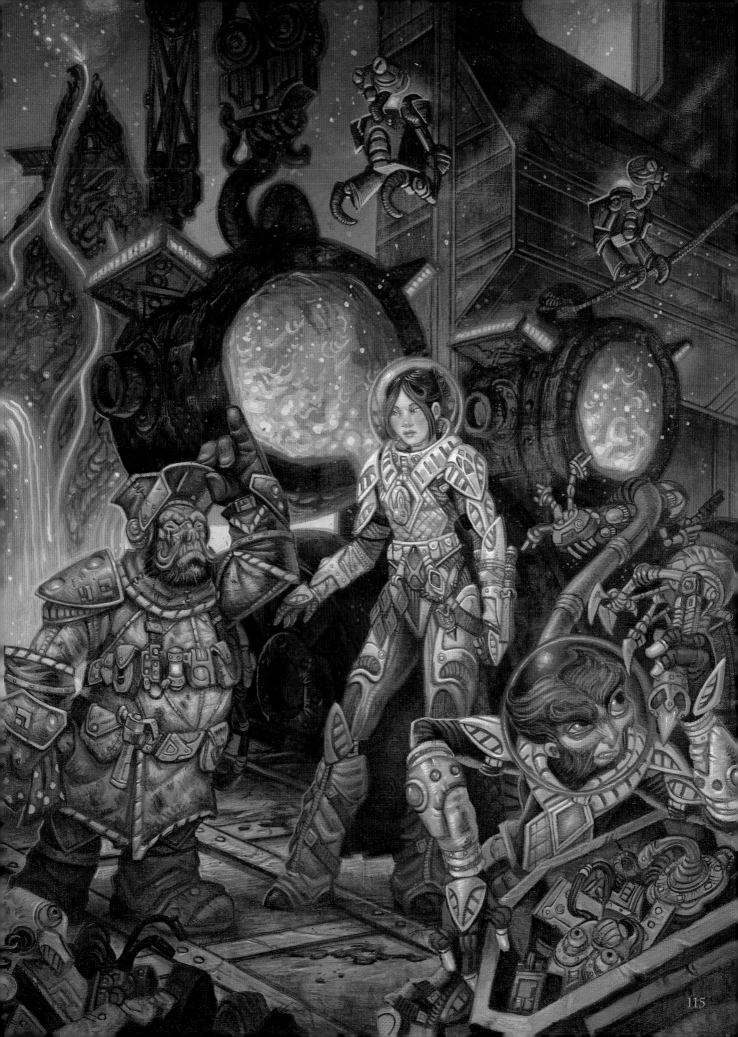

The Metalworks

Tussoc is a lawless land, pocked with rabble-rousers. Nilton runs an efficient enterprise at Mugwort Metalworks, and he thought his plant was safe from the wild gunslingers of the dirigible ports below. But the pirates have broached the security of the foundry. Let's draw the engineer's room where the crime took place. Look at steel mills and industrial factories for inspiration. Don't slip in the grease!

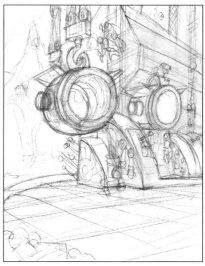

1 Compositional Breakdown

Establish the edges of the composition (approximately 8" × 11" [20cm × 28cm]). Place the horizon line a little below the halfway mark, and establish the vanishing points off the sides of the page (see page 21). Block in some basic shapes. Draw two ovals, each with an oval inside to form the smelting barrels that transport the precious melted metals. In the center of the composition, draw a vertical line down to the horizon line. Using the vanishing points, sketch the upper portion of a giant turbine: draw a quarter of a circle, then follow the contours to draw the other side. The rest of the turbine is below the engineer's room.

2 Barrel Transport

Draw a circle for the bottom of each smelting barrel, and connect the top and bottom with lines. Draw rectangular shapes for the pulley winches holding the barrel. Add two ovals on top of each rectangle for the pulleys. In the background, draw an angular volcanic mountain. Round off the room floor with two parallel curving lines that meet the horizon line. Add more of the wall by following the vanishing points back in space. Draw another line beside the first to create thickness.

3 A Busy Room

Loosely rough in the rest of the smelting barrels. Add rectangular steel guides on either side of the barrels and oval pivot joints on the sides that you can see. Rough in the robots overhead with ovals and circles. Give them hooks to help guide the rigging to transport the smelting barrels.

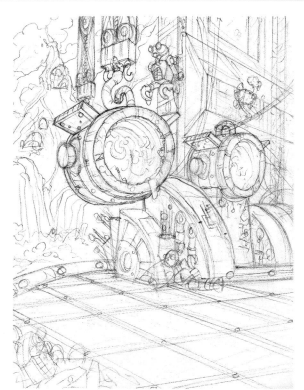

4 Blueprint

In the foreground, rough in a pile of extra robot parts made up of ovals and rectangles. Add some wires. Draw flames inside the smelting barrels with swirling angular lines that come to a point. Add cut marks and stains to the barrels. Finish the pulley system with a giant hook along with smaller hooks on either side. Using a ruler, block in the floor tiles. Add small circular rivets to each overlapping beam. Rough in extra robot parts leaning up against the turbine system in the back.

5 A Sooty Finish

Use crosshatching to finish the rendering; stippling would also create that sooty feel (see page 19). Think about the textures of the smelting barrels and how the light will play on them. Are they in shadow or are they being hit with direct light? Add dirigible ports to the distant volcano. Create small areas where residents reside in the side of the mountain. Add veinlike lava streams running from the top of the volcano to a large basin. Draw circular puffy clouds of smoke at the top of the volcano. Create the rocky formation with flowing horizontal lines. Lava hardens in random patterns, so have fun with it!

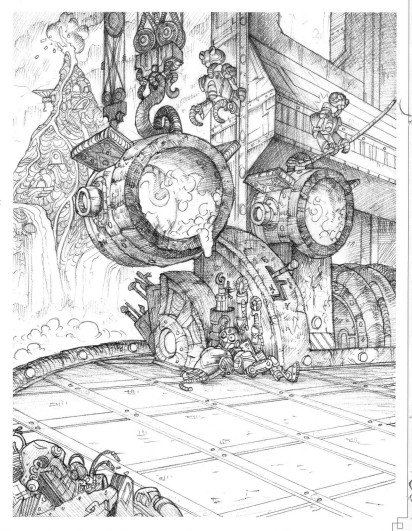

Exercise

Try designing a new robot. Can you think of any robots that could help Nilton at Mugwort Metalworks? Use basic shapes such as circles and ovals to create a new robot for his shop.

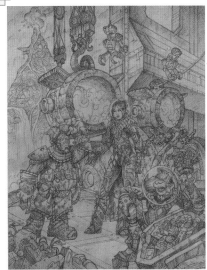
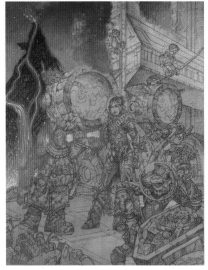
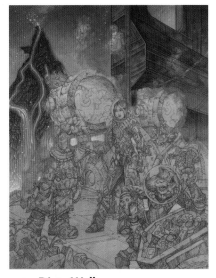

6 Umber Soot

Prepare the painting surface (see Step 7 on page 48), then apply an acrylic wash of diluted Burnt Umber with a 2-inch (51mm) flat. Dilute with more water if necessary.

Adding the Characters

Remember, at this point you will have already drawn the characters (see pages 120–121 and 124–125) along with the background drawing (see page 30 for more on drawing these elements at the same time).

7 Volcanic Eruption

Mask the painting surface with frisket paper, then cut out and remove the frisket from the far background. Working in acrylics, block in the volcano and sky using nos. 4 and 5 flats. Mix the sky colors with Cadmium Orange, Cadmium Yellow, Eggplant Purple and English Yew Green. Apply the paint with a no. 5 flat and blend the colors with a no. 4 flat. Block in the volcano with a no. 4 flat and Burnt Umber, Noir Black and Cadmium Orange. Add in the lava flows with Cadmium Yellow, Cadmium Orange and Cadmium Red Light with a no. 3 round.

8 Dirty Wall

Remove the frisket paper from the next section in the near background. Block in the back wall with Noir Black and English Yew Green and a no. 5 flat. Using a ruler as a guide, follow the line you initially drew for the background, hitting the edges with light. Mix a touch of white into the Noir Black and English Yew Green mix for the highlights and apply with a no. 5/0 round. Add water to the paint to create a smooth, clean line (but not to the point that it drips off the brush). If necessary, go over the line a couple times to place the highlights. Add in an orange glow coming from the lava below on the underside of the wall. Use a mix of Noir Black, Cadmium Orange and a touch of Burnt Sienna.

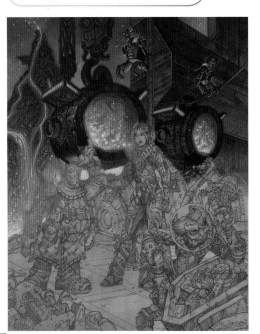

9 Smelting Cauldrons

Remove the frisket from the smelting barrels and the floating worker-bots. Block in the barrels and the bots with a diluted wash of Noir Black. Build up the opaque blacks. Use a no. 4 round and random strokes to create a gritty texture for the barrels. Add highlights to the sides of the barrels with a no. 2 round and a touch of white and Yellow Ochre. Using a no. 4 round, add backlight from the lava pit below with Noir Black, Cadmium Orange and a touch of Burnt Sienna. Block in the inside of the barrels with Cadmium Red Light, Cadmium Orange and Cadmium Yellow. Add a touch of white to the Cadmium Yellow to get it to pop. Add the glowing green lights with Viridian Green and Cadmium Yellow.

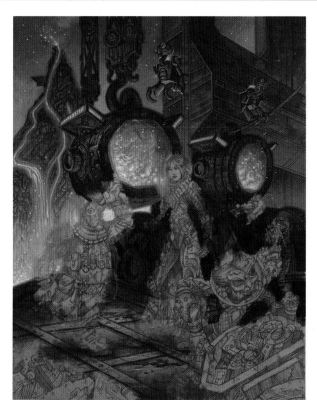

10 Broom Anyone?

As you work each layer, add a little splat effect for the embers floating in the air. Using a larger round, add a bit more water to a mix of Cadmium Red Light and Cadmium Orange. Hold your index finger over the painting and tap the brush on your finger. (Practice this on scrap paper first.) Remove the frisket from the foreground. Block in the back turbines with a no. 4 flat and Noir Black and Burnt Sienna. Build up the Noir Black to an opaque. Add edge lines as you go with a no. 4 round. Block in the paneled ground area with a no. 5 flat and a touch of Titanium White and Yellow Ochre. Glaze the shadows beneath Nilton and Hachi with Noir Black.

11 Green Glow and Smoke

Tighten up the details and add some glows, a smoky haze and backlight with oil paint. Remember, once you use oil paint, you can't go back to acrylic. Add the backlight to the turbine with Cadmium Red and Yellow Light. Paint the edges of the turbine with a no. 2 round. Add backlighting anywhere light from the lava might hit the inside of the metalworks. Mix a light warm tan and drybrush a smoky haze over the foundry. Do this sparingly to give the feeling of dirt hanging in the air. Switch to a no. 3 round and drybrush a glowing effect on the smelting barrel lights and the lights on the robots. Use Viridian Green and Cadmium Yellow Light, and fade out the glow subtly.

See the complete scene on page 115.

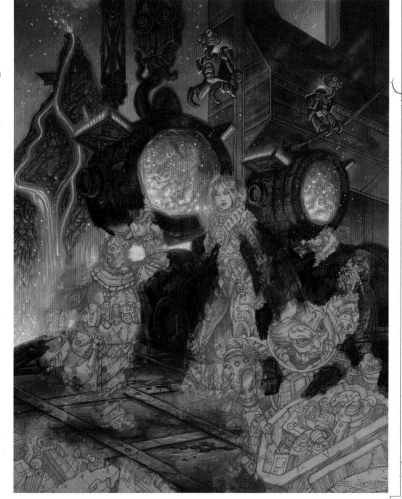

Nilton

As the plant manager at Mugwort, Nilton keeps the flow of precious metals steady for business, shipping to all parts of the galaxy. But his true talent is his ability to design and create robots to help around Mugwort. Like Nilton designing a blueprint, let's engineer this riddler from Tussoc!

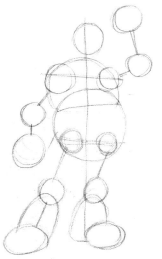

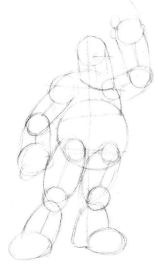

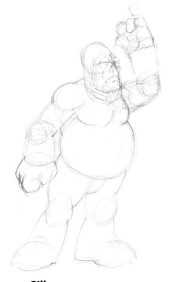

1 Construction Lines

Draw a cross to represent Nilton's height and shoulders. Next, establish the basic shapes. Draw a circle for the head and two larger circles for his chest and belly. Draw two circles on either end of the horizontal axis of the cross for his shoulders. Draw in circles for the joints and connect them with lines to establish the arms and legs. Draw squat ovals for the calf muscles.

2 Building Muscles

Draw elongated ovals for the upper arms and forearms. Draw wide ovals for the thigh muscles. Draw a rectangular shape for his jaw. Bend the shape a bit to fit over the circle representing the back of his head. Draw a cross to place his eyes and nose. Draw small circles for eyes.

3 Silhouette

Clean up the drawing, leaving only the basic silhouette. Follow the bottom of the circular head shape to fill out his cheeks. Draw a rounded triangle for his pig nose. Create two long horizontal ovals for his brow. Draw a downward-pointing swoosh shape for his frowning mouth. Add little checkmarks for the left corner of his mouth. Loosely rough in the hands and fingers with small ovals for each finger and thumb.

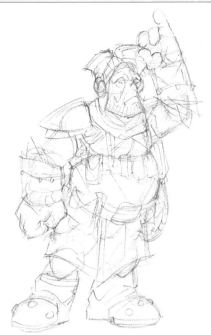

5 Line Drafting

Redraw and follow the contours from the previous step. Add seams with stitching and edge lines. Make a candy cane design on the edges of his cowl piece, gloves and tunic. For this design, draw evenly spaced lines slanted at the same angle. Define Nilton's tool belts by adding edge lines to the pockets and add a hammer. Give him a handkerchief to dry away his tears!

4 Engineer's Gear

As a Tussoc native, Nilton can withstand the heat of the lava flows, so the elements won't hurt his exposed face. Using angular lines, roughly draw his clothing. Give him two tool belts, one at the top of his belly and one far below. Sketch small rectangular and square shapes for all the pockets. Form the shoulder armor with an arrow shape on his right shoulder. Add circular rivets on the toe of his heavy boots for an extra-sturdy look.

6 Grimy Details

Use crosshatching to render and add details. I was inspired by Old West train conductors of the past, which I referenced in his hat, suspenders and gear. Add shading, starting at his head and working your way down. The light source is in the upper right, so the shading becomes gradually darker towards his feet. Add small circular buttons to keep his pouches closed. Add soot stains on the bottom of his tunic by making crosshatching marks in the opposite direction from the rendering. Nice and dirty!

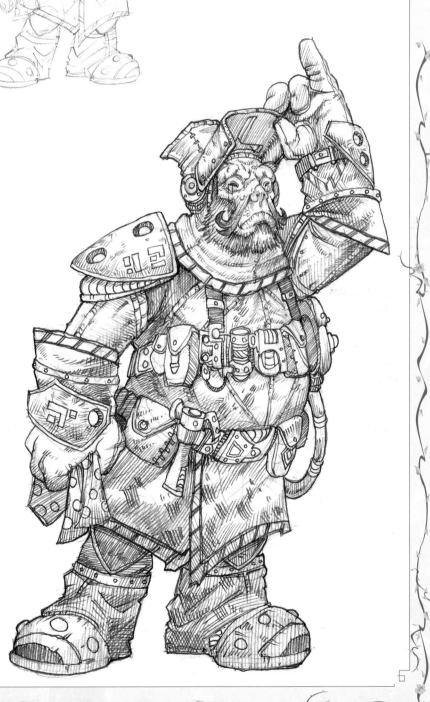

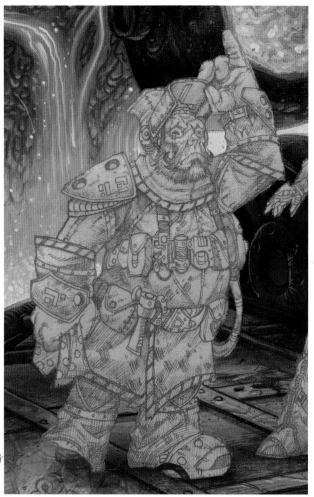

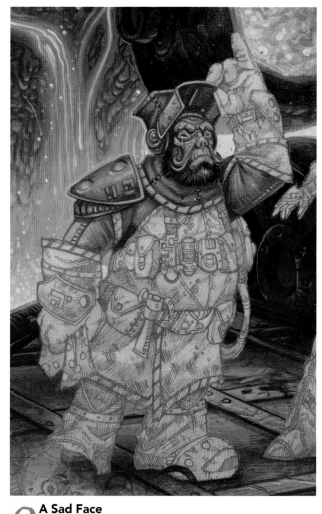

7 No Dirt Here!

Remove the frisket paper from Nilton to reveal the Burnt Umber wash. This will serve as the underpainting.

8 A Sad Face

Switch to your oil palette and start working from the top down. Use a no. 0 round and a mix of Yellow Ochre, Dioxazine Purple, Cadmium Red Light and Titanium White for Nilton's smudgy purple face. Work on Nilton's cowl piece with a mix of Mars Black and Yellow Ochre. A little bit of Mars Black goes a long way, so don't use more than a touch. Add the yellow strips along the cowl's edge with Yellow Ochre. Add the metal shoulder armor and face mask with a no. 1 round and a warm gray mix of Mars Black, Raw Umber and Titanium White.

For the glowing green parts of the suit, mix Cadmium Yellow Light and Viridian Green. These parts are actually little cooling orbs embedded in his suit.

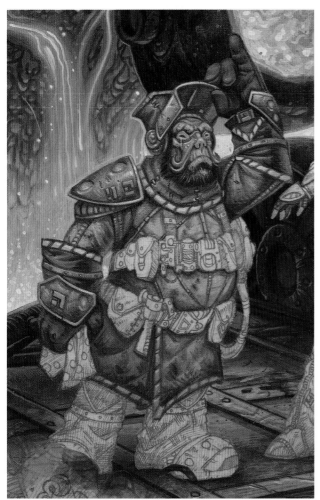

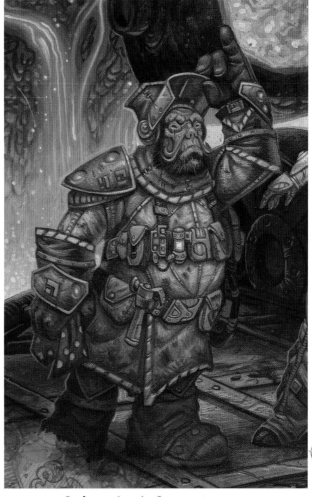

9 Smock

Using a mix of Yellow Ochre, Raw Umber and a touch of Mars Black, block in the entire smock with a no. 2 round. Add Titanium White and Cadmium Yellow Light to the mixture, and add the highlights. The light source hits high up on Nilton's chest. Use highlights to help show its form and shape. Work your way down to the gloves and armor plating. For the gloves, use the cowl color scheme (Mars Black and Yellow Ochre). Add Titanium White to the mix for highlights. Continue adding green cooling orbs, using the mix from Step 8.

10 Gadgets Just in Case

Finish the smock with various mixes of Yellow Ochre and Mars Black, some with more black and some with more yellow. Use a no. 0 round to paint Nilton's double belts and gadgets with a glaze of Raw Umber and Burnt Sienna. Paint in all the pockets at the same time, using the same paint. Add highlights on the pouches with Titanium White and Yellow Ochre. Use a mix of Mars Black, Viridian Green and Titanium White for the metal gadgets, blocking them in with a no. 1 round and adding darks with a no. 0 round. Draw with the paint to get details just where you want them. Add flickering lights with a mix of Viridian Green and Titanium White. Nilton looks to be in a sad state of affairs.

See the complete scene on page 115.

Hachi's Orun Heat Suit

Designed by Linanthus, Hachi's and Pigweed's heat suits have a self-contained environment able to withstand extreme heat. Without these suits, Hachi and Pigweed would be more than just sweaty on this lava planet!

Concept Sketch

Before going to a finished sketch, work out your concepts on a scrap of paper to get an understanding of what the design might look like. Work quickly and without worry. You might have to work several concepts to nail down a design you're happy with.

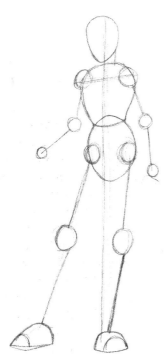

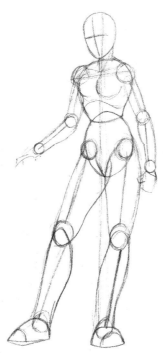

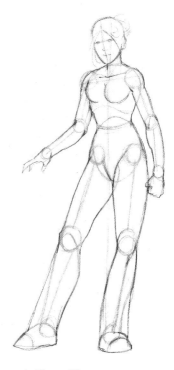

1 Wire Flame

Draw a cross to establish the shoulders and Hachi's stance. Draw an egg shape for the head. Add two circles for the shoulders. Form the torso with a round-edged trapezoid. Draw an egg shape for the pelvis and a circle on either side. Draw smaller circles for the elbow and wrist joints, and larger circles for the knee joints. Create rounded triangular shapes for the feet with a rounded line to establish the toes.

2 Basics Burning

Starting at the shoulders, draw an elongated oval for the upper arms. For the forearms, draw elongated ovals with a dent inside the arms. Create larger ovals for the thigh muscles. Continue down to the calf muscles with elongated ovals that attach at the ankles. Look at yourself in the mirror to get a better understanding of how anatomy works. Add a cross to establish the center of the face.

3 A Clean Flame

Clean up the drawing and retrace the contours of the silhouette. Pay attention to how the parts of the anatomy fit together. For example, create Hachi's right armpit by drawing into her rib cage, stopping where her chest muscles start. Draw small circles for the eyes. Draw the nose about halfway between the eyes and chin. Draw two lines for the mouth about halfway between the nose and the chin.

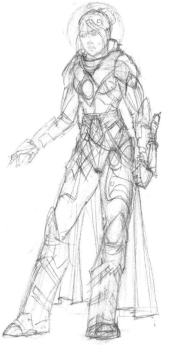

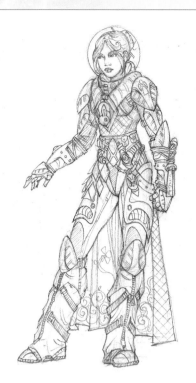

5 Burning Line Drawing

Retrace the basic shapes, clearly defining each individual shape. Draw small rectangular vents on each part of the suit. Draw a circle for Noot's bunny head and elongated oval shapes for his ears. Sketch squat rectangular pouches on Hachi's belt, then add small circular buttons. Add a seam down the inside of the leg and zippers flowing down the front of the calves. Add a ribbing pattern to parts of the suit close to Hachi's body by drawing parallel lines in a tight formation.

4 Heat Suit; Neat Suit

Following the contours of Hachi's body, roughly sketch the simple shapes of the heat suit. Draw an angled oval for the cowl piece (don't cover her neck). On either side of the shoulders, draw a long rectangular piece that connects with a diamond shape in the center of the chest. Draw an oval inside the diamond; Noot will reside here. Add a rounded diamond on each shoulder, then draw an elongated diamond shape that goes down the upper arms. Draw an upward-pointing triangle coming off her left forearm; add the Orun light rod here. Its sausage-shaped handle attaches to the rectangular rod. Draw a belt following the contours of Hachi's hips. Add circles and triangle shapes for the gear. Draw the thigh coverings with rounded triangles. Add upward-pointing triangles on the knees. Draw the boots, following the contours of the calves. Add two rectangular straps on either side.

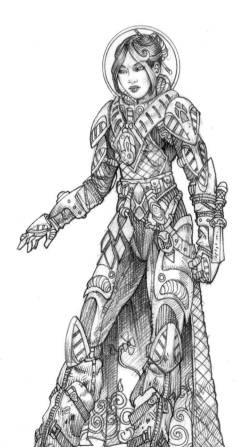

6 A Fiery Sketch

Use crosshatching to finish the drawing. Create edge lines, pattern and texture, following the contours of each shape. For example, draw an edge line on the lower part of the shoulder pad. Edge lines indicate how thick or thin a shape is. Add small circular rivets to the gloves. Use a compass or a circle stencil to create the mostly clear helmet. Hachi and Pigweed are both ready to do some investigating on Tussoc!

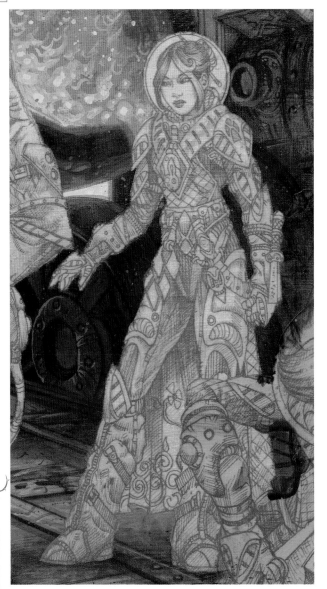

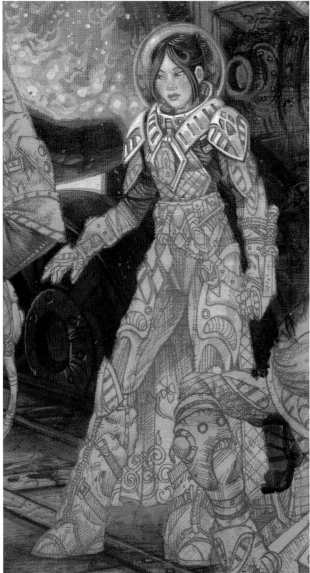

7 Too Hot? Gear Up!

Slowly peel off the frisket paper, revealing the drawing and the acrylic Burnt Umber wash. Use this as your underpainting.

Start With the Head

Our eyes unconsciously gravitate toward the head and hands, so it's important to take some time with them. Start with the head and work your way down.

8 Energy Helmet

Switch to your oil palette and work from the head down. Mix a flesh tone with Yellow Ochre, Alizarin Crimson and Titanium White. Work the details of the face with a no. 0 round. Paint Hachi's hair with a mix of Mars Black and Raw Umber, using Titanium White for the highlights. Use a mix of Phthalo Blue and Titanium White for the blue streak. Add more white for highlights.

Using Magenta and Titanium White, block in the helmet. Add highlights with a no. 0 round and a mix of Cadmium Yellow Light and Titanium White. I use a technique called *impasto* for the highlights. This is a thick application of paint.

Starting with the suit's upper portion, paint the light parts with a no. 0 round and a white mix of Titanium White with a touch of Yellow Ochre. Add the vents and design elements with Magenta and Titanium White. Add highlights and darks. For a warm dark, mix Magenta, Dioxazine Purple, Raw Umber and a touch of Mars Black. Draw with your paintbrush, following the contours of the suit's triangular shapes.

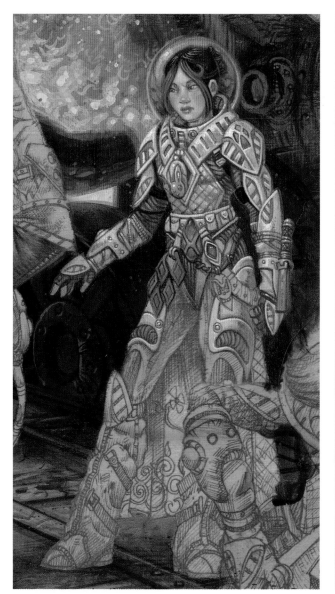

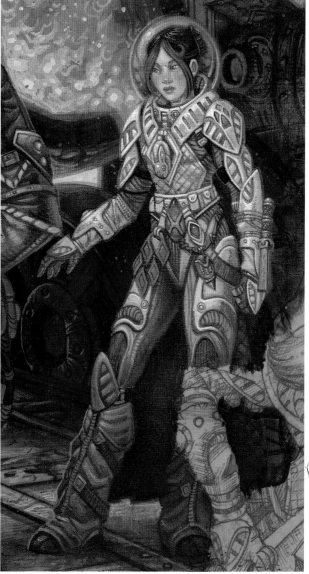

9 **Heat-Resistant Armor**
Continue down the arms and body, adding darker paints as you go. Push and pull the space, adding more highlights closer to the upper portion of Hachi's body. The light source is directly above Hachi and Nilton, similar to a spotlight on a stage.

10 **Straps and Boots**
As you work your way down to the boots, think about how light will play on certain parts of the boots like the edges of the pink straps and buckles. Edges are important for showing the form of an object, so use a no. 0 round to hit up all edges with a highlight mix of Titanium White, Yellow Ochre and a touch of Magenta. As you work to the lower portion of the boots start adding Mars Black to the white mix from Step 8. Block this in with a no. 1 round, and add details with a no. 0 round. Add orange backlight on the right boot with a mix of Cadmium Yellow Light, Cadmium Red and Burnt Sienna. The Burnt Sienna will knock the chromatic intensity of the orange back a bit so it won't be as intense as the orange in the smelting barrels. Linanthus would be proud of his creation!

See the complete scene on page 115.

Continued from page 114.

"Noot, how are we going to find Phlox's suit?" I asked. "We don't even know where to begin looking."

"I believe this was a calculated heist, Hachi. The pirates in question knew that the suit was property of the Oru. It was no random act of banditry. And on this planet, there is only one pirate bold enough to attempt such a heist—One Eye Voster."

"Why wouldn't you tell us that?" I asked Nilton.

"That name be like a flood on embers."

I didn't need a translation. Nilton was scared.

"If this One Eye Voster is such a legendary pirate, what chance do we have of finding him?"

"A better chance than you might think," Noot replied. "The pirates of Tussoc are notorious braggarts. If the heist occurred only three hours ago, then they are probably docked in one of the more sordid sections of Tussoc, drinking and regaling their pirate cronies with tales of their latest deed."

Noot said our best bet would be to begin our search at the port of Rue Dod. We took to the air in a sturdy dirigible that was owned by the plant. Balloons, zeppelins, blimps and all sorts of bizarre, bulbous aircraft floated like ocean buoys on the currents of hot gasses billowing up from the lava below. They moved around in a whirl of color, like swarms of bugs making their way through the sticky air of a late summer day. Our Supreme Huckinworth turned out to be a capable pilot as well. He pulled us into the dock at Rue Dod in no time at all.

We disembarked and found ourselves in a tourist's nightmare. The dock was crammed with rickety carts overflowing with inedible-looking food and cheap souvenirs. Hucksters slinked through the crowd offering "the best tours in town."

Pigweed grabbed my arm. "Wait here for a moment." He dashed over to a small alien boy who was in the middle of a negotiation with a young couple who appeared to be on their honeymoon. The boy looked upset at being interrupted, but his attitude changed quickly as Pigweed talked to him.

"What's he doing?"

After a few minutes, it appeared as if they had come to some sort of agreement, and Pigweed slipped something into the boy's pocket. Then he darted back over to us.

"Were you buying information?" I asked him.

"Yes and no," he said. "I came to terms with the young man for details on the location of the pirates. He supplied me with some directions, which are of course bogus, and I gave him payment. As I am telling you this, the boy is surely on his way to tell the pirates we are looking for them."

"And you're letting him go?"

"Most certainly, for the payment I slipped into his pocket was not merely currency. It also contained a small tracking device that will lead us directly to the pirates."

"Well done, my furry little friend," commended Noot.

"What's so great about it?" I said. "Now they'll know we're looking for them."

Pigweed shook his head. "The pirates knew someone would be looking for them as soon as they stole the suit. Now their muscle will be camped out in the spot where the boy instructed me to go, waiting to pounce. But we, of course, will never show up. Instead, we will follow the boy to the pirates, and the pirates to their ship, where I'm sure they will have Lily." Pigweed looked very pleased with himself, and I must admit I was impressed.

My admiration didn't last long. The tracking device, which I assumed would be some high-tech piece of gadgetry, turned out to be a toy bird. "How is that thing going to help us follow the boy?"

Pigweed leaned in and whispered, "Mixed in with the money I put in the boy's pocket was some bird seed. This bird will chirp faster and faster the closer we get to the seed."

"Did it occur to you that this kid might find it odd that he keeps hearing a bird chirping behind him everywhere he goes?"

"Um, well, no, not at the time, at least."

"Ugh. Let's just get going."

The story continues on page 130.

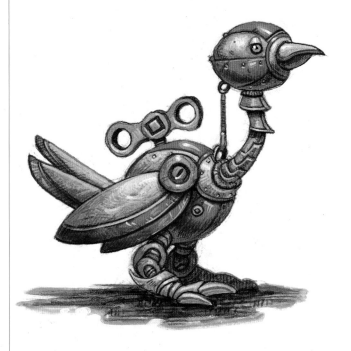

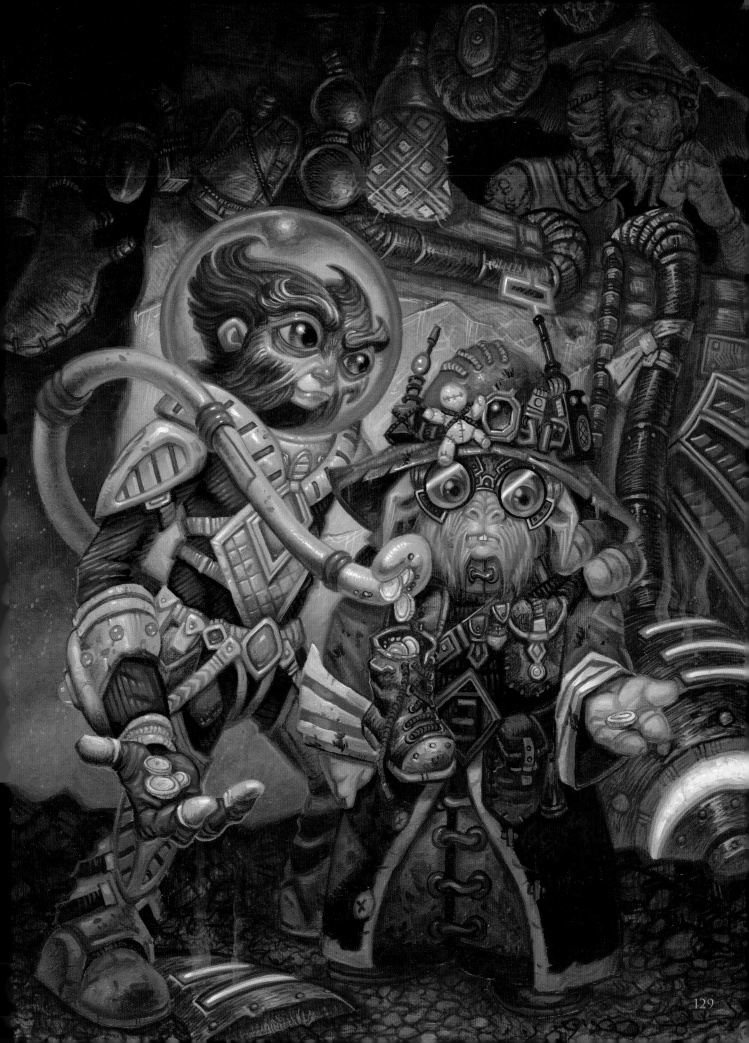

Continued from page 128.

If a short, furry creature with a chirping toy bird in his hand and a human girl with a talking rabbit amulet would have been a sight in Rue Dod, I would have been worried, but that was far from the case. We blended in perfectly with the face-painted fire jugglers, green-coated coolant sellers and patchwork bands of water thieves. The crowd gave us plenty of cover from both the eyes and ears of the boy as he made his way into a tavern called the Cutleaf.

"We need to get in there and see what's going on," I said.

Noot stopped us. "The boy will surely have described Pigweed to the pirates already, but I think I have a plan. That is, if Pigweed doesn't mind cramped spaces." I liked the sound of it already, but Pigweed seemed less than eager.

Noot explained, "See that rather large fellow there? He's called a Rastyr, or an element vendor. Those large buckets and barrels he carries across his shoulders are filled with ice, water, and various minerals and gasses that are unique to Tussoc."

My job was to distract the Rastyr. Pretending that I had money to spend, I beckoned him over. The building I was standing by had low enough eaves that Pigweed, with Noot around his neck, could slip into one of the Rastyr's barrels without being noticed.

I looked at him coyly. "My girlfriend was just asking about you."

He raised one of his heavy eyebrows, "What does she look like?"

I watched Pigweed lower himself gently into one of the barrels. "She's really cute. She's got dark hair, and, um, green horns. She just went into that tavern," I motioned to the Cutleaf, "and she wants to buy you a drink."

He gave me an awkward wink and headed straight to the Cutleaf. I guess he liked girls with green horns.

I hid amid the crowd in the street, nervous, as they entered the tavern. Through my link with Noot, I could hear fragments of a rowdy voice over the raucous crowd. I heard a man boast of "the finest hunk of Mugwort Metal" and "a fitting end to that Oru scum." It was clear they had found the pirates.

The wait was interminable. I didn't know what was going on inside. Even if they got their information, Pigweed couldn't just pop out of the barrel and run. What if the Rastyr was upset that there was no girl waiting for him and decided

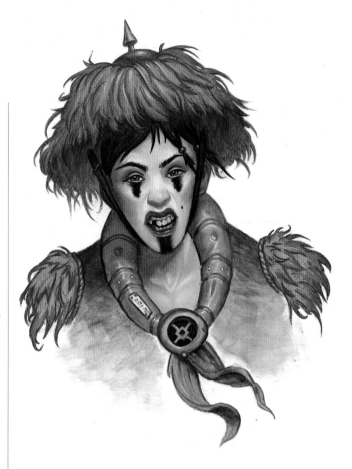

to get drunk? My worrying was cut short. Inside the bar there was angry shouting, a challenge being called, breaking glass, the distinct clank of metal hitting metal, a shriek from Pigweed and Noot's calm voice informing me, "We're coming out now."

The door of the Cutleaf shattered and the patrons poured out into the street. The crowd gave way like oil to water as pirates and thugs—men and women—drew swords and threw mugs, bottles and broken pieces of furniture at one another.

The Rastyr had his hands full with three pirates. Pigweed's terrified eyes peeked over the rim of the barrel on the Rastyr's back as the giant smashed a chair leg over a pirate's head. I wanted to get in there and help out, but that wasn't the plan. We had to know where the pirates had taken the suit. The boy who had sold us out darted past me and vanished into the sea of people. The brawl was like a volcano exploding, filling the landscape with violence. The port police arrived and began restraining people. The pirates took this as their cue to cut and run. This was our chance. A group of furious patrons, led by the Rastyr with Pigweed still on his back, chased after the pirates, and I followed.

The story continues on page 143.

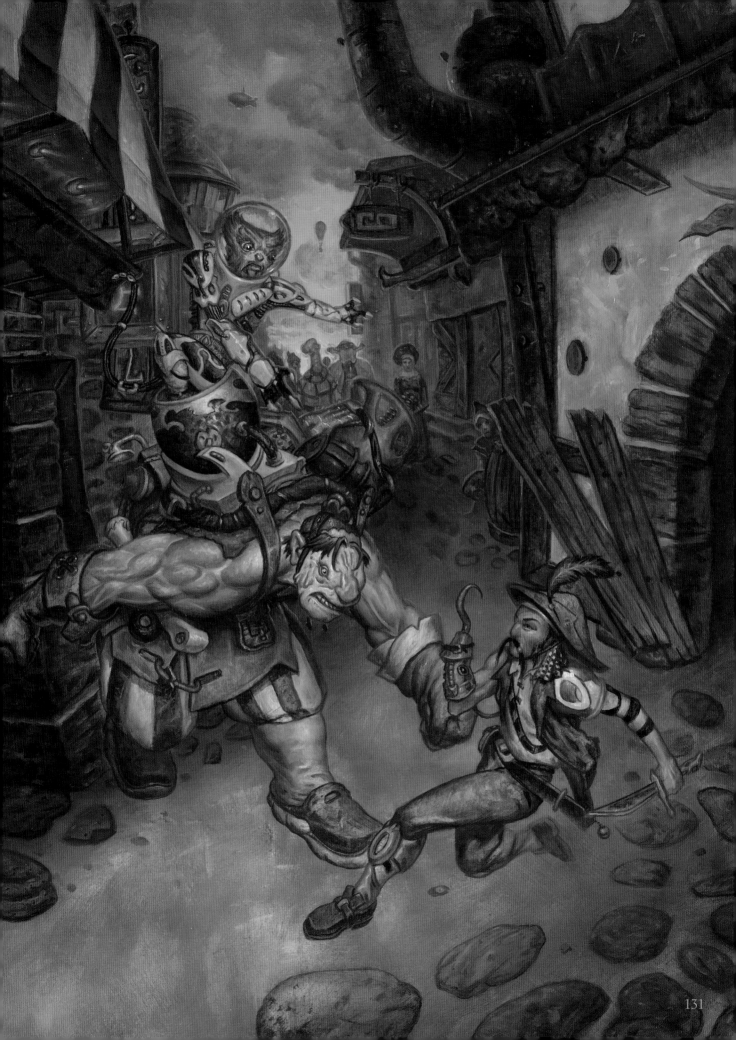

The Alley

The pirate brawl scene outside the Cutleaf has the potential to become a very confusing composition. There are many elements to take into consideration: buildings, people in the street, brawling bar patrons, pirates,

Pigweed and the Rastyr. To cut down on some of the confusion, let's make the fight between one of the pirates and the Rastyr (with Pigweed still on his back) the focal point of the piece.

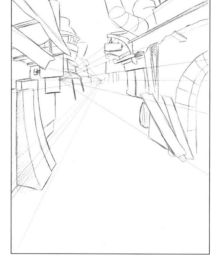

1 One-and-a-Half-Point Perspective?

Sketch quickly back and forth, filling the page with dark shapes, leaving a clear area for the street. Change the stroke direction every so often. Indicate door openings, rooflines and building edges with solid lines.

The perspective in this scene is a modified one point, but not using two points. It makes the buildings look a little out of whack. Things aren't quite lined up right, and the street feels cramped.

Create a horizon line a third of the way from the top. Near the center of the line make a vanishing point for the buildings on the left. Draw a series of lines radiating from this point as a guide for the roofs, windows and doors.

Add another vanishing point to the left of the original point. Draw lines radiating from this point to the right for the right-side building.

2 Tracing Paper Is Not Just for Tracing

Lay a piece of tracing paper over the drawing. Squint at the dark shapes beneath, and draw solid edges to define the buildings. Stores, restaurants and bars should have awnings and signs sticking out to grab tourists' attention. Tussoc is a planet of lava and steel, so incorporate steel girders and bolts as well as lava rock brick into your designs.

3 Building the Cutleaf

Finish detailing the buildings. Not all buildings are made up of straight lines. Throw in some curves and ovals for variety. Put stripes and weird alien lettering on awnings. Remember to follow the vanishing point guidelines from Step 1.

Draw some large tubes on the buildings. Tussoc is incredibly hot, so there would need to be some kind of system for removing the hot air and pumping in the cool.

The building in the front right is the Cutleaf. Draw its door thrown open, hanging wrecked on its hinges. Create a little logo of a sword cutting a leaf. Let there be no doubt in the viewer's eye that this building is the Cutleaf.

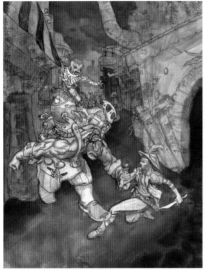

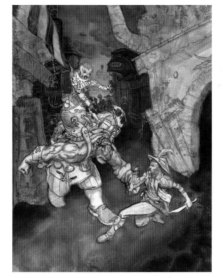

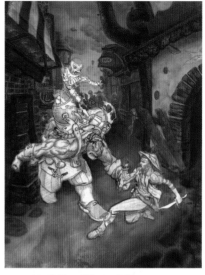

4 Fire in the Sky

Paint this piece from the start in oils. Cover the background and the ground around the figures with a thin layer of Burnt Sienna using a 1-inch (25mm) flat. Don't use frisket, but try to keep the figures free of paint as you work.

Use Cadmium Orange near the horizon, and gradually work into Cadmium Red Light and Cadmium Red Deep as you move up the sky. Brush in some darks near the top with Raw Umber, Mars Violet and Cobalt Violet.

Block in the ground quickly. Mix browns in with the oranges and paint big overlapping strokes with a 1-inch (25mm) flat. Mix in lighter browns such as Yellow Ochre and Raw Sienna by the foreground figures.

5 When Red Isn't Really Red

Start on the buildings in the back and work to the front. Mix liberal amounts of Cadmium Red Light (actually a deep orange) into the base colors for the distant buildings. Use warm grays or mix in some Olive Green to add color variety and help define the different materials on the buildings, such as stone and metal. The buildings farthest away will have the least contrast and will have the greatest amount of orange in them.

As you work toward the foreground, add intense accents of color through the neon signs. Use Cobalt Turquoise and Viridian Green as the base colors, and work Titanium White into them while they are still wet to achieve that neon glow.

6 Building Materials

Introduce strong darks to the foreground buildings by using Raw Umber and Lamp Black in the lava stones and the sooty, grimy metal.

For contrast, color the walls of the building on the right lightly. With a large angled flat, paint Yellow Ochre and Naples Yellow loosely over the Burnt Sienna base. Use random marks for a coarse look. Let the Burnt Sienna show through in some places, and use a round to paint gray cracks and crevices.

Adding the Characters

Remember, at this point you will have already drawn the characters (see pages 134 and 136–138) along with the background drawing (see page 30 for more on this process).

7 Metal and Stone

Add a red painted metal roof to the building on the right. Cover the painted metal area with Alizarin Crimson. Bring up highlights with Cadmium Red Deep, and add some reflections of light with Cadmium Red Light.

Finish the ground with two areas of lava rocks set in the ground at the edges of the painting. With a small round, outline the edges of the rocks with Raw Umber and Lamp Black, then paint in small cracks and pits in the rocks. Use a no. 2 filbert to add cool gray highlights.

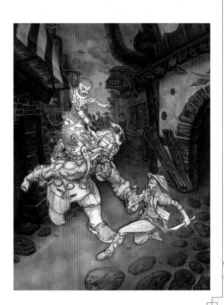

See the complete scene on page 131.

Charging Pirate

This is an action scene, so draw this charging pirate in a dynamic pose from a dramatic angle. The horizon line is fairly high, which usually indicates a low point of view.

However, if you pull back from the action, the viewer can look down at the charging pirate from an overhead angle, providing a clear view of the action.

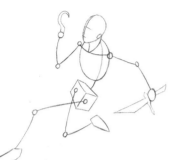

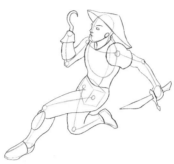

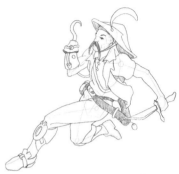

1 Let's Fight

Start with the basic figure construction of lines and shapes. The pirate's left leg is forward, planted firmly on the ground. He's in full stride, so his left arm is drawn back to balance his weight. Bring his right arm up in front to emphasize his running motion. This arm will also block a punch thrown by the Rastyr. And, of course, since he is a pirate, one of his arms should end in a hook.

2 Past Meets Future

Flesh out the pirate. He has basic human proportions, so look at reference of people running to nail down the anatomy.

The design of the lava pirates is important in telling this story. They need elements that link them to ordinary pirates with hooks for hands, hats with big sweeping brims, billowing shirts and flared boots. They also need unique elements, which is where a touch of science fiction will come in handy.

3 A True Lava Pirate of Tussoc

Balance the traditional with the fantastic. For example, draw a plain cloth vest, but place it over a large piece of mechanical shoulder armor. Repeat this theme on his lower body. Tuck loose-fitting pants into hard-edged, segmented boots. Use belts, straps and buckles in unison with tubes and wires carrying electricity and coolant. An even mixture of rough leather and polished chrome will define the lava pirates of Tussoc.

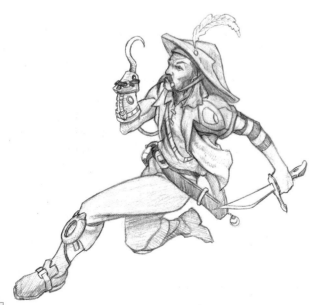

4 A Shadowy Figure

Use hatching to indicate the dark areas of the pirate's outfit. Make the stripes on his sleeve, hat and belt dark by filling them with a tight concentration of marks. The rest of his garb is neutral, so use fewer marks. Use crosshatching to create shadows. There is an overhead ambient light created by the reflection of lava light off the cloud layer. This means that areas on the bottom side of things, such as the wide brim of his hat, are cast in shadow.

5 Bold Attitude, Bold Colors

The pirates of Tussoc are a bold, rowdy lot. Portray this through the use of brightly colored clothing. Use Olive Green mixed with Cinnabar Green Light for his hat and pants, Cadmium Yellow for his shirt, Indigo Blue for his vest and Alizarin Crimson on his shoulder armor. Cover his exposed flesh with a combination of Cadmium Red Light, Raw Sienna and Flesh Tint.

6 Accent Colors

Continue adding color, focusing more on smaller areas. Mix a warm gray with Lamp Black, Titanium White and Raw Umber for the areas of bare metal, such as his hook, forearm guard and knife blade. Use Indian Yellow for his buckles, his shin and wrist ornaments, and his knife handle. Paint a Viridian Green oval within the shin guard. Cover the leather belt and shoes with Raw Umber.

7 Ruddy Pirates

Using small rounds, finish painting his head. Use short, overlapping strokes of Cinnabar Green Light and Chromium Oxide Green to bring up the highlights, and add coarse weave texture to his hat. Apply similar strokes of Cobalt Violet and Radiant Pink to the hat feather.

Paint the facial hair simply with thin layers of Raw Umber and Lamp Black. Work Raw Umber at the edge of his face that meets the background. Redden his cheeks and nose with Cadmium Red Deep. Add a highlight of Yellow Ochre and Flesh Tint to his cheek and above his eyebrow.

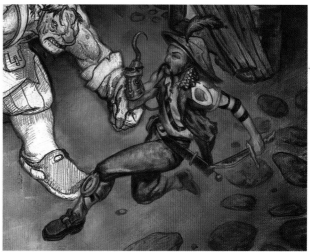

8 Different Kinds of Highlights

Strengthen the shadows and add highlights. When adding highlights, take the type of material you're painting into consideration. For example, use loose, brushy marks of Cinnabar Green Light and Yellow Ochre on his pants to create the look of old, worn fabric. For smooth metals and plastics, use a filbert to smoothly blend a midtone over the local color. For the shoulder armor, mix Cadmium Red Deep with a little Titanium White. For the highlight, use a small round with plenty of the brightest highlight, such as Naples Yellow. Apply a defined dab at the point in the center of the midtone.

See the complete scene on page 131.

The Rastyr and Pigweed

The Rastyr is a lumbering giant of an alien, but he still has two arms and two legs, so his gesture will be similar to that of a human. In this scene he is throwing a wild punch at the lava pirate. Since he's so tall, he must hunch over in order to land the blow.

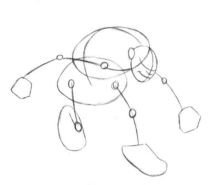

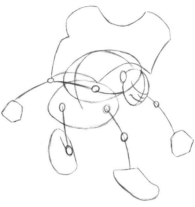

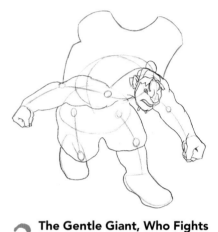

1 Throwing the Punch

Draw an oversized oval for the rib cage. It overlaps the pelvis shape due to his lunging gesture. Because of the extreme tilt of the Rastyr's rib cage, his head is close to the halfway point. His hands and feet are much larger than a normal person's.

2 A Heavy Burden

Create a shape on top of the Rastyr's back that will define the various barrels and containers he carries with him. The shape should be bigger than his rib cage to emphasize his tremendous strength. He must carry this heavy burden around all day.

3 The Gentle Giant, Who Fights a Lot

Draw the Rastyr's huge shoulders and muscular arms. Draw loose pants and knee-high boots. Stick to simple shapes at this point as you will want to refine their design later on.

Use exaggerated human elements to make the Rastyr's face look alien. Play off the gentle giant theme. The Rastyr is basically a nice guy, but his size tends to get him thrust into more than his fair share of fights. His nose should be large and flat, as if it has been punched too many times. His eyes are small and beady and set very far apart. His ears are large.

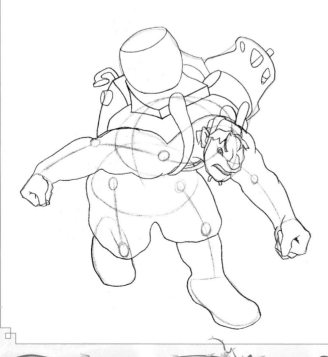

4 It's Not Just a Barrel

Refine the shapes on his back, assigning a function to each one. Think carefully about what purposes they serve. For example, the rectangular shape that curves over the Rastyr's back is a blanket and pad. It protects his back from all the heavy items he carries. The straps that go over his shoulders keep everything supported and in place. Finally, rough in the barrels themselves. To emphasize the chaos of the scene, let the barrels stick out at odd angles. Work in a few details like knobs and levers.

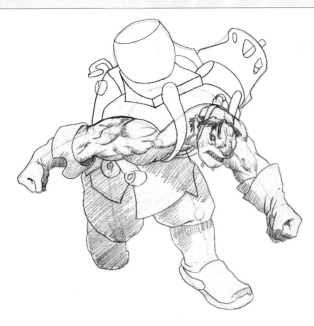

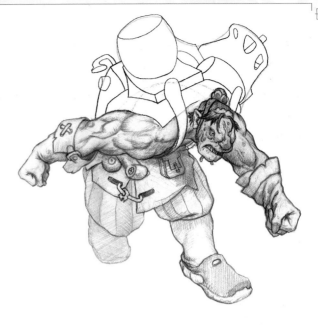

5 Uniform Light

Draw large gloves for handling dangerous materials, and an apron like that of a blacksmith to cover this thighs. Draw a couple of new containers and dispensers at his waist for smaller items.

Start defining the light and shadow. As with the lava pirate, the light is overhead. This creates a cast shadow from his hunched upper body that falls across his thighs. His rear leg is completely in shadow. Use hatching to fill in these shadow areas.

6 A Big Finish

Finish rendering the Rastyr. Define all of the individual muscle groups of his upper body with crosshatching. Check out pictures of bodybuilders to make sure the muscles look right.

Thicken his brow and add some roosterlike skin folds on his cheek. Pencil in some small dark circles around his face so it looks pitted and rough.

Add details to his clothing, such as laces and buckles on his gloves, stripes on his pants and soles on his shoes.

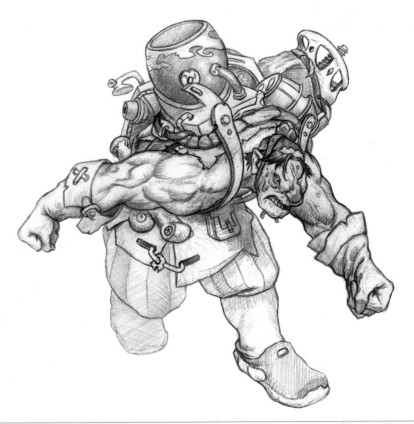

7 Securing the Fine Points

Cover the pack and barrels with binding belts and ropes, temperature-controlling tubes and knobs, and fastening nuts and bolts. Each barrel should have its own design. Some are ornate, while others look more industrial.

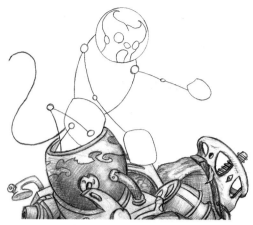

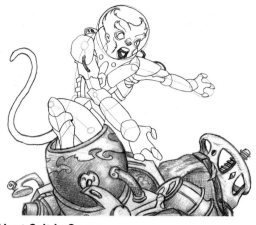

8 Don't Forget About Pigweed

Now, we've got to throw our good friend Pigweed into the mix, as he is in one of the Rastyr's barrels at the time of the brawl. Pigweed should have a wild gesture since his body is being thrown around by forces out of his control. Draw his arms going in the opposite direction from his legs, with one arm coming forward and the other thrown back.

Pigweed's body structure is more like a monkey's than a human's. His arms are very long, while his legs are short, and he has narrow shoulders. Give his tail an S-shaped sweep to stress his movement.

9 Heat Suit in Space

You've already designed the heat suit in an earlier demonstration (pages 124–127). Pigweed's suit is nearly identical to Hachi's, but now you need to draw it in a different pose. The heat suit is made up of a series of simple shapes, so all you have to do is consider how those shapes change as they are tilted at different angles and draw them accordingly. Think carefully about the perspective. The closer an object is to the viewer, the larger it will appear.

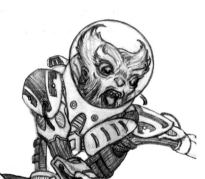

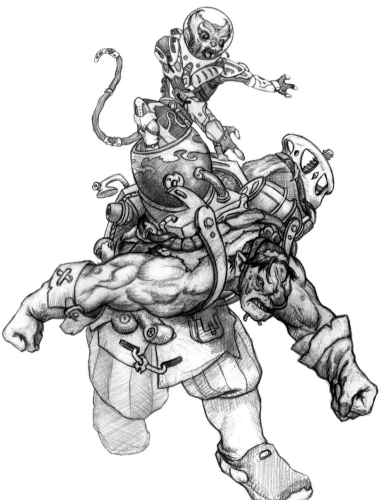

10 Aaaahhhh!!!!

The most important part of drawing Pigweed in this setting is his facial expression. Convey a sense of panic in his face. Draw his eyes open as wide as possible, making them almost complete circles. Bring his nose a little higher on his face, and scrunch it up. Most importantly, open his mouth wide in terror, exposing his teeth, gums and tongue.

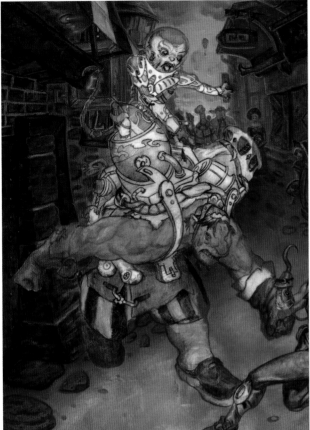

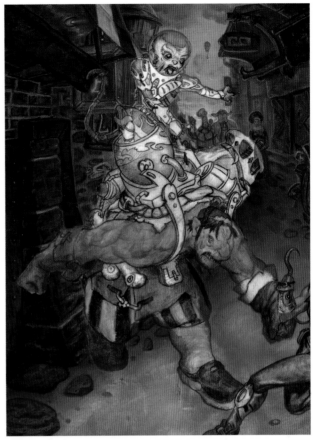

11 Pale Skin

Apply local color in stages, first to the Rastyr, then to his pack and barrels, and finally to Pigweed.

Since the rest of the painting is so colorful, make the Rastyr a neutral color so that he stands out as the center of interest. Mix a gray with Raw Umber, Titanium White, Yellow Ochre and Burnt Sienna, and paint it thinly over his flesh with a no. 6 filbert. Add a little Cobalt Violet and Cadmium Red Deep on his nose and cheeks.

His clothing should have some color so that he fits in with the style we have set up for Tussoc, but it should be muted in comparison to the pirate's. Paint the stripes on his pants in an alternating scheme of Olive Green and gray. The rest of his apparel, except for his hat, is brown leather or gray fabric. The Rastyr's leather is lighter than the pirate's, so mix in some Raw Sienna with the Raw Umber for those areas.

12 The Hat Is Where It's At

The Rastyr's hat is an important color element in this piece. It helps the transition from the neutral Rastyr to his more colorful pack, and it pulls the viewer's eye to the Rastyr's face, which is the focal point. To achieve this, use some basic color theory. The first part is already in place in the neutral color of the Rastyr's face. The second part is to apply complementary colors (colors opposite each other on the color wheel) next to that neutral area. So cover the hair with Sap Green, and the hat with Cadmium Red Deep, and *pow!* there you have it. The complements create a vibrant, eye-catching contrast.

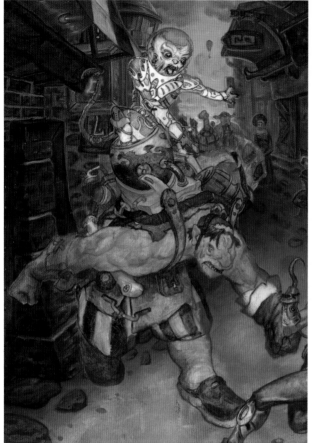

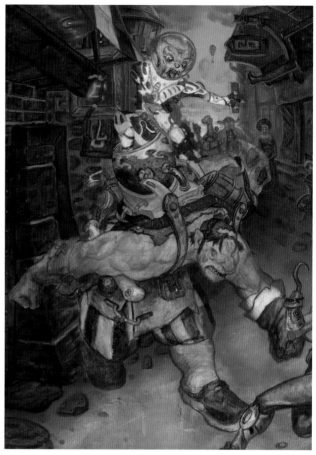

13 **Pack Man**
Apply local color to the items that make up the Rastyr's pack. Feel free to try color combinations you might not have considered before. For example, try making the barrel Pigweed is hiding in a striking color such as Cobalt Blue. This will help bring the viewer's attention to another key story-telling element. Then really mix things up. Use grays and golds for various metals, reds for buttons and leather, and greens and blues for cloth.

14 **You've Done This Before**
You've already determined the colors for Pigweed's fur and a heat suit in previous paintings (see pages 80–81 and 126–127), so now plug them in here. Use Burnt Sienna for his fur and French Ultramarine Blue for the accents of his suit. For the main parts of his suit mix a cream color with Titanium White, Raw Sienna and Flesh Tint.

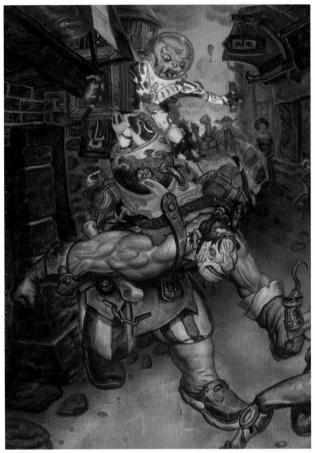

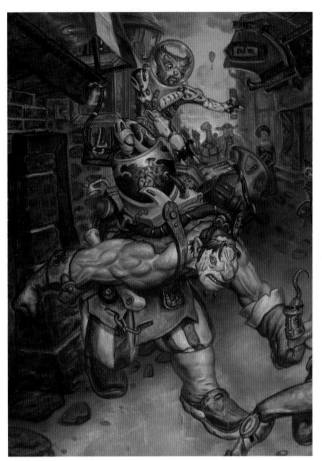

15 Highlights of Different Temperatures

Make sure the Rastyr's face is the brightest and most dynamic area of his body by mixing up a variety of highlight colors. Make a cool highlight with Cerulean Blue and Titanium White, a warm highlight with Radiant Pink and a neutral highlight by adding Naples Yellow to the basic flesh mixture from Step 11.

Use rim light to separate him from the background. Paint a mixture of Cadmium Red Light and Light Red on the upper edge of his punching arm and forward leg.

16 Unifying Everything

Apply the same rim light (see Step 15) as you complete the Rastyr's pack and Pigweed. This will help tie all of these elements together. Also bring the stripe pattern on the Rastyr's pants into items on the pack. Put thin blue stripes on the piece of cloth tied to the gray canister on the right, and Yellow Ochre stripes on the deep red pad covering his shoulders.

Finally, vary the highlights and how you apply them. Make small circular marks using a small round with a mixture of Cerulean Blue and Titanium White on the barrel that Pigweed is in. This will give it the appearance of a rougher, hammered metal in contrast to the smooth gold accents on the same barrel.

To highlight Pigweed's suit, apply a midtone smoothly with a filbert, then add strong, detailed highlights with a very small round.

See the complete scene on page 131.

Lighting Effects

Rim light is a thin line of light painted on the outer edge of an object that is facing a light source.

Continued from page 130.

The pirates made their way back to the docks with the angry mob hot on their heels. We charged out of a narrow alley onto the rough-cut boards of the dock and scattered like cockroaches. I took cover behind some crates to keep an eye on where the pirates were going. The pirates had called out to their comrades on board their ship for reinforcement, and the battle ignited once more. A vicious blow staggered the Rastyr, and Pigweed leapt from the Rastyr's barrel and ran over to me.

We stared in awe at the pirate's ship. Compared to the other ships at the dock it stood like a proud lion among frightened kittens. Its sleek metal hull was held aloft by an array of mismatched balloons clumped together like a patch of wild mushroom caps. Thick bristly rope held everything together to give the whole thing the feeling of a sinister traveling carnival. The pirates had been loading supplies when the mob arrived, and a huge cargo hold was open close to our hiding spot.

"I bet the suit's still on the ship," I said. "We can sneak on board while they're distracted."

"Are you sure that's a good idea?" asked Pigweed.

"No, but it's our only option. Hurry, let's go." Pigweed cracked a nervous smile and nodded.

We snuck on board undetected. The cargo hold was filled with bins and chests teeming with supplies. There were enough food stores, weapons and machinery to be worth ten fortunes. We found Lily standing against a wall. Like everything else, it was secured with ropes. They probably never expected anyone would dare sneak in and steal anything from them. There was a loud thud, and the cargo bay doors closed. In a panic we began to cut the ropes off Lily. The pirates cut some ropes of their own, and the ship roared as it pulled away from the dock. I braced myself against the sure-footed Pigweed. This wasn't part of the plan; the pirates were back on board and we were airborne. Now we had to use Lily to get off the ship.

Before we left for Tussoc, Phlox had given us detailed instructions on Lily's start-up procedure and controls. I sent Pigweed up to the suit's cockpit to get Lily fired up while I kept watch.

"Hurry up!" My nerves were getting the better of me. "I want to get off this ship now!"

"I move faster when there's money involved," Pigweed said with a nervous chuckle.

"Stop joking around and get back to work." I paced around the suit anxiously.

"Hachi, don't take another step." It was Noot.

Too late. I heard a faint click. Blinding lights and deafening sirens blasted from the walls of the cargo bay.

"Run for it!" I yelled to Pigweed, but I don't know if he heard me.

A fierce blow struck my helmet and I fell to the floor. My vision was reduced to a molten blur of light and color. Hands like iron vises gripped my arms and legs and carried me out of the cargo bay. I was thrown down onto unforgiving steel but pulled myself together enough to get up to my knees.

My vision started to clear. I was on the deck. I couldn't see Pigweed anywhere, but I could make out plumes of swirling smoke around a wide, dark figure standing at the helm of the ship. The figure descended to the deck like a rocky avalanche, dust billowing in its wake. A wide-brimmed hat topped a thicket of dark, matted hair. An oily, patched coat fit snugly over a thick barrel chest and bloated belly. This mountain of a man had a demeanor as gray as charcoal. He brought his soot-smeared face close to mine. A widening smile caused the patch over his left eye to wrinkle and exposed a mouth full of crooked teeth like cinders from a fire long since stamped out.

"So tell me, dearie, what're you doin' on my ship?"

"I've come to see One Eye Voster. I'm guessing you're him."

The story continues on page 145.

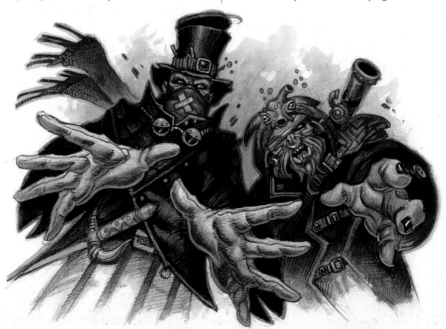

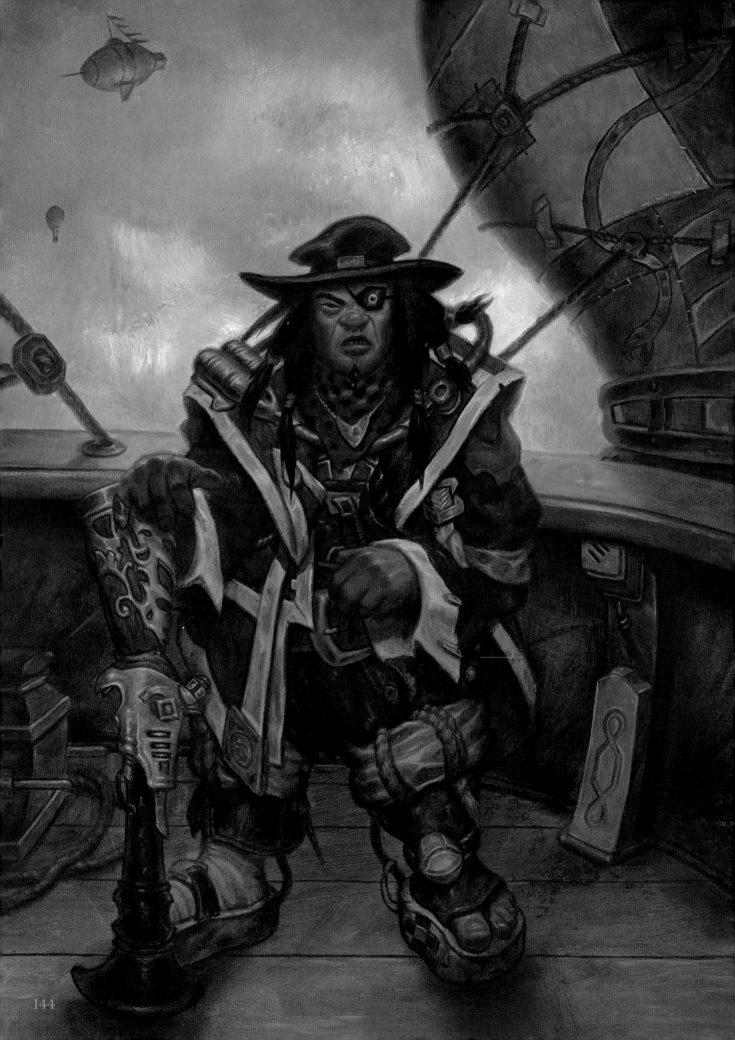

Continued from page 143.

"Aye, that I be. So, word of One Eye Voster has reached even the mighty Oru." His voice was sickening. "You hear that, boys? Tales of our deeds have stretched to the farthest ends of the galaxy."

"I think it's your body odor that caught our attention first," I said. "We could smell you from three star systems away."

Voster's fingers twitched by a pistol tucked into his belt. "By the flames, an Oru with a sense of humor. 'Tis as rare as a glacier in these parts. Will probably last as long." He shoved me back onto the deck as he bellowed, "Boys, ready the plank. This one's going for a little walk."

A roar erupted from the crew as they kicked me toward the starboard edge of the deck where a short plank stuck out over the side. One of the pirates jabbed a metal pipe into my ribs and forced me on wobbly knees out onto the plank.

"A flying suit would surely help out someone in your position right now, little girl. Just so happens I have one for sale," One Eye Voster taunted. "Want to buy it?"

I could tell they were having a good laugh, but the sounds weren't registering. I could only see, and what I saw meant doom for me. Yellow and orange, fire and death.

"So, have ye any last words?"

"Noot, you got anything?" I whispered.

"Nothing dignified."

Voster leveled a hefty rifle at me. "To the core with ye!"

Lights flashed on the side of the gun as it powered up, and I glimpsed a flash of blue and white speeding toward Voster. I made a move to jump back onto the ship as Pigweed plowed into One Eye. The fireball from the rifle passed over my shoulder and blasted a hole in one of the ship's balloon ballasts. The ship lurched, and I toppled sideways off the plank.

My fingers grasped the edge of the plank. Shouts and blaster fire exploded from the deck, and the ship careened to starboard, but I held on. I crawled up hand over hand and nearly had a grip on the railing when I saw One Eye Voster's face and his rotten grin.

He slammed his finger into a button at a console on the railing. The plank disappeared as though it was never there.

As I plummeted through layers of smoke and ash, eyes closed, feeling only velocity, I was struck by a memory from my childhood. I remembered running through rows of laundry hung out to dry in the early summer air. I ran as fast as I could, getting tangled up in the pants and sheets. Eventually I broke through and stumbled into the waiting arms of my father. If only he were here to catch me now.

Time slowed as I waited for death. My frantic breathing overpowered the sound of the blasting wind. A terrible burning tore at my shoulder. The heat from the lava crept over me. My suit wouldn't protect me for long—it would only prolong the pain. I opened my eyes for one last view of the world, even if it wasn't my own.

I wasn't in the lava. I wasn't even near it. I was floating gently on the air currents far above the lava pools like a feather. Like a feather! Like the feather Master Vetch had tattooed on my shoulder.

I was flying! I concentrated on moving left, and it happened. I concentrated on moving up, and it happened. I was flying!

And I was angry. I sped back toward Voster's ship.

"Not bad for a human. I thought you were a goner," said Noot.

"Now you decide to get chatty."

I focused. As I soared up to the ship, I spotted a figure flailing in descent—it was Pigweed. I swooped in and grabbed him by the arm. His cries turned to hysterical laughter as I swung him up onto my back. He whooped and squealed with delight. "Hold on tight," I said. "I'm going to drop you off in the cargo bay while I create a diversion. You get Lily started up. Once you get it going, head back to the metalworks. I'll be right behind you."

The story continues on page 158.

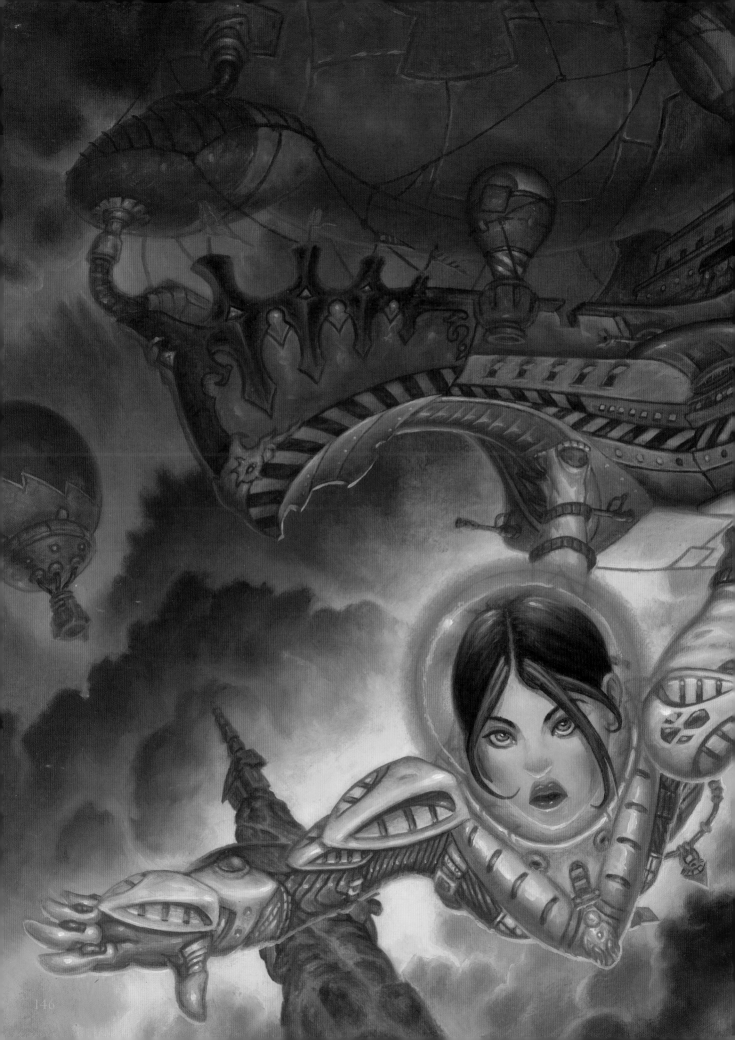

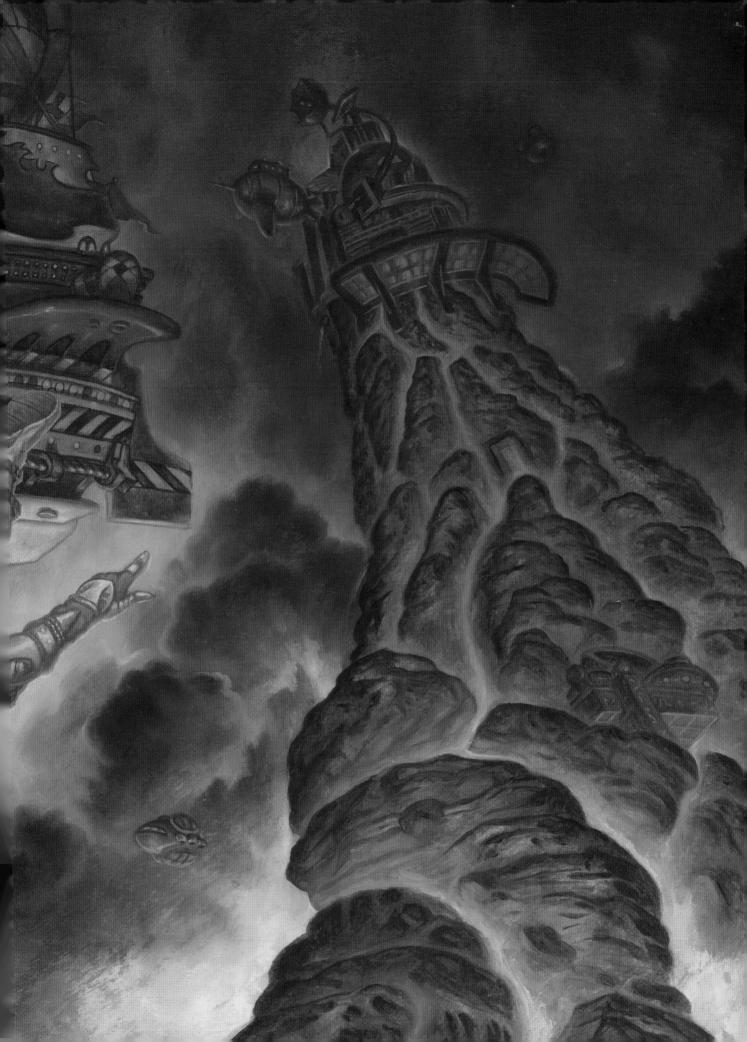

Tussoc Sky

This scene shows the action-packed climax of the story: Hachi's realization that her feather tattoo enables her to fly. Creating an exciting composition is of utmost importance.

Establishing the importance of the things within the composition is called a *hierarchy of elements*. Hachi is the most important part of the scene, so she should take up the most space in the foreground. Voster's lavish and deadly ship should take a secondary position. The brilliant Tussoc sky, with some smaller airships and a couple of hardened lava spires, rounds out the scene in the background.

1 Flying Right

With the hierarchy of the elements in mind, decide where to place the viewer in relation to it all. Take a dramatic angle on the scene to emphasize Hachi's exciting new skill. An extremely low vantage point will allow you to place Hachi in a dominant position in the foreground, and Voster's ship and the fiery sky of Tussoc will still be visible.

For an even more dynamic composition, set the horizon line at a 25-degree angle. Since the viewpoint is so extreme, we can't actually see the horizon, but it's a good idea to draw a few lines parallel to the horizon so that you can line up other elements properly.

Draw a large slender cone with its top cut off on the right. This will be the base shape for a tall growth of cooled lava that is the foundation of small docks and industrial complexes. Draw a smaller version of this shape to the lower left. Finish roughing in the background with a variety of oval shapes for the bustling aircraft.

2 Lava Energy

Use curved lines to make the base of the lava formation wider. Group complex shapes together to form the architecture on the rocks. When drawing the shapes, think about the types of structures and their functions. Since the surface of Tussoc is mostly lava, there would be different kinds of mechanisms to gather the rising heat for conversion into energy. The buildings also have dishes and towers for communication purposes.

3 Lava Rock

Lighten the lava tower guidelines with a kneaded eraser. As this structure formed over the years, hot lava erupted through the surface and poured down over the rock, creating a new bubbly mass as it cooled. Form new edges with a series of irregular curving lines. Create a bunch of small units that make up a whole, similar to an ice cream cone. These units should appear larger near the bottom and become smaller as they go up due to perspective.

4 Wrapped Around a Cone

Continue working on the rocks, adding hatchmarks for tone and texture. Since the main structure is a cone viewed from a low perspective, make the initial hatchmarks follow the form of the cone, conforming to an upward arc around the tower. Use crosshatching to add depth to the individual formations and to create shadows in the crags of the rocks. Lightly erase the narrow snaking areas between the rock groupings. These are where active lava cascades down the rock.

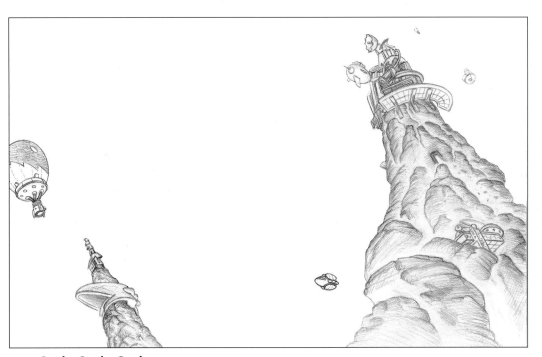

5 Ovals, Ovals, Ovals

Add details to the airships and buildings to complete the background. Use ovals as the cornerstone in the construction of the airships. They can be used for the main shape of the balloons or hull, as well as for the smaller components such as lights, connecting devices, storage areas and thrusters.

For the buildings, let your creativity run wild. You're not an architect, so you don't have to worry about whether your buildings would stand the test of time. As long as your designs are based on interesting shapes, you can draw whatever you like.

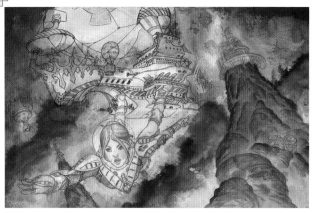
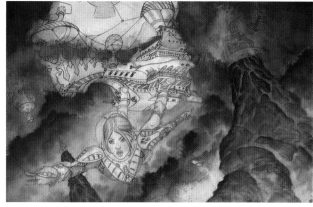

6 Fire in the Sky

The sky in this painting should match the intensity of the scene taking place within it, so let's fill it with layers of rolling, fiery clouds. Start with watercolors to set up the framework for the clouds. Squeeze out streaks and pools of Burnt Umber with an eyedropper. Spray the pools with a water mister so that the color swirls around. Apply Lemon Yellow, Flame Orange, Pumpkin and Carmine in the same manner to fill the background. As the colors dry, cloudlike patterns will naturally appear.

Since the main light source is coming from the lava on the ground, objects will be lighter at their base and become darker towards the top. Switch to acrylics and use washes of Burnt Umber to darken the tops of the clouds. Cover the rock formations with a wash of Burnt Sienna. Darken them near the top with Burnt Umber, and lighten near the bottom with Cadmium Orange.

Adding the Characters

Remember, at this point you will have already drawn the ship and Hachi (see pages 152–153 and 156) along with the background drawing (see page 30 for more on drawing all the elements at once).

7 Halo Effect

Now switch to oils and work wet-into-wet to give the clouds soft, rolling edges. Establish a bright area around Hachi with a mixture of Cadmium Yellow and Titanium White. Work out from this area gradually with Cadmium Orange, Cadmium Red Light and Burnt Sienna.

The upper left and right corners are the darkest areas of the painting. Using a large flat brush, mix Raw Umber, Alizarin Crimson and Dioxazine Purple directly on the painting. Add reflected light in these dark areas with Permanent Rose and Cadmium Red Deep.

Glaze Viridian Green over the buildings on the right. This will help separate the man-made from the natural in the piece and give the buildings an industrial feel.

8 Rivers of Lava

Continue refining the clouds tonally. Keep building the bright area around Hachi with thick applications of Cadmium Yellow and Titanium White. Away from the bright spot, use glazes of Burnt Sienna, Permanent Rose and Raw Umber to gradually strengthen the dark areas.

Start working on the rock formations. Lava is pouring down the rock surface in rivers, erupting out of cracks in the rock. The gradation we set up in Step 6 will make this process simple. Build the edges of the rocks with glazes of Raw Umber. Starting at the top, paint the lava between the rocks with a mixture of Cadmium Orange and Light Red. Make the lava brighter and brighter down the rock, gradually switching to Cadmium Orange, then Cadmium Yellow, and finally ending with bold strokes of Cadmium Yellow and Titanium White at the bottom.

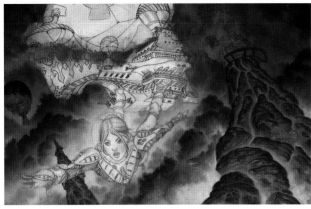

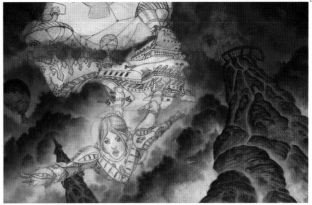

9 **Atmospheric Warmth**

When painting the balloons and airships in the background, remember that the intense color of the light source will affect everything in the background. Thus, when you add purple or blue to one of the balloons, you can't use color straight out of the tube. You need to mix in yellows and oranges, even if it seems like it is muddying your colors as you mix them on your palette. On the painting, it looks right surrounded by all the intense warm colors.

10 **The Shape of Industry**

The Viridian covering the buildings now seems too green. Knock down its intensity by glazing over it with Burnt Sienna and Mars Violet. Paint silhouettes of the tops of the buildings with Raw Umber, thinning out the paint toward the bottom of each structure so the green shows through. This will bring out the shapes of the structures without a lot of fuss over details that wouldn't be visible in this setting. The buildings are far away from the viewer, in a sky that is filled with bright reflecting light and smoke, so detail is at a minimum.

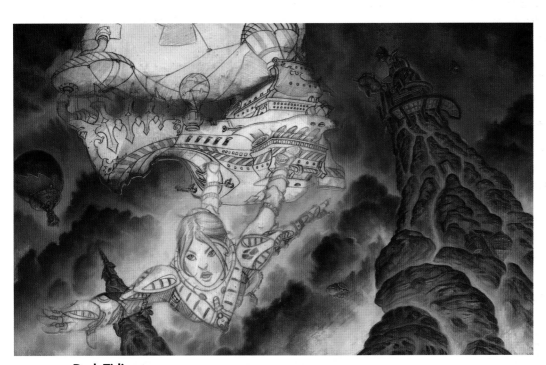

11 **Dark Tidings**

Use a small round to finish the background. Paint a rim light (see page 141) of Cadmium Orange on the bottoms of all the free-floating objects. Add warm grays to the metal buildings and ships, then a few highlights of Radiant Green to the buildings on the right.

To finish the clouds, paint Cadmium Red Light and Permanent Rose into the darker areas. This will give some visual interest to the dark areas of the sky. Think about the clouds before a thunderstorm. They are mostly dark, but there are areas where light breaks through, creating an ominous look.

See the complete scene on pages 146–147.

Voster's Ship

One Eye Voster's ship, like almost everything you've drawn so far, will be made up of a combination of themes. First and foremost, it is a pirate ship, so a large portion of its design should be based on pirate ships from the eighteenth century. Second, it flies using the same principles as a hot air balloon, so it will need some balloon shapes. Finally, it needs that science-fiction touch to make it fit in with the story. Combining all these elements could get complicated, so start off as simply as possible.

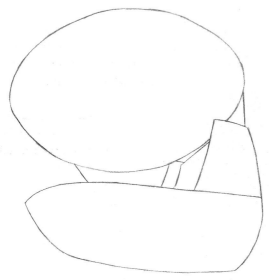

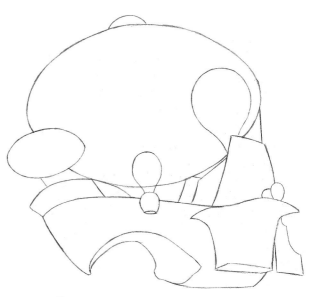

1 Pirates, Hot Air and Science Fiction…
Draw a large horizontal oval. This will be like the main sail of the ship, but in balloon form. Beneath the oval draw a very simple shape for the ship's hull. At the rear of the ship, add another large rectangular shape on top of the hull. Let it overlap the oval.

2 …Balloons…
One balloon isn't enough for an awesome ship like Voster's, so add several more oval shapes of different sizes and orientations. The ship itself needs to be more ornate as well. Add an arched shape to the front of the ship for a railing and a rudder to the back. Carve out an arched segment on the bottom of the hull to refine its shape. Add a curved wing to the side with a large storage area beneath it.

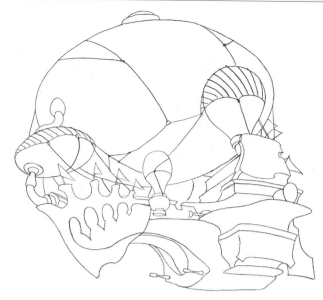

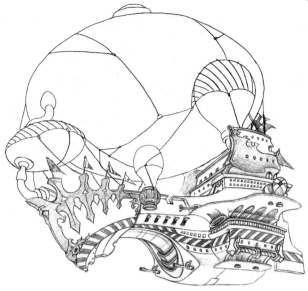

3 ...Guns...

The balloons are filled with hot air produced by the lava below, so there need to be nets and ropes to keep them from pulling away from the ship. Also there should be tubes that pump hot air directly into some of the balloons. The balloons on the side of the ship have oval-shaped pods with open bases to collect the hot air.

Create some ornate designs on the ship to give it that eighteenth-century look. Use a good mixture of straight and curved lines so that it doesn't become too flowery or too industrial. Finally, we can't forget the cannons. All good pirate ships have an ample supply of cannons, although yours should have a more streamlined and technical feel to capture the science-fiction aspect.

4 ...Ornaments...

The details of the ship will help establish its scale. It's huge. You can illustrate this by filling the ship with rows of tiny windows and other small openings. If each small window represents a room, your ship has quickly become a massive beast lumbering through the sky.

Finish the base of the ship with more ornamental detail. Draw a row of stripes running the length of the ship. The trim work along the bow (front) has a fair share of sharp points, like fangs, to make the ship look menacing.

5 ...and Lots of Colors

The last bit of work involves the balloons. Tussoc has a fairly monotonous natural color scheme. Lots of orange and brown. Thus, it's only natural that its inhabitants would want to add lots of color where they can. Give the material that makes up the ship's balloons lots of different colors and patterns. Add stripes, diamonds, ovals, rectangles and even large emblems to the coverings of the balloons.

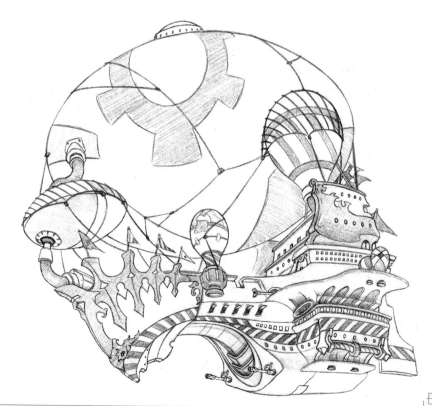

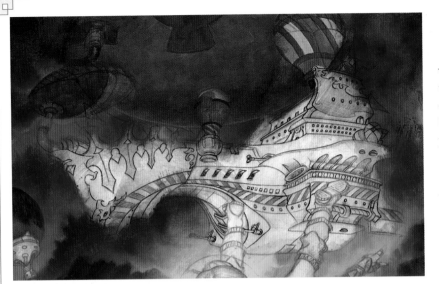

6 Not Too Bright

Use your oil palette to paint the ship. The pirates of Tussoc like to wear colorful clothing, so it's safe to assume that the balloons of their ships would be equally colorful. As with the airships in the background, mix all the colors with the yellows and oranges that are so dominant in the sky. Thus, the green of the large central balloon becomes a very warm green. Also, because it is far in the distance, the green shouldn't be very intense. Begin with Olive Green and mix in Chromium Oxide Green, Cadmium Yellow and Burnt Sienna. Use this mixture as the local color for the balloon. Add medium highlights into the wet paint with Raw Sienna and Cadmium Orange. Use Olive Green and Burnt Sienna for the shadow areas. Use the same color mixing scheme for all the colors on the other balloons.

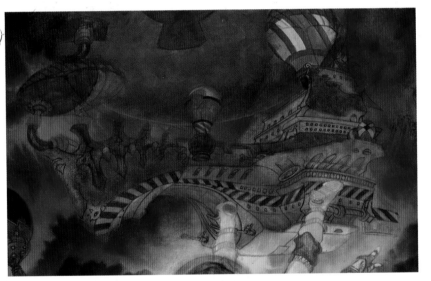

7 Out of the Blast Furnace

Start laying in the base colors for the metals of the ship's hull. Mix Raw Umber, Burnt Sienna, Mars Black and Titanium White for the areas of bare metal. Add more white to this mixture and a touch of Cerulean Blue to create a midtone. The decorative elements along the front of the ship are made of black iron. This will make the ship look more intimidating and will make a strong contrast with the orange sky. Don't use black from the tube though. Even the deepest black will be affected by the sky, so mix some brown into the black first.

The bottom of the ship and all of the metal surfaces that face the lava beneath will be dominated by the lava light. Cover them with Cadmium Orange and Burnt Sienna.

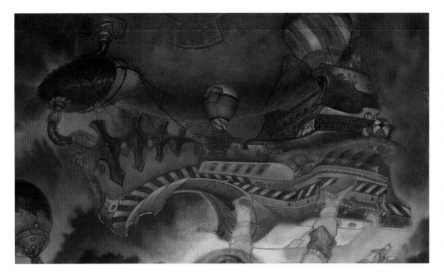

8 Cooler Portholes

Fill in the portholes (windows) with various colored lights. On a regular pirate ship all the interior light would be supplied by lanterns, but since this is a science-fiction world, you can make the light sources anything you like. Mix a light green with Radiant Green and Cadmium Yellow.

Add the highlights on the bottom of the ship with Lemon Yellow and Cadmium Yellow. When complete, this will be much brighter than any other part of the ship.

Add more variety to the metals of the hull. Scumble a mixture of Yellow Ochre and Flesh Tint over some of the surfaces so that they look like a lighter metal. Flesh Tint is a great mixing color for painting metal in warm light.

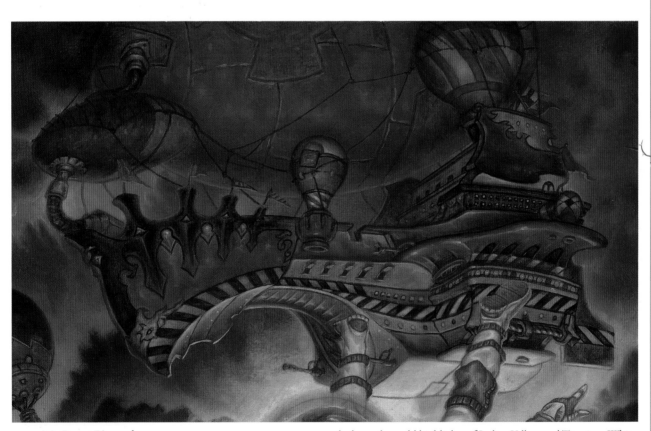

9 It's Been Rigged

Paint the rigging of the ship with various browns. Paint the ropes closest to the viewer with Raw Umber and Burnt Sienna so that they stand out against the colored balloons and orange sky. Mix Light Red into the ropes on the far side of the ship so that they fall back in space.

Paint gold decorative details on the ship, such as the bird-shaped head at the base of the prow (front). Use Raw Sienna for the base, then add highlights of Indian Yellow and Titanium White with some reflections of Cadmium Orange.

Bring up the highlights and shadow areas, but make sure that all of your colors remain warm.

See the complete scene on pages 146–147.

Hachi Flying

Wow! Hachi can fly! At this climactic point in the story, you find the main character under an incredible set of new circumstances. Convey that excitement through the figure. She can't simply hover—she should swoop across the pages, right into the viewer's face.

1 I Knew It Would Be Flying

Use a forced perspective to crank up the dynamics of the figure. Using ovals and lines, lay out the framework. The hand that is stretching out toward the viewer should be huge, and her feet should be small. Because of the angle, her head overlaps her rib cage, and the rib cage almost completely covers her pelvis.

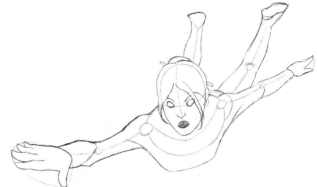

2 She's in Awe of Herself

Rough in the musculature. The shapes do not have to be exact since the layered heat suit will cover up most of them. Add ovals for her eyes and mouth. Her mouth should be slightly open, conveying her sense of awe. (Don't take it too far, or she'll look like she's horrified or in pain.) Make the hair shape thicker than the skull oval so that the hair has mass to it.

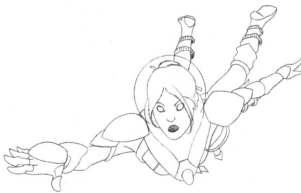

3 Suiting Up

Draw the heat suit as you did before (see pages 124–127). You'll need to make adjustments to the shapes so that they fit in space properly. The foreshortening of this figure is extreme, so all the suit shapes will be as well. Shorten the ovals and draw the wrappings so that they fit the body properly. The straight line of a strap in a head-on view takes on the now-familiar oval shape of a round object tilted in the air.

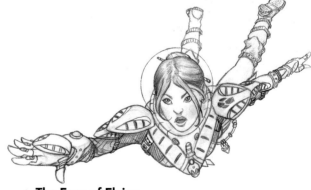

4 The Face of Flying

Work on Hachi's expression. Her eyes are open wide, but not bulging out of their sockets. Her eyebrows are raised slightly. Shade the opening of her mouth and give her cheeks some color with the side of a pencil. Shade the hair with the side of a pencil, then use the tip to draw strokes showing the direction it wraps around her head. Use an eraser to carve the hair's part.

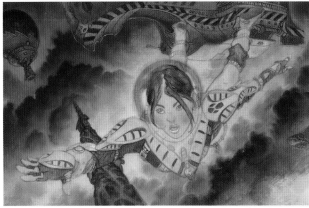

Pretty in Pink

5 To make Hachi pop from the background, lessen the effects of the warm glow of the lava light on her figure. Create a cream color for the suit with a mix of Naples Yellow and Flesh Tint. Add the pink accents and the glow around her head with a mix of Permanent Rose and Radiant Magenta. Use Raw Umber to block in her hair except for the altered strands in front. Color those strands with Cobalt Blue. For her face, mix Naples Yellow, Flesh Tint, Yellow Ochre and Burnt Sienna, adding some Cadmium Red Light to her cheeks and the tip of her nose.

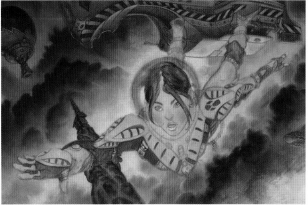

Creating Distance With Color

6 Once this has dried, glaze a mixture of Indian Yellow and Burnt Sienna over her legs and the lower part of her left arm so that they recede in space. Then, paint a thin line of Cadmium Red Light along the bottom edge of her body. This will be the base for an intense yellow rim light that will be the final means of tying the colors of the painting together, as well as an indicator of how close she is to the lava.

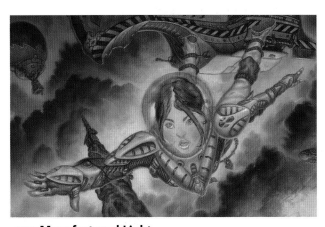

Manufactured Light

7 Start painting Hachi's suit from the feet and work forward. Paint the darkest shadows on her feet and legs with Burnt Sienna and the brightest highlights with Naples Yellow. Save the highest level of contrast for the upper body and face. Create a white light source in the upper left, drawing the viewer's eye directly to Hachi.

Use a no. 2 round to paint a hard edge of Raw Umber and Raw Sienna along the top edge of Hachi's shoulders and arms. Add highlights of Naples Yellow with a little Flesh Tint, then add tiny highlights of Titanium White.

In the pink areas, use a shadow color of Permanent Rose and Mars Violet, and highlights of Radiant Magenta and Titanium White. The warm rim light along the bottom of her body is incredibly intense. On top of the base of Cadmium Red Light, work outwards with Cadmium Orange, and finally a thick line of Lemon Yellow.

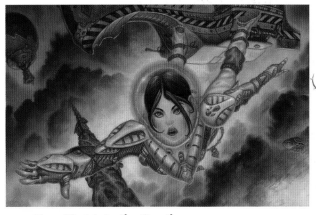

Face First Into the Depths

8 For Hachi's hair, brush on Lamp Black mixed with Mars Violet, avoiding the blue strands. At the crown, paint reflected light from her glowing helmet with Permanent Rose and Radiant Magenta. For the blue streaks, use Cobalt Blue with a highlight of Radiant Turquoise.

The lighting on Hachi's face is tricky, so keep the light sources in mind. There is a strong warm light coming from below, so mix warm colors into her chin and jaw. Add Burnt Sienna to the flesh mixture and apply it thinly with a no. 4 filbert. For the bottom of her chin and nose, use the intense Lemon Yellow rim light from Step 7. Add Naples Yellow and Titanium White to her forehead and cheeks. A thin layer of Permanent Rose and Cadmium Red Light on her cheeks and the tip of her nose will help separate the warm light of the lava from the white light from above.

See the complete scene on pages 146–147.

Continued from page 145.

The pirates were distracted, trying to repair the ballast and right their ship, so they didn't notice when I dropped Pigweed on the aft deck and he scurried down into the cargo bay. I dropped down underneath the hull, then made my way cautiously toward the spot where I had been thrown off. I could see pirates still yelling insults over the side. I suppose I should have tried to think up an elaborate distraction, but Pigweed had said he needed only a few minutes to get Lily started, and I couldn't contain my rage. I flew straight at the pirates, arms locked tight in front of me. I caught one square in the jaw with my left fist and sent him spinning. I swung back around to the center of the ship and landed on the deck amidst a crowd of startled pirates who were slow to react. Using the skills Draba had taught me, I let loose. My fists and feet connected with bearded chins and softened bellies. The slackened ropes caused the rigging to collapse on a bunch of the crew. Someone fired at me, but I flew above the blasts, and the fireballs ripped through the deck instead. One Eye Voster shouted out to stop firing. I hovered over the deck and fixed my eyes on Voster. "Your turn, fat man."

He furrowed his brow and bared his brown teeth. "I wouldn't have it any other way, girlie."

I dove under the hull, out of sight, and came up over the aft of the ship. Voster's head was turned toward the cargo bay. A huge mechanical fist had punched its way through the deck floor. The shriek of twisting metal from the cargo bay rang out harmoniously as I swung my leg through the air, kicking Voster hard on his backside. He turned to catch a glimpse of his attacker, but caught only my fist directly in his good eye.

I spotted Pigweed wearing a huge grin in Lily's bubble cockpit. "Time to go," I called to him. He gave me a little pirate "aye-aye" salute as blue flames ignited at the feet of the suit. It launched into the sky, breaking ropes and tear-ing balloons as it went. The pirate ship listed and started to lose altitude. Voster roared with rage and tried to grab me. I zipped through the air, dodging his flabby arms. As a final insult, I snatched the hat off his oily head and dropped it into the searing landscape below as I flew off after Lily.

"Well done," Noot said.

At the metalworks, Nilton greeted us with a toothy grin, which stood out pleasantly against his sooty face. "The queen bee has ordered the hive. Honey for all."

"He is very happy and grateful," Noot translated. "Hachi, he requests that you roll up the sleeve of your heat suit for a moment."

I wouldn't last long exposed to the high temperature of Tussoc, but I had learned to trust Noot. I removed my right glove and rolled up my sleeve to the shoulder. Nilton reached out with his hand and dragged a gritty finger in a semicircle on my arm, leaving a greasy black streak. He smiled and bowed. I looked curiously at the mark. "Thanks, I guess."

Arnica brought the *Yarrow* into Tussoc's orbit. Since Lily was too big for the Bounce Corridor, Pigweed and I crammed ourselves into her cockpit and flew back to the ship.

Once we had debriefed with Brome, I took a much-needed shower, but the mark Nilton left would not wash off. I tracked down Phlox, who was gleefully putting Lily through her paces in the cargo bay. I floated up to the cockpit. (I loved showing off my new power.) "Hey, your buddy Nilton put this dirty splotch on my arm, and it won't wash off. What am I supposed to do?"

"Are needles and ink the only way to receive a tattoo?" Phlox inclined his head. He laughed when he saw my expression. "Good luck figuring out what that one does."

He pounded on the instrument panel of the cockpit in a fit of laughter, and I realized I still had a lot to learn about these strange creatures known as the Oru.

The story continues on page 172.

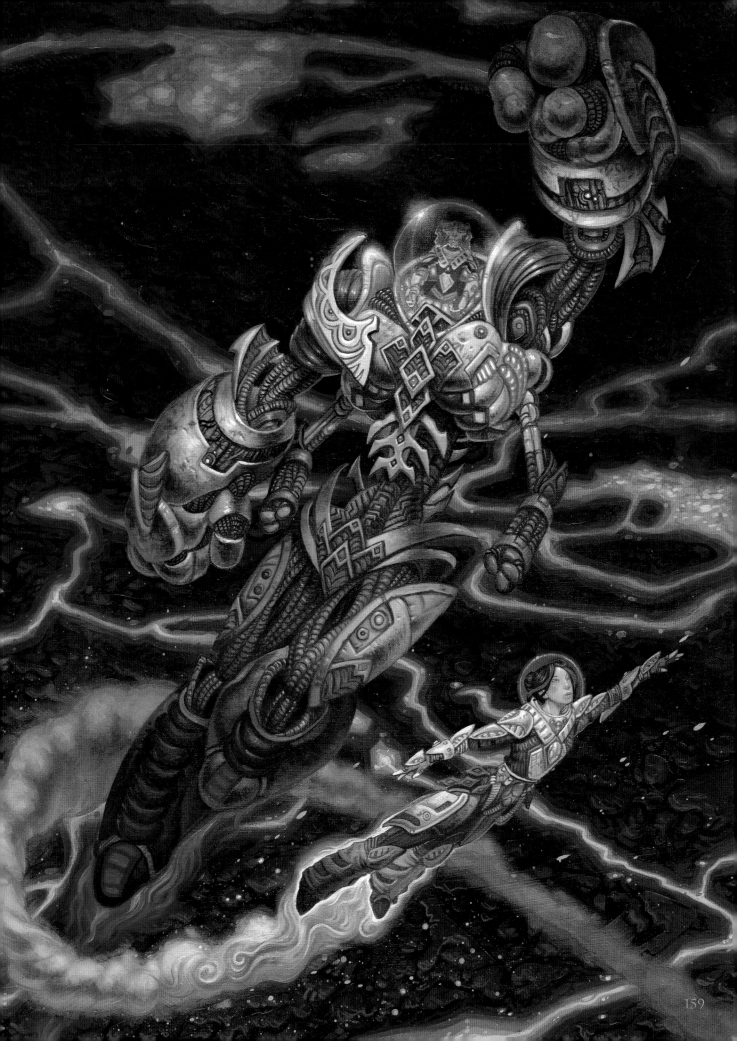

Tussoc Topography

Tussoc's landscape is veined with lava rivers and lakes that blast to the surface, continually altering the terrain of the planet. Thick gasses float in the atmosphere and loom in pockets of clouds, waiting for the perfect time to unleash a blistering heat storm. The Orun heat suit would definitely come in handy here.

1 Horizon Out!
Draw the border of your sketch. The horizon line is way off the top of the page, creating a bird's-eye view. Roughly block in some river lines, and break up the planet's surface with different planes. Add ovals for the lava lakes. Make sure each corner of the composition has something different going on.

2 Hardened Lava
Draw the hardened lava surface. Use reference of volcanoes and hardened lava. Keep the hard surface flowing downward, drawing continuous, repeating S-shapes at an angle to create a layering effect. Keep it loose.

3 Sketchy Landscape
Clean up the drawing and define the rivers and lakes, adding jagged lines at the edges. Add smaller rock formations around the river's edge in the lower parts of the sketch. Use flowing, simple linework.

4 Rivers and Lakes

Clearly define the shapes of the lakes and rivers with a jagged edge. Fill Tussoc's surface with random patterns. Draw in rocky formations with angular circles in varying sizes. Continue developing the surface with squiggly lines and shapes.

5 Crusty Surface

Render the surface, following the shapes of the line drawing. Draw rounded, stretched C-shapes in a consecutive pattern to create the ridges and bumps of the landscape. Draw darker lines to separate the ridges and folds of the dried lava flow. Darken the lake and river edge lines, and lighten the lakes and rivers with a kneaded eraser. Work down the drawing, continuing with these techniques. Draw the C-shapes of each plane in a different direction to give the impression of lava flowing from different angles.

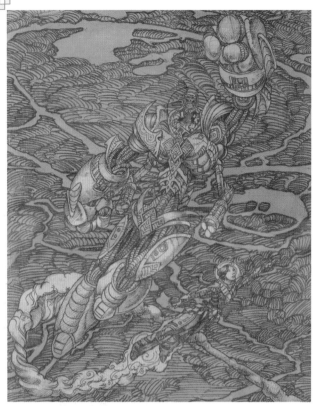

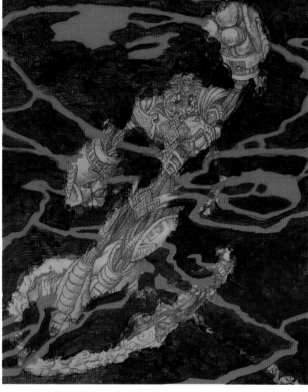

6 Preparing for an Escape

Mount the drawing and prepare the surface (see Step 7 on page 48). Apply diluted Burnt Umber acrylic paint with a 2-inch (51mm) flat. Let it dry.

7 Mask and Acrylic Block

Mask the surface with frisket paper. Smooth out bumps with your hand, and use a craft knife to trim out the characters. Remove the paper covering the background, leaving the characters covered. Using a no. 5 flat, block in the background with Noir Black acrylic paint. Block in the lava rivers and pools with Cadmium Red Light. Cover the surface without worrying about the details.

Adding the Characters

Remember, at this point you will have already drawn Hachi and Lily (see pages 164–165 and 168–169) along with the background drawing (see page 30 for more on this process).

8 Knifing Your Way Out!

Using a no. 5 flat, block in a wash of Ultramarine Blue and a touch of Titanium White over the Noir Black. Mix Ultramarine Blue, Titanium White and a touch of Eggplant Purple. Load a palette knife on one edge and roughly block in the Tussoc surface. The random texture created by a palette knife is great for hardened lava. Don't make the same stroke twice. Use a loaded edge to control the strokes. Add more Titanium White at the lower portion of the painting, and fade to a darker blue at the top.

9 Falling Rocks!
Hone in the rock details with a no. 4 round and thinned Noir Black, breaking up the formations. The smaller the rocks, the better. Continuing with the no. 4 round, use Titanium White and Purple to work the rock edges with highlights. The light source is coming from the bottom left corner. Follow that source to the top, hitting all the rock edges with light. Add Cadmium Orange to the rivers and pools mostly in the lower portion of the painting.

10 Atmospheric Push
Punch up the black areas with opaque Noir Black. Continue to work the rock details with highlights and darks. Mix a purple glow for the lava rivers and pools with Cadmium Red Light and Eggplant Purple. Use a no. 4 round to add the glow around the edges. Pull a little of the glow into the nearby rock. Add Cadmium Yellow Light to the center of the rivers. Add small pools. Keep the main details at the bottom portion of the painting. Add highlights and glow light on the rocks.

11 A Long Way Down
Avoiding the lava pools and rivers, glaze the rocks and Tussoc surface with diluted Noir Black and a no. 5 flat. This pushes these elements back in space. Repeat as necessary.
Add the flying embers that Lily and Hachi have kicked up in their wake. Load the no. 5 flat with either Cadmium Yellow Light or Cadmium Orange. Hold the brush over the painting and tap it on your finger to create a splatter effect. Start gently and build up to a more aggressive splatter. Lily's out of there!

See the complete scene on page 159.

Soaring Hachi

At the last second, just before plummeting to her doom in the lava, Hachi discovers her tattoo power of flight. This *Koru-Jinshi*, given to her by Master Vetch on the planet Doona, not only saves her life, but helps her kick Voster's butt.

1 The Loop Line
Draw a line that curls around and overlaps itself, starting from the top and looping down and around. Draw an angled horizontal line close to the top. This is where Hachi's shoulders will be.

2 Flying Shapes
Draw ovals for Hachi's torso and pelvis, then make an egg shape for her head, tilting it slightly so she's looking upward. Draw circles to place the shoulders and arm joints, and for the pelvis joints, knees and ankles. Connect the joints with lines for the limbs. For the smoke plume, draw a second line that follows the contours of the first loop.

3 A Fuller Flight
Draw elongated oval shapes from the shoulders to the elbows and elbows to the wrists. Do the same for the legs from the pelvis to the knees, from the knees to the ankles. Rough in the feet with triangle shapes. Add a cross to the center of the face. Add puffy round pencil strokes to the plume of smoke.

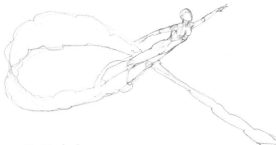

4 No Turbulence
Draw the silhouette, following the outline of the basic shapes. Add more billowy smoke following the two parallel lines.

5 Protective Gear

Add the shapes for the heat suit. Draw an angled oval for the cowl at the neck. At either side of her shoulders, draw a rectangular shape that connects at a diamond in the center of her chest. Draw a diamond with a rounded top for the shoulder pads. See pages 124–127 for more heat suit details. Continue to draw the smoke trail, adding extra smoke wisps inside the basic shape. Try to keep them puffy. Look at photos of puffy clouds for reference.

6 Smoke Trail

Follow the contours of the shapes from the previous step with a sharp pencil. Look at your reference for clouds. I was inspired by how clouds fold in on each other and wanted to mimic that for Hachi's smoke trail. Draw S-shaped lines flowing upward at the point where the smoke starts to loop over. This will make the overlap clear.

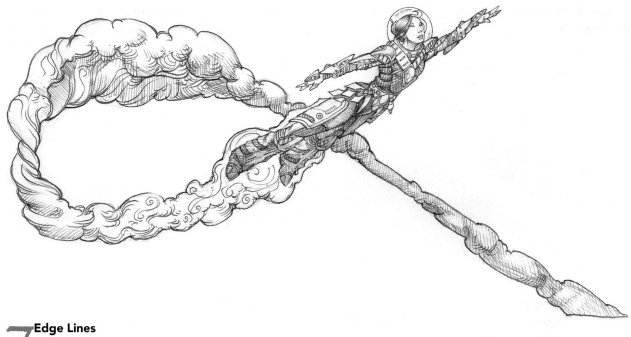

7 Edge Lines

Establish the light source above Hachi and begin rendering the drawing with crosshatching. Use thin and thick lines to show space. With thick lines, the drawing comes forward; with thin lines, it recedes into space. Make the outside line of the smoke trail thicker than the inside detail lines to create form and weight. Draw the inside lines in a swirling pattern at different sizes. When rendering, follow the rounded contours of the shapes. Drawing with the form, not against it, will create a better sense of shape.

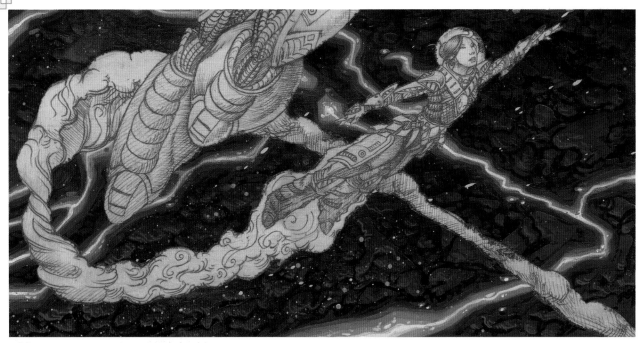

8 Powers Revealed

Remove the frisket paper from Hachi. The prep work from Step 6 on page 162 is still in place. The Burnt Umber underpainting is the perfect ground to get our heroine up and away!

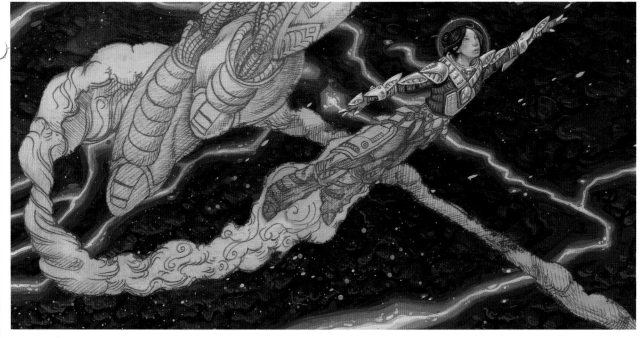

9 Protection of the Heat Suit

Switching to oils, use a no. 0 round to mix Yellow Ochre, Alizarin Crimson and Titanium White for the base skin tone. Add more Titanium White for lighter areas. Use a touch more Alizarin Crimson for her cheeks and lips. Add a touch of Dioxazine Purple and Mars Black to the skin tone mix, and using a no. 00 round, delicately paint in Hachi's eyes and eyelashes and the dark part of her nostrils. For her hair, apply Phthalo Blue and Mars Black, following the contours of the drawing. Using a no. 0 round, block in the light areas of the heat suit with Titanium White and a touch of Burnt Umber and Mars Black. Block in the rest of the suit with opaque Magenta and Titanium White. For all the detail work, use a no. 00 round and fine detail medium to get the edge lines of the heat suit popping.

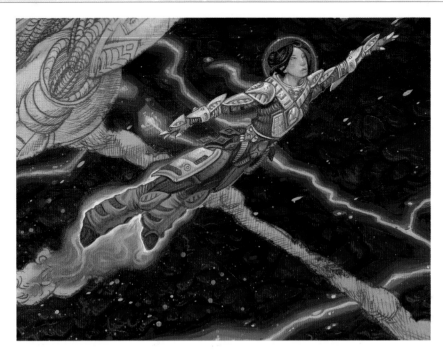

10 The *Koru-Jinshi* Glow

Finish the suit, using the same colors from Step 9. From the waist down, start fading darker, adding more Mars Black and Burnt Umber as you work down the leg. Add backlight from the lava rivers and pools to Hachi's legs with a warm orange mix of Cadmium Yellow Light, Cadmium Red and a touch of Titanium White. This mix should be similar in value to the dark gray of the suit. Apply the orange light, following the contours of the underside of the legs with a no. 0 round.

Paint in the smoke trail closest to Hachi's legs. Switch to a no. 2 round and block in a purple-blue mix of Phthalo Blue, Viridian Green, Dioxazine Purple and Titanium White. Farther away from the glowing legs, the trail becomes purpler. Using a no. 2 round, follow the contours of the lower body and legs with pure Titanium White. Switch to a no. 0 round to fade into the blues. Add swirls coming from the magic effect.

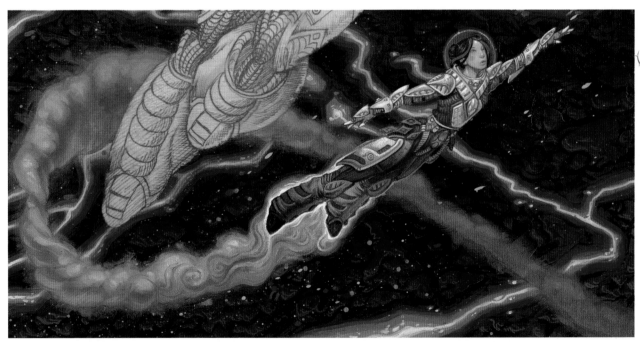

11 Eat Hachi's Dust!

Finish the smoke trail with a no. 2 round. Mix a warm gray that fades into a deep purple with Titanium White, Mars Black, Burnt Umber and Dioxazine Purple with a touch of Cadmium Red. Block these colors in loosely and fade them out to cover the surface. Add backlighting to the smoke trail with Cadmium Red and Cadmium Yellow Light. Blend it smoothly. Add highlights to the edges of the smoke trail, pushing the trail forward in spots. Don't add highlights to the trail behind Hachi since it should be pushed back in space, allowing Hachi to soar forward. Push areas back as necessary with a glaze of Mars Black and fine detail medium.

See the complete scene on page 159.

Lily

Lily is a powerfully strong robot that helps Phlox both on and off the *Yarrow*. Lily is essential to the Orun crew. Her strength combined with Phlox's natural abilities makes Phlox one of the greatest engineers in the universe.

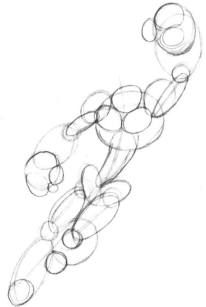

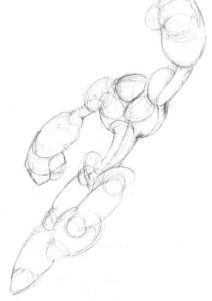

1 A Swooping Robot

Draw a dynamic swooping line with a horizontal line at the top to mark Lily's shoulders. Draw a large oval for the torso. Add ovals for the shoulders, smaller circles for the elbows and larger ovals for the forearms. The shapes for Lily's raised arm should be a bit bigger since it is coming forward in the picture plane. Draw another oval on top of each forearm oval for the hands. Draw two overlapping, elongated ovals for the pelvis. Add circles on either side for the pelvis joints and the knees. Draw a circle for Lily's foreshortened left leg and an oval for the other leg. Connect all the arm and leg joints with lines.

2 In Phlox's Seat

For the neck/cockpit area, draw an egg shape. Add thin, elongated ovals for the upper arms. Create three distorted ovals on each hand for the fingers and thumbs. Draw two ovals for the pectorals on the chest. Although Lily is humanoid in shape, we can mess with her anatomy a bit. Create long, thin abdominals with a long oval shape attaching just below the pectorals and tapering at the pelvis. Add elongated ovals for the thighs and two circles for the tips of the feet.

3 Powerful Silhouette

Clean up the drawing and smooth out the silhouette. Focus on the positive and negative spaces. Clearly define how the shapes interact with each other, using overlaps to show foreshortening and space. For example, Lily's left shoulder is in front of the pectorals and her right shoulder is behind the pectorals. Continue to push and pull part of Lily's anatomy forward and backward so that it all makes sense.

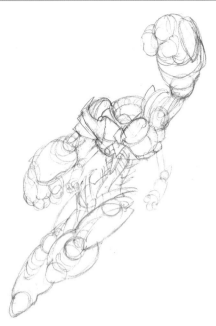

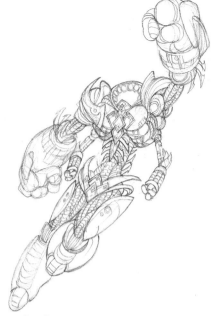

4 A Pricey Item

Follow the contours of the oval cockpit, and draw a line for the control panel. Add a contoured oval shape for the shoulder armor. (Look at a football player's shoulder pads to see how the armor lies on the body.) Draw a diamond shape in the center of the pectorals with another diamond of similar size just below it. Add extra limbs to help Lily haul cargo (follow the same steps you used for the larger arms). Break up the torso into smaller circular shapes. Draw a wavy line attaching to the back of the torso for the spinal cord. In front of that, draw spiky barbs coming off the diamond shapes in the center of the chest. Continue down to the pelvis and legs. Following the rounded contours of the pelvis ovals, draw a V-shape for the pelvis. Add extra plate armor to the thighs.

5 Orun Design

Add ovals around the neck area to create Phlox's 360-degree control panel. Continue to follow the rounded form of the shoulder armor in a circular motion. Follow the contours of the diamond shapes on the chest to create an edge line. Draw vertical lines for the tightened, overlapping muscle cords on the arms and legs. Draw side-by-side C-shapes for the rounded lines running horizontal to the vertical muscle cords.

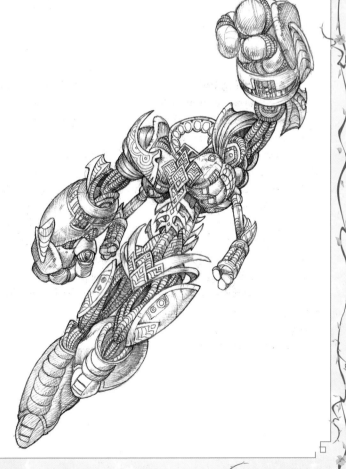

6 Details to Freedom!

Use crosshatching to establish the light source overhead and render the drawing. Draw reflected light, rendering the side of the object and leaving the edges white. For example, on the fingers of the raised hand, the light source comes in from the top and the shadow begins around the edges. Light from the little finger reflects up onto the larger finger. This also helps give the impression of roundness. Pull out highlights with a kneaded eraser as you go. Use varying line thickness to place parts forward and backward in space. Continue adding rounded C-shapes to the edges and joints for an organic robot. Add in pattern and texture to the solid metal plates, such as the torso covering and arm and leg coverings. Whoa! Slow down, Lily, you might lose Hachi!

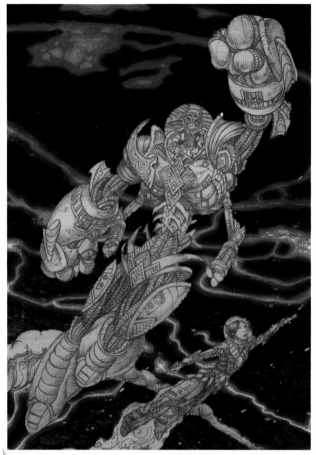

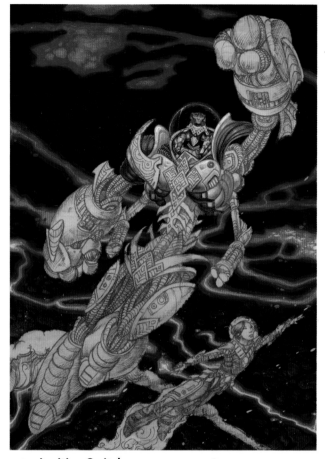

7 Primed and Fired Up!

Remove your frisket paper from Lily. The Burnt Umber wash from Step 6 on page 162 will serve as an underpainting.

8 Ignition Switch

Switching to oils, use a no. 2 round to block in the chest with a mix of Titanium White and a little Raw Umber. Add the detail work with a no. 0 round, cleaning the edge lines as you go. Paint Pigweed in the cockpit, using a no. 0 round for the small details (see pages 80–81). Use Burnt Sienna, Cobalt Blue, Raw Umber and Titanium White for his heat suit. Paint the bubble that encapsulates Pigweed with a mix of Cobalt Blue, Titanium White and Mars Black. Add more Mars Black as you go to fade it into the background with soft edges. Add a highlight with a hit of Titanium White. Work the copper coil muscles that show between the chest plates and the shoulders and cockpit. Apply a Burnt Sienna glaze and hit the coils with a highlight of Yellow Ochre and Titanium White. Finish the design pattern on the undercarriage with a glaze of Dioxazine Purple and fine detail medium. Mix a little Titanium White with the Dioxazine Purple to highlight the purple floral design. Continue to push and pull the space with highlights and backlight.

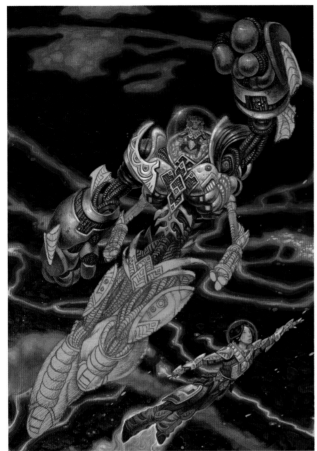
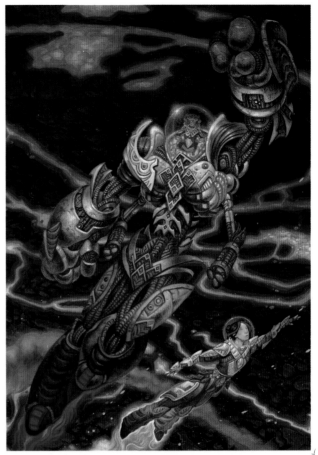

9 All Systems Go!

Using the color palette from Step 8, paint the arms. Add more purple backlight on some of the elements of the arms. The reflected light will help push Lily behind Hachi and integrate the robot into the background. Block in the copper muscle coils on the arms with a glaze of Burnt Sienna and Viridian Green. Add highlights with Yellow Ochre and Titanium White. Using a no. 0 round, add darks to the underside of the coils with a mix of Mars Black and Alizarin Crimson, thinned with fine detail medium. Add the decorative Orun design on the chest with Indian Yellow and Magenta. Add highlights with Titanium White. Using a flared, worn-out no. 2 round, drybrush a glare on the bubble helmet and fade out the edges of the shoulder armor. The glare effect is great for a hazy look.

10 3…2…1…Blast Off!

Using the same color scheme, finish the legs and smaller arms at Lily's side. The lower portions of Lily's legs are in shadow with heavy purple-orange backlight. This gives focus to the upper portion of her body. Darken this area if necessary, using a no. 4 round and a mix of Mars Black and fine detail medium. Push and pull the space on the entire figure, using warm highlights on edges and rounded forms. Mix an extra-warm highlight with Titanium White and Indian Yellow, and add the highlights with a no. 0 round. Add the blue booster flames with Titanium White, Phthalo Blue and Cerulean Blue. With Pigweed in the cockpit, who knows, maybe he'll take Lily to the Merchant Alley and muscle a deal?

See the complete scene on page 159.

Epilogue

Continued from page 158.
Two months later.

"Valer centran *Yarrow* gig Wei Ghong, pinnat?"

Linanthus had spent over an hour arranging his mind for the difficult task of Polyhyborn communication.

"Valer centran *Yarrow* gig Wei Ghong, pinnat?"

Unfortunately, the only response to his repeated calls was a faint and disturbing sizzle.

In a room deep within the *Yarrow*, Brome sat in quiet concentration. The forceful blue light of a computer console reflected in the concerned creases of his face. He had hoped to work undisturbed through the night. The gentle tapping at the door set off a flash of unease within him.

"Please, come in, Linanthus," he said with a weary sigh.

Linanthus's dark hooded form moved into the room with the stillness of a statue. "I'm afraid there is still no response from Khalria," Linanthus reported. "Wei Ghong has never gone this long without responding to my hails. All I receive is an ominous crackling. It causes me great dread."

Brome stared blankly at the blue screen. "We need Wei Ghong's report desperately, but we can't risk blowing his cover. If any of us go to Khalria, we will be spotted immediately." He sighed deeply. "We need to send someone who will not be recognized as a member of the Oru."

"That leaves us very few options," Linanthus responded.

"The way I see it, it leaves us only one."

Linanthus drummed his bony fingers together. "Do you think that is the correct course of action?"

"Sometimes situations dictate the use of methods that one would rather not employ," Brome said vacantly.

"If you don't mind me saying so, you seem to be using that phrase with growing regularity."

"Your concern is noted." Brome was on edge. "However, I see no other way. This situation needs to be resolved immediately. Set up a mission plan tonight, and explain everything to Hachi and Noot in the morning. Have Draba outfit her accordingly."

"Weapons as well?"

Brome fixed his eyes on Linanthus. "Yes. We have no idea what she may encounter on Khalria, especially if the Mark have arrived. She must be prepared to fight."

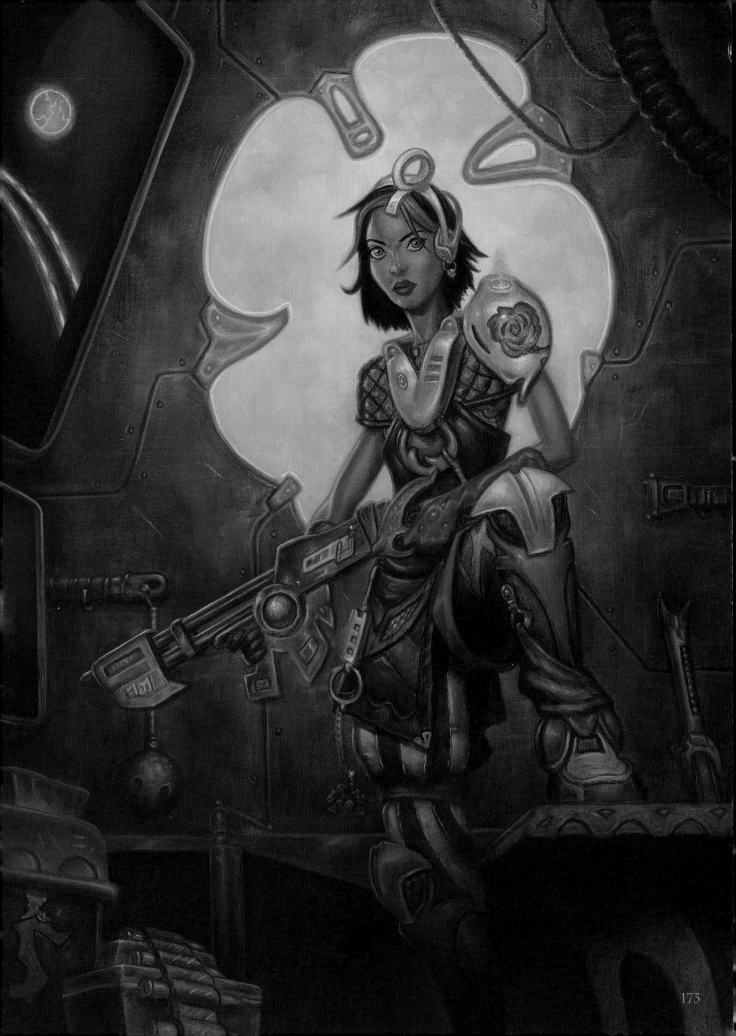

Index

Learn from the Pros with *IMPACT* Books!